MEDALS OF DISHONOUR

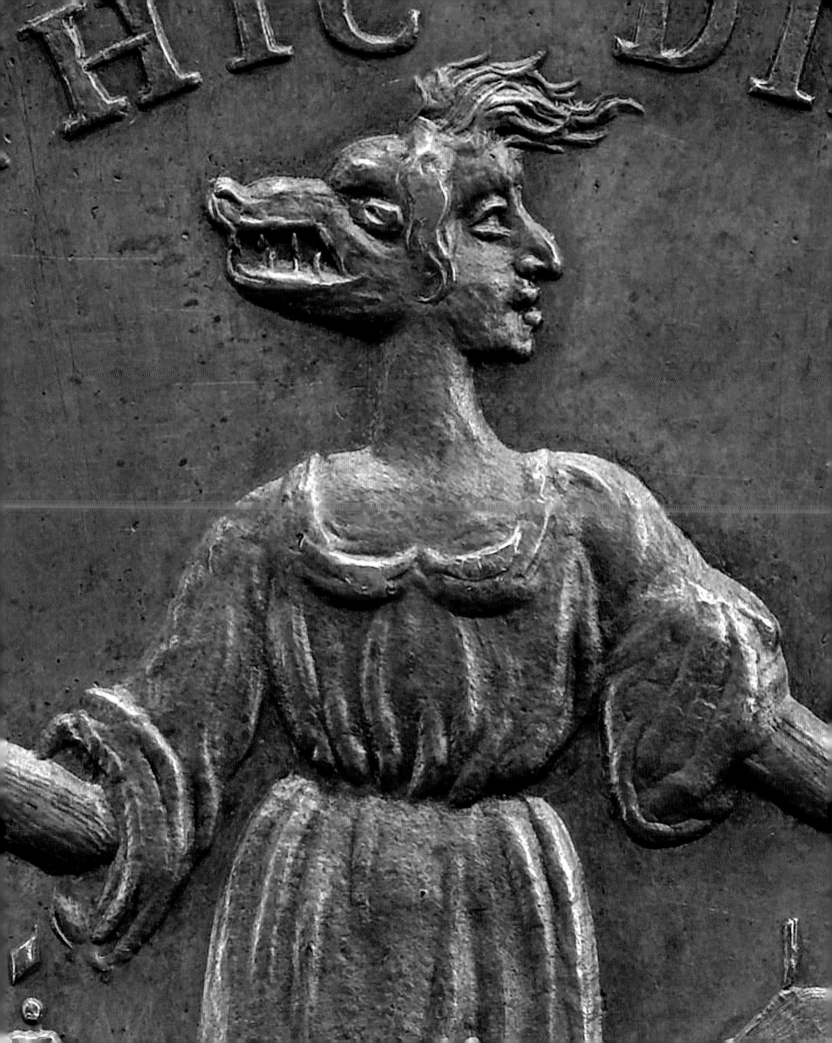

MEDALS OF DISHONOUR

Philip Attwood &
Felicity Powell

THE BRITISH MUSEUM PRESS

This book is published to accompany the exhibition at the British Museum from 25 June to 27 September 2009

First published in 2009 by the British Museum Press
A division of the British Museum Company Ltd
38 Russell Square, London WC1B 3QQ
www.britishmuseum.org

A catalogue record for this book is available from the British Library.

ISBN 978 0 7141 1816 1

Design by Andrew Shoolbred and Anne Sørensen
Cover design by Thomas Manss & Co
Printed in Italy by Printer Trento

Frontispiece: detail from the reverse of *The Good Fortune of William III*, 1689, by Jan Smeltzing (cat. no. 5, p. 49)

Supported by Chora and the British Art Medal Trust.

Papers used by the British Museum Press are natural, recyclable products made from wood grown in sustainable forests.
The manufacturing processes conform to the environmental regulations of the country of origin.

Mixed Sources
Product group from well-managed
forests and other controlled sources
www.fsc.org Cert no. CQ-COC-000012
© 1996 Forest Stewardship Council
FSC

CONTENTS

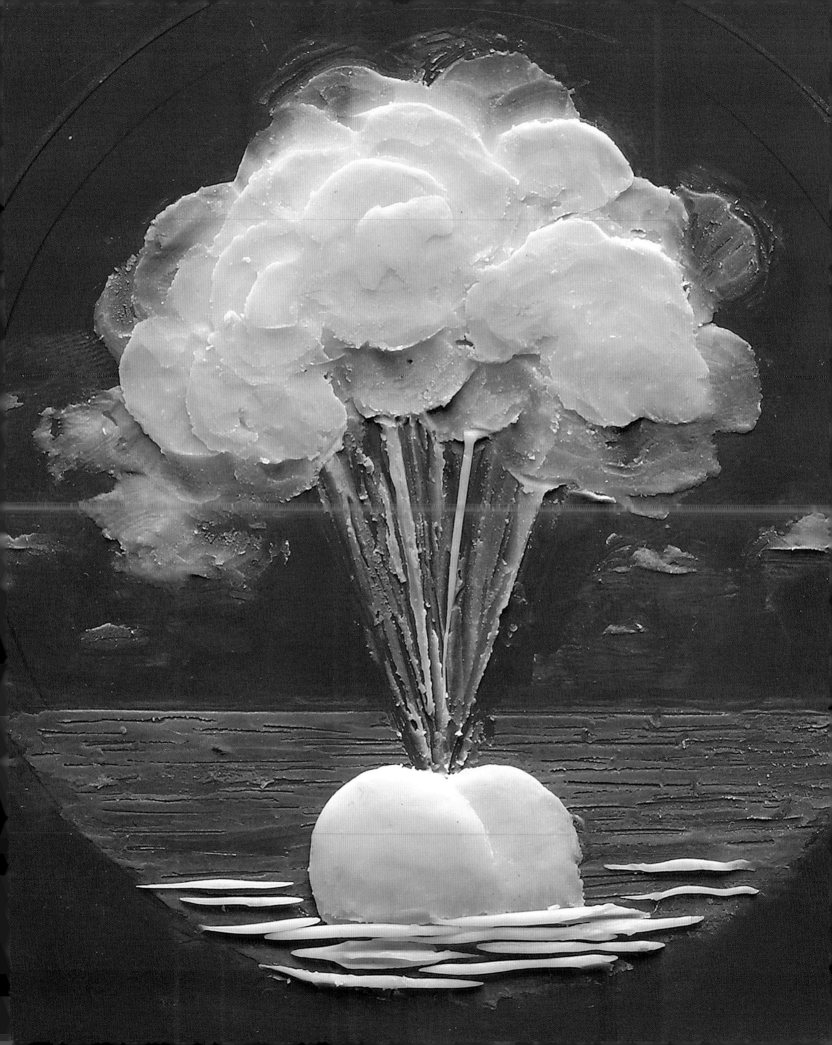

SPONSOR'S FOREWORD

It was a memorable late afternoon. The heat of the August sun had all day to warm the tiles underfoot. Eight artists, all from different disciplines, sipped espresso in the peace of the late afternoon heat. We spoke about Chora, our plans and projects, and how we might endeavour to support creativity.

One of these artists, Felicity Powell, was working on a concept which seemed to us the perfect pilot project for Chora. As an artist whose work includes the design and fabrication of medals, Felicity was exploring with Philip Attwood, the British Museum's curator of medals, a means by which the historical medals in the British Museum's collection might be more widely shared with the public. Her proposal was to select medals commemorating moments perceived by the artists who made them to be particularly dishonourable, and then to add to this selection a group of contemporary artworks that would further explore the medal as an artistic medium.

The dialogue with Chora began in August 2003, and has been informed by Felicity's deep love of cultural history and her wry intelligence and keen wit. The exhibition has therefore been six years in the making. Chora's involvement was firstdis-cussed on the island of Pantelleria, and subsequently in London, Los Angeles and again in southern Sicily in the summer of 2008. Chora's support for this project is part of a long-term dialogue about ways to help innovative projects succeed.

Putting together an exhibition that is relevant both historically and to contemporary art practice is a grand challenge. It is one to which Felicity and Philip have responded with great agility. During these six years Chora has reached out to support several projects that developed from dialogues around that bougainvillea-laden table. This one has special meaning to me.

From it, I have learned a great deal about the history of medals, the role of the medal collection within the British Museum, and the way in which artwork and the archiving of cultural history interweave. Chora is glad to be a sponsor of this exhibition.

Lauren Bon
Chora
The Metabolic Studio

DIRECTOR'S FOREWORD

Built up over more than 250 years, the British Museum's collection of medals is one of the largest and most important in the world, ranging from works by the painters and sculptors of the Italian Renaissance to contemporary medals produced by artists of many nationalities working around the globe. As with all parts of its extensive modern holdings, the Museum's twenty-first century medals represent a natural growth of its historical collection, extending it into the modern day. Together these medals allow us to trace the development of ideas over more than half a millennium – ideas that have helped shape the world in which we live.

The medallists of the Renaissance invented an art form with extraordinary possibilities, an art form that can be held in the hand and enjoyed for its aesthetic qualities and its very personal nature, and is also capable of condensing all sorts of thoughts into the very smallest of spaces. This exhibition encourages us to forget for a moment the medal's usual celebratory associations and to focus instead on an aspect of medallic art and history that until now has been largely ignored. The earliest medal shown here commemorates an assassination attempt in fifteenth-century Florence; the latest ones address subjects chosen by the artists as areas of contemporary concern. In between are medals branding princes as wrong-headed, politicians as unprincipled, financiers as greedy, revolutionaries as malevolent, whilst others condemn the brutality of war. The views range from the subversive to the reactionary; the language from the considered to the vitriolic.

This exhibition – the result of a collaboration between the British Museum's curator of medals and a practising artist – looks at medals in a new light. It also encourages us to look with new eyes at some of the important issues facing today's world, issues that are addressed in the contemporary medals seen here for the first time. The Museum is grateful to the British Art Medal Trust for presenting it with these works, which were created especially for this show by some of the major artists of our times. The Museum is also particularly grateful for the support of Chora, without which neither the acquisition nor the exhibition would have been possible.

Neil MacGregor
Director
The British Museum

ACKNOWLEDGEMENTS

This exhibition and catalogue could not have happened without the generosity of Chora and the enthusiasm of Lauren Bon whose enlightened commitment to the whole project since its inception has been unwavering. We are also grateful to the British Art Medal Trust for facilitating the commissioning of the medals that form the second half of the exhibition and to the American Friends of the British Museum.

Throughout the time that this project has been underway Mark Jones, Tim Marlow and Ansel Krut have provided encouragement and understanding. Thanks are also due to Barrie Cook, Stephen Coppel, Sheila O'Connell and Luke Syson for their various very useful suggestions, and to Rod Mengham for his valuable contribution to the catalogue. The Estate of David Smith provided us with access to the David Smith archive and agreed to lend objects from the collection, including examples of Smith's influential *Medals for Dishonor*, and we are particularly grateful to Peter Stevens, Executive Director, and Susan Cooke, Associate Director, for their unfailing generosity and helpfulness. As well as making a medal, Richard Hamilton also kindly agreed to lend his example of Marcel Duchamp's *Sink Stopper* medal.

Former and present colleagues within the British Museum who have helped in various ways with either the catalogue or the exhibition include Richard Abdy, Silke Ackermann, Jane Ballard, Frances Carey, Clive Cheesman, Joe Cribb, Amelia Dowler, Claire Edwards, Constanza Gaggero, Amanda Gregory, Antony Griffiths, Iona Keen, Ivor Kerslake, Janet Larkin, Ann Lumley, Artemis Manolopoulou, Carolyn Marsden Smith, Sam Moorhead, Jonathan Ould, Jennifer Ramkalawon, Aerian Rogers and Andrew Shore. Through Chora the lively voices of William Basinski, Dorian and Maya Bon, James Elaine, Hannah and Saskia Krut-Powell, Oguri, Roxanne Steinberg, and Zenji and Kaden Steinberg-Oguri have provided encouragement to the project from its earliest stages. Thanks also go to Richard Nielsen, Al Nodal and Jeremy Rosenberg at the Metabolic Studio. We are also extremely grateful to the following for helping in various ways: Kevin Clancy, Anthony Daniels, Rita Donagh, Ron Dutton, Johan van Heesch, Jonathan Kagan, Melissa A. Kerr, Viktória L. Kovásznai, Jeremy Lewison, Dale McFarland, Frances Morris, Gregor Muir, Melanie Oelgeschläger, Ira Rezak, Charlotte Schepke, Stephen K. Scher, Howard and Frances Simmons, Graham and Antje Southern, Mike Thomas and Ben Tufnell.

At the British Museum Company, we would like to thank our editors Laura Lappin and Caroline Brooke Johnson and designers Andrew Shoolbred, Anne Sørensen and Tom Featherby; also Miranda Harrison and Axelle Russo. The photographs, which play such a crucial part in enabling the appreciation of these relatively small objects, were mostly taken by Stephen Dodd.

The British Art Medal Trust would like to thank all the artists who agreed to make medals and all those individuals and companies who helped with their production (the names are given in this catalogue at the headings to the various entries), and also Peter Bagwell Purefoy, Irene Bradbury, Christine Cushing, Tim Fattorini, Katherine Gardner, Irene Gunston, Keith Harvey, Matthew Holland, Mike Honey, Jerry Hughes, Kate Hume, Rob Lansman, Linda Leibowitz, Anne McIlleron, Raphael Maklouf, Jane Poole, Nigel Schofield, Joanna Stella-Sawicka and Fiona Toye.

Philip Attwood and Felicity Powell

Overleaf: Christian Wermuth: Detail from *The Bombardment of the French Coast*, 1694 (fig. 7, p. 19).

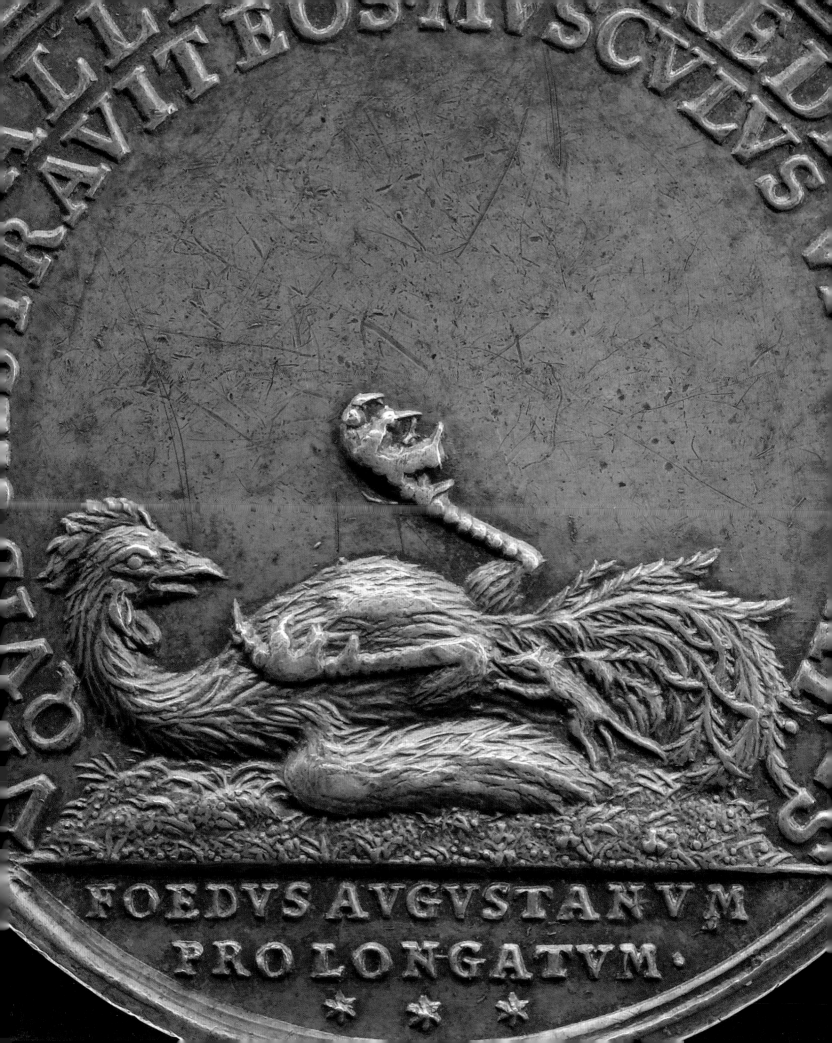

FOEDVS AVGVSTANVM
PRO LONGATVM·

INTRODUCTION

Medals have always been associated with honour and glory. The earliest medals of Renaissance Italy were intended to convey the virtues and qualities claimed by the individual portrayed. Produced as multiples and exchanged as gifts, they reached far and wide. As the medal was turned in the hand, the likeness on the obverse and the imagery on the reverse became one, and the person represented became a metaphor for steadfastness, prudence, benevolence, piety, wisdom, beauty, a combination of these characteristics, or a more general virtuousness. When, in ensuing centuries, medals came to be worn as indications of loyalty to a prince, and when, more recently, the custom of awarding medals for acts of gallantry and sporting achievement became established, the equation of medals and honour was reinforced still further.

And yet, another kind of medal has run in parallel with these celebratory pieces for more than four centuries – the medal that disparages rather than honours or glorifies, that condemns rather than condones, that centres on what is perceived as wrong rather than what is thought to be right. The strength of this alternative tradition has varied according to time and place, but the sorts of accusation levelled and modes of attack have remained remarkably consistent. This book *Medals of Dishonour* and the exhibition it accompanies form a brief introduction to these medals, which record not the glories to which humanity has risen but the iniquities to which it has sunk – or rather the individuals and events perceived as iniquitous by those who made or commissioned the medals. The earliest work represented here belongs to 1588; the latest to 2009. Only a small proportion of the medals produced in this vein could be included, but together they form a representative selection of over four hundred years of medallic acrimony.

From the fifteenth century, medals were instigated not only by the individuals portrayed on them but also by others, including the artists who produced them. The earliest of these were intended as compliments or tokens of friendship that would communicate to the world and to posterity the admirable nature of their subjects. But the widespread practice of making medals that had not been commissioned by the people portrayed on them opened the possibility of conveying messages that were not wholly complimentary, and indeed might be virulently hostile. This option was first taken up in the sixteenth century, when medallists and those who commissioned medals came to realize that an effective way of promoting their own beliefs was to denigrate those of their rivals. Their target might be another faith or an enemy state (cat. no. 1) or, from the eighteenth century, someone nearer to home – a politician (fig. 9, p. 21) or even a theatre manager (cat. no. 12). Alternatively, as many north European medals focused on broad issues without reference to particular individuals, the object of criticism could be generic. Financial speculators (fig. 8, p. 20) and food producers (cat. no. 11) were among the groups singled out for vilification. Medals had joined other media as vehicles of partisanship.

These types of medal survived into the twentieth century, when they were joined by medals that focused more wholly on the unpleasant results of human actions rather than on the perpetrators. The First World War, the conflict that changed the world in so many ways, had a profound effect on medallic art. Alongside medals attacking the enemy (cat. nos 17 and 18), German artists produced works that attacked the very notion of war itself (cat. no. 16). Medals of earlier centuries had touched upon the consequences of war, to highlight either the culpability of an enemy or their own side's superiority, and had poured copious praise on peace, but the production of medals with the sole purpose of exposing the savagery and futility of war was a new phenomenon, indicating a decisive shift both in attitudes to war and in the range of roles permissible to medals. In the years after the war, medals were used by artists as diverse as Karl Goetz (cat. no. 20) and David Smith (cat. nos 21 and 22) to highlight social problems, as well as political concerns. It is from David Smith's series of fifteen medals from the late 1930s, *Medals for Dishonor,* that this exhibition's title is derived.

The role of the medal continued to expand, and the second half of the twentieth century saw a growing interest on the part of artists in the forms medals could take. Marcel Duchamp was the most celebrated artist to participate in this development, producing in the 1960s a medal that undermined the pretensions of the medallic tradition itself (cat. no. 23). Artists have continued to use the medal as a vehicle for a range of ideas and emotions as broad as that expressed through other branches of the arts, and these have included discontent. Some of their medals have followed historical tradition by making very direct statements, whilst others show a more nuanced approach – leaving those who view them space in which to develop their own meaning. The group of recently commissioned medals, with which this book concludes, demonstrates the continuing vibrancy of this long tradition (cat. nos 24–36).

Regardless of the degree of subtlety involved, the strategies adopted by medallists over the centuries have remained remarkably consistent. Satire has been an important element, with the devices employed by satirists working in other media proving equally effective in medals.[1] Key among these devices has been humour, for entertainment can often be the first step towards engagement and successful communication – and, as with many forms of humour, it is incongruity that generally provides the catalyst. Reducing the subject's status and rendering him (or occasionally her[2]) humiliated or absurd may result in a blindfolded emperor, a pope without shoes (cat. no. 1 and detail opposite) or a vomiting and defecating king (cat. no. 6). As this last example shows, scatological imagery, an essential ingredient of satire from Aristophanes and earlier, can add significantly to a medal's impact through its divergence from the visual language generally associated with the medium (cat. no. 7). Animal metaphors are also used to belittle – the actor manager John Kemble is reduced to a recalcitrant ass (cat. no. 12), the future Napoleon III to a beetle notorious as an agricultural pest (cat. no. 15), the 'coalition of the willing' to a pack of vultures around a dead goat (cat. no. 29) – or to demonize, as in the German medals of the First World War in which Britain becomes a savage dog (cat. no. 17) and the United States a monster with distinctly asinine characteristics (cat. no. 18). Monstrous beings may also suggest inhumanity in a less humorous fashion – the forces of William III resemble the legendary poisonous hydra killed with difficulty by Hercules (cat. no. 5), while the Hungarian Soviet Republic is a devilish Medusa-like creature surrounded by snakes symbolic of evil (cat. no. 19). The language of allegory was particularly important in the various forms of political discourse of the sixteenth to eighteenth centuries, when it was informed in the visual arts by the many emblem books published from the 1530s on, and it has continued in telling fashion into modern times.

An alternative strategy has been to associate the subject with anti-Christian forces such as the devil (cat. nos 2 and 14) or the Beast of the Apocalypse (cat. no. 3). An association with obscenity, another traditional component of satire, is brought into play in a German medal of 1920 that is intended to shock rather than to amuse (cat. no. 20). In other instances, allegory is replaced by a narrative also intended to disturb. Although ostensibly descriptive, these narratives remain essentially symbolic. The tortures and murders on a Dutch medal of about 1686 do not represent an actual scene; rather the images are brought together in order to indict Louis XIV for sanctioning the killing of people on account of their religious faith (cat. no. 3). A medal commemorating the Peterloo massacre of 1819 has a particularly documentary aspect, but it is clear that the artist has manipulated the scene in order to emphasize the brutality of the soldiery and the defencelessness of the protestors (cat. no. 13). Equally, the figures hanging from a tree in 1919 have an historical lineage that reveals their symbolic nature (cat. no. 19).

As well as likening their subjects to that which is evil, medallists have also made sure to emphasize their messages by contrasting them with what is considered admirable. As medals usually have two sides, they are well placed to carry such messages. Thus the 'uncharitable monopolizer' is placed in opposition to the charitable hand that appears on the reverse (cat. no. 11), and the young Queen Victoria forms a striking contrast to her diabolical prime minister (cat. no. 14). More often, though, the two opposing forces interact more closely – a scene of atrocious barbarities also represents the martyrs' ultimate victory (cat. no. 3), the stupidity of John Kemble brings to the fore the determination of John Bull (cat. no. 12), and so on. Whether the images are narrative or allegorical, their meanings are generally elucidated or amplified by inscriptions, some newly devised, others gleaned from the Bible or classical literature. This combination of text and image finds a parallel in political and satirical prints, as does the ability of medals to reach a wide audience through their production in large numbers. A society receptive to the one is equally likely to be engaged by the other.

Political medals have been made in greatest numbers at times of upheaval and divisiveness. Notable examples include the Reformation in the sixteenth century, the British Civil War and revolution of 1688, the European wars of the late seventeenth and early eighteenth centuries, the French revolutions of 1789 and 1848, and the First World War. Particularly numerous were those by Dutch and German medallists denouncing Louis XIV and those of 1914–18 by German artists attacking both the enemy and the war. This historical tradition forms the subject of Philip Attwood's essay (pp. 14–31). Recent decades have also seen momentous events, including the collapse of

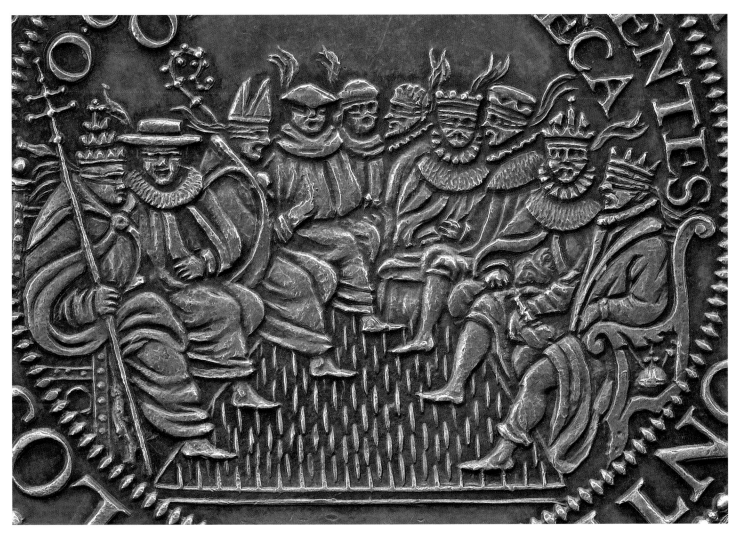

Gerard van Bijlaer: Detail of the reverse of *The Destruction of the Spanish Armada*, 1783 (cat. no. 1).

communism in Europe, the continuing conflict in the Middle East, and growing concerns over the future of the planet. These have been reflected in a rise in the number of medals referencing political and social issues. To those have now been added the medals recently produced under the auspices of the British Art Medal Trust (a charitable organization dedicated to encouraging the practice and study of medallic art) in response to the artist Felicity Powell's idea of commissioning medals on the theme of dishonour from internationally established artists who had not previously worked in the medium but whose practice already had a socio-political dimension. These medals would then be presented to the British Museum, where they could be exhibited alongside historical medals on similar themes. The artists were left entirely free as to the ideas they wished to explore, with the sole proviso that they bore in mind the medal's long history as a vehicle of opposition, dissent, subversion, outrage and crude humour. The very diverse results of these commissions are the subject of Rod Mengham's essay (pp. 32–7). Together they address some of the most contentious issues of our times.

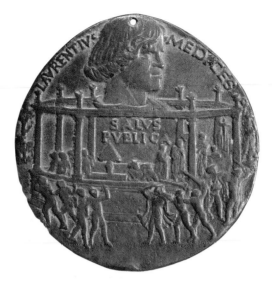

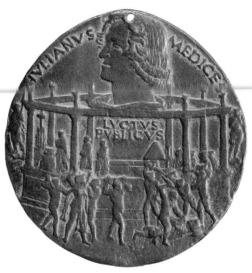

Fig. 1 Bertoldo di Giovanni: *Lorenzo and Giuliano de' Medici and the Pazzi Conspiracy*, 1478, cast bronze, 66 mm.

'NOTORIOUS FOR THEIR VILLAINIES'

Philip Attwood

The primary purpose of the first medals of Renaissance Italy was to confer honour. Only occasionally did infamy or ignominy play a part in their message and, when they did appear, their role was to provide a dark contrast that would further enhance the glory of the medal's main subject. An early example of a dishonourable presence is provided by the unusual narrative of Bertoldo di Giovanni's medal commemorating the failure of the Pazzi family's conspiracy to remove the Medici from power in Florence, in 1478, by killing its two leading members in the city's cathedral (fig. 1).[3] The heads of the surviving Lorenzo de' Medici and the murdered – or martyred – Giuliano de' Medici rise above representations of the assassination scene, which is pictured within the recognizable interior of the cathedral. As medals came increasingly to commemorate events as well as to celebrate people, and as their use as vehicles for overt political comment became more widespread, the scope for including such negative exemplars increased, but for one hundred years the principal focus of medals was celebration.

This was all to change in the sixteenth century, in the wake of the religious divisions opened up by the Reformation. Although the great majority of medals continued to be celebratory, another type of medal now emerged, bringing with it a fundamental shift in perceptions as to the possibilities offered by the medium. The first medals wholly concerned with disparagement, rather than including this function as a corollary to praise directed elsewhere, showed on one side a pope and on the other a cardinal who, when rotated by 180 degrees, were transformed respectively into a devil and a fool.[4] These seem to have been a sardonic response to medals with a pope and an emperor conjoined in a similar fashion on one side and a cardinal and a bishop on the other, which were intended to stress the unity of the Roman Catholic church and Holy Roman emperor in their opposition to Lutheranism. Clerics had long been the subjects of literary satire, as in the works of Chaucer and Boccaccio, and this was continued in the sixteenth century by such writers as Rabelais, who made fun of priests, monks, bishops and cardinals, and went so far as to depict the popes as cruel warmongers. It is this tradition, fuelled by the Reformation, that underlies the medallic equation of bishop and fool, but the pope/devil motif emerged directly from the circle around Luther. In the engravings that Lucas Cranach produced for Philipp Melanchthon's pamphlet, *Passional Christi und Antichristi*, published in Wittenberg in 1521, the pope is not only condemned for extravagance and pride, which is contrasted with the humility of Christ, but equated with the devil himself. The earliest dated pope/devil medals belong to the early 1540s Some bear the initials of Hans Reinhart, a goldsmith working in Leipzig, but other German medallists were quick to develop the theme and to find other ways to humiliate the papacy. A medal of 1546 by the sculptor Hans Schenk has a sombre and pious portrait of Hans Klur of Danzig on the obverse – but the mood changes significantly on the reverse. Here Pope Paul III rides naked on a snake and cowers before the Christ child, while one man defecates on his thigh, another does the same into his upturned papal tiara, and a cardinal flees in alarm.[5]

The different confessional faiths continued to underpin most of the condemnatory medals of the seventeenth century. Production was centred in Protestant countries, in particular the Netherlands where graphic satire was also most prevalent. Whereas a Dutch medal ridiculing the Catholic princes at the time of the defeat of the Spanish Armada had been an official product of the state (cat. no. 1), these seventeenth-century medals were generally produced by the artists concerned as speculative ventures, to be sold to collectors and to those whose political and religious views they confirmed and whose sense of humour they engaged. Pope/devil medals continued to be popular and could be adapted as required, with even the puritanical Oliver Cromwell finding himself being portrayed in this way in a medal of 1650 (cat. no. 2).

A few years later Cromwell was the subject of another Dutch medal which, although purporting to be celebratory,

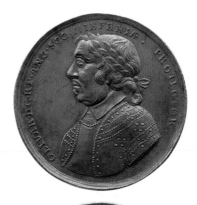

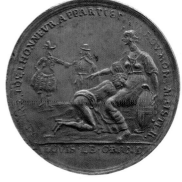

Fig. 2 Unidentified Dutch artist: *Oliver Cromwell and the French and Spanish Ambassadors*, 1655, struck silver, 47 mm,

man, doubly ironic. The medal was reproduced in a mid-eighteenth-century print entitled 'The differance [*sic*] of times, between those times, and these times',[7] which explained, 'so submissive ware those great powers in those days and so much aw'd that they dreaded a Frown from the PROTECTOR.' An accompanying verse read:

> BRITANNIA'S ISLE, like Fortune's Wheel,
> In Politicks does daily reel.
> What's up today, tomorrow's down;
> And from a smile ensues a frown.
>
> She sits in pompous state you see,
> And bears HIS HEAD upon her knee;
> Whilst two ambassadors contend,
> Which first shall kiss his nether end.

The war between the English and the Dutch of 1652–4 was still a recent memory when this medal was made, and the mauling received by Dutch naval power perhaps contributed to the half-heartedness of the medallist's compliment to Cromwell.

The 1680s and 1690s witnessed particularly large numbers of satirical medals. In Britain, the broader public interest in domestic and foreign politics that developed in the second half of the seventeenth century provided a market not only for the literary outpourings of such writers as Samuel Butler and Andrew Marvell, and for satirical prints, but also for medals offering comments on the events of the day. The 'large vein of wrangling and satire' that Jonathan Swift found in modern literature in 1697 was in no way restricted to the printed word.[8] The use of medals as vehicles for scorn and derision was noted by the essayist and politician Joseph Addison in his essay, 'A parallel between the ancient and modern medals', the third of his *Dialogues upon the usefulness of ancient medals* written in 1702. Commenting on ancient coins, Addison wrote: 'Had we no other histories of the Roman Emperors, but those we find on their money, we should take them for the most virtuous race of Princes that mankind were ever blessed with ... Tiberius on his coins is all Mercy and Moderation, Caligula and Nero are Fathers of their Country.'[9] This, he noted, was very different from many of the medals of his own time: 'On the contrary, those of a modern make are often charged with Irony and Satire. Our Kings no sooner fall out, but their mints make war upon one another, and their malice appears on their Medals.' This was not necessarily to be seen as a retrograde development, and Addison places an argument in favour of the modern practice in the mouth of one of his interlocutors: 'For my part, I cannot but look on this kind of Raillery as a refinement on Medals: and do not see why there may not be some for diver-

included imagery calculated to undermine the man who was now Lord Protector of England (fig. 2).[6] The principal targets of the medal were the two most powerful states of Europe at the time, France and Spain, whose desire to have England as an ally forced them to deal with a man who was not only a republican but a regicide, for Cromwell was one of those who only a few years earlier had signed the death warrant of Charles I. The obverse of the medal shows an heroic Cromwell, described as, 'by the Grace of God, the protector of the republic of England, Scotland and Ireland', and crowned with a laurel wreath, but on the reverse all dignity gives way entirely. The ambassadors of the two rival states are made to appear ridiculous in their eagerness to demonstrate their respect, with the representative of Louis XIV pushing his Spanish counterpart away and declaring in his native tongue, 'Withdraw, the honour belongs to the king, my master, Louis the great'. Cromwell is not spared in this lewd scene. His ignominious pose, with his head in Britannia's lap and his uncovered rear placed prominently in the centre of the composition, make the word 'honour', employed by the French-

sion, at the same time that there are others of a more solemn and majestic nature.'[10] This sort of medal was also attractive to collectors. Writing just a few years before Addison, John Evelyn listed those who were 'Notorious for their Villainies and Ambition' alongside the virtuous as categories of individuals whose medallic portraits were worthy of being collected.[11] It is from Evelyn's observation that the title of the present essay is taken.

Such medals inevitably brought with them controversy. PROBIS HONORI INFAMIAEQUE MALIS (To honour for the good, to infamy for the bad) is the legend of the Leiden medallist Jan Smeltzing's medal of 1688 celebrating the liberation of seven bishops imprisoned by James II for refusing to endorse his expansion of religious toleration[12] – but it was hardly possible for there to be agreement on who was good and who was bad. Seven years earlier, the Earl of Shaftesbury, a principal figure in parliamentary attempts to exclude the Roman Catholic James from the throne, was imprisoned by James' brother Charles II on a charge of treason. His release after a few months was celebrated in a medal that became so popular that the king joked that his unpopular brother should wear it.[13] The poet John Dryden, however, took a different view in his *Epistle to the Whigs*, calling the medal 'a piece of notorious Impudence in the face of an Establish'd Government', and he also criticized it in his poem, *The medall: a satyre against sedition*, where it is described as a 'Polish Medal' – that is, a work advocating an elected monarchy, as in Poland, with Shaftesbury as king: the earl had no right to be placed on the front of a medal, a space reserved for the rightful monarch. Medals had an astonishing power to touch nerves. Some years earlier Charles had felt compelled to voice his concern over imagery used by the Dutch medallist Christoffel Adolphi to celebrate the Treaty of Breda of 1667, while the British declaration that began the Third Anglo-Dutch war in 1672 cited medals as a factor, stating of the Netherlands that there was 'scarce a Town within their Territories that is not filled with abusive pictures, and false Historical Medals.'[14]

The close interconnections between British and Dutch politics were reinforced after 1688 by William III's dual role as king of England and stadtholder of the Dutch Republic, and meant that many medals had a direct relevance to both countries. The searing anti-Catholic comments of Jan Smeltzing, for example, were guaranteed to appeal to Protestants either side of the North Sea. In a particularly vitriolic example Smeltzing depicts James II, who is identified by his rosary, as a bear being attacked by the bees that emerge from three hives representing England, Scotland and Ireland. 'Punishment, the companion of crime', reads the legend, with below: 'Thus the British lay claim to their liberty and religion from those who plunder it' (fig. 3).[15] The reference is to the Act of Parliament of January 1689, whereby Roman Catholics were excluded from office and the

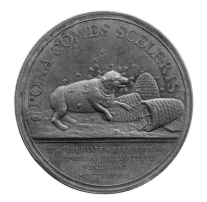

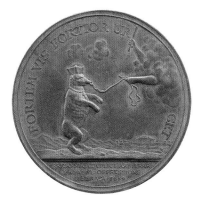

Fig. 3 Jan Smeltzing: *The British Throne Declared Vacant*, 1689, struck silver, 49 mm.

throne declared vacant. On the other side the bear, wearing a Jesuit's cap, is led back to France by the hand of God, who for good measure also wields a stick. The inscriptions read: 'A stronger power constrains the strong', and 'Britain freed from the double oppression of tyranny and the papacy, 1689'.

A portrait of James by Smeltzing of about the same time mocks him as a king who has had to flee his country (cat. no. 4), and over the ensuing months the medallist capitalized on this powerful image by producing two further reverses for it, thereby creating two new medals for a relatively small outlay (the three medals being made from four dies – one obverse and three reverse – rather than the more usual six). The new medals offered further comment on the continuing misfortunes of the former king. In one he makes a direct contrast between James and William, reinforcing the notion that James was yesterday's man. Rather than a column, an old oak tree, similarly broken in two, symbolizes James, whereas next to it a young orange tree, representing William of Orange, thrives. William's ships can be seen in the distance and the legend below explains:

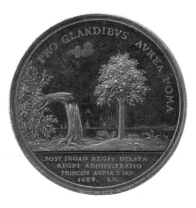

Fig. 4 Jan Smeltzing: *James II's Forfeiture of his Kingdom to William III* (reverse), 1689, struck silver, 49 mm.

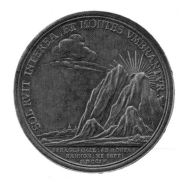

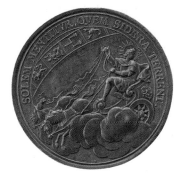

Fig. 6 Martin Brunner: *The Battle of Malplaquet*, 1709, struck silver, 43 mm.

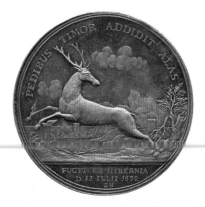

Fig. 5 Jan Smeltzing: *James II and the Battle of the Boyne* (reverse), 1690, struck silver, 49 mm.

'After the flight of the king, the administration of the kingdom was offered to the Prince of Orange, 3 January 1689' (fig. 4).[16] The following year the engraver used the obverse for a third time, executing a medal marking James' flight from Ireland after his defeat by William at the battle of the Boyne in July 1690. On this occasion he portrayed James as a stag running at speed and looking anxiously behind, with a legend derived from Virgil, 'Fear added wings to its feet' (fig. 5).[17] James had been a passionate huntsman, but in Smeltzing's medal the monarch, the pursuer in royal hunts, has become the beast pursued.

Smeltzing also made medals critical of William III (see cat. no. 5), and indeed was forced to leave the Netherlands for a time because of his outspokenness. But more prominent among the subjects of Dutch satirical medals, as of Dutch satirical prints, were the Catholic princes of Europe. France, the most powerful European nation of the second half of the seventeenth and early eighteenth centuries, and a country that was almost continually at war with its Protestant neighbours, was the favoured target (cat. no. 3). Since the monarch was regarded as the personification of his or her realm, prints and medals that humiliated Louis XIV, king for seventy-two years from 1643, were also seen as humiliating France. Accordingly, the man who styled himself 'the sun king' is shown receiving an enema in an etching of 1689 by the Dutch printmaker Romeyn de Hooghe,[18] an image mirrored in a Dutch medal of the same year in which the king is also vomiting (cat. no. 6). In an observation that could equally be applied to medals, the ancient Roman satirist Juvenal mocked the great men of yesterday whose statues were melted down to be turned into 'little jugs, basins, frying pans and chamber pots',[19] but perhaps even more degrading is this medal in which Louis is shown actually using two of the latter receptacles. Medals were particularly appropriate as vehicles through which to diminish Louis, as the king made great use of them for his self-aggrandisment, with exten-

sive medallic histories of the principal events of his reign being published in 1702 and 1723. By using the medallic form, his Dutch and German critics sought to undermine the medium as well as the message.

In a medal commemorating the battle of Malplaquet of 1709 (fig. 6),[20] the German medallist Martin Brunner responded directly to the imagery of a medal from Louis' medallic history, which shows the king traversing the skies in a chariot below a similarly placed zodiacal path with the legend 'Happy France'.[21] In place of the portrayal of Louis XIV as the sun god, Brunner represents him in the guise of Phaethon. Confronted by zodiacal signs symbolizing the Netherlands (Leo, for the Dutch lion), Britain (Virgo, for Queen Anne), justice (Libra) and defeat (Scorpio), he loses control of his chariot as his horses rear and the reins snap. The legend explains: 'He is a false sun, whom the stars terrify.'[22] On the other side the sun (Louis) sinks behind a mountain, and there is a distant view of Mons. Captured by the French in 1691, the city had subsequently changed hands several times, but had been in Louis' possession since 1701. The inscriptions read: 'Meanwhile the sun sets and the mountains [or Mons] darken'; 'The slaughter of the French near Mons in Hainault, 11 September 1709'; and, around the edge of the medal, 'He now repents having claimed Spain with too much headlong fervour.' This refers to Louis' desire to see his grandson Philip V of Spain retain his full inheritance, the central area of contention in the War of the Spanish Succession (1701–14), of which the battle of Malplaquet was an important engagement. Although France was defeated at Malplaquet and Mons was retaken, the fighting was exceptionally bloody and the huge losses incurred by the allies prevented them from capitalizing on the victory by pursuing the retreating French forces; nor did the battle do anything to diminish Louis' claims for his grandson. This equivocal outcome and the weakened position of France's enemies are ignored by Brunner in both this medal and another he produced to commemorate the same battle, which shows the French king as the Colossus of Rhodes breaking up under its own weight.[23] The ancient statue represented the sun god Apollo and could therefore stand for Louis, who, the medal suggests, had overstretched himself and was as a consequence falling apart.

As another symbol of France, the cock was shown in various states of discomfort in medals produced in enemy countries. The German engraver Christian Wermuth likened a British bombardment of the French coast in 1694 to a small mouse emasculating the French cock, describing the action in the medal's legend: 'They [the French] came as cocks. They returned as wretched capons. Who castrated them? It was one little mouse' (fig. 7).[24] On the other side of the medal Louis kneels before Minerva, goddess of war, at the same time avert-

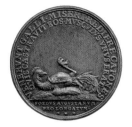

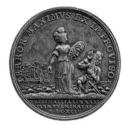

Fig. 7 Christian Wermuth: *The Bombardment of the French Coast*, 1694, struck silver, 31 mm.

ing his gaze from her shield, as British ships begin their bombardment of the French coast. The inscriptions explain, 'The greatest terror proceeds from the unexpected', and 'The coastal towns of France bombarded, 1694'. The British action was in effect a renewal of the Treaty of Augsburg of 1686, hence the obverse inscription, 'The Treaty of Augsburg prolonged'. The treaty had led to the formation of what came to be known as the 'Grand Alliance', in which several European powers, including the Netherlands, the Holy Roman Empire and Spain, joined together to counter Louis' territorial ambitions. The inclusion of the mouse may have been suggested by a medal portraying the French king and deriding the treaty with a line from the ancient Roman satirist Horace, 'The mountains will be in labour and a silly mouse will be born'.[25] In Wermuth's medal the small mouse inflicts injury on the large cock, just as in Brunner's medal of 1709 the stars, represented by the zodiac, were to be shown toppling the sun. By portraying the French as the cock and the sun, these works implicitly acknowledge that country's superior size and brilliance but at the same time suggest that it is far from invincible, a Goliath to its enemies' David.

Wermuth was a prolific maker of medals, including official pieces for Saxony and Prussia but also numerous satirical pieces, which have been estimated as forming around one tenth of his total output.[26] These were produced speculatively and, in order to maximize the market, issued in cheap metals such as

Fig. 8 Christian Wermuth:
The End of Credit, 1701,
struck silver, 26 mm.

pewter as well as in silver. Advertised in lists published by the artist, they were sold to anyone who was amused by their images and texts, but the business was not without risk, and the medals' subject matter may have been a factor in an action taken against Wermuth by the Leipzig authorities in 1705.[27] His targets included political subjects, such as the flight of James II in 1689, the rivalry between Louis XIV and William III, and German discontent with the Treaty of Utrecht of 1713 (cat. no. 7) – but he also tackled areas of social concern, for example exploiting anti-Semitic prejudice through medals accusing Jews of profiting from hardship by storing grain while prices rose.[28] His earliest medals on the dangers of financial speculation date to 1699 and the subject remained a staple part of his output (often with resonances particularly strong in the economic climate of 2009). On one of 1701 is the inscription, 'Credit is as dead as a rat', next to which a man lies dead, holding in one hand a briefcase marked 'Bills of exchange' and in the other the caduceus of Mercury, symbolizing commerce. The other side is inscribed 'Bankruptcy is the fashion', with the back of a financier and VISIBILIS INVISIBILIS (Now you see him, now you don't) (fig. 8).[29] On another of a few years later, the hand of God reaches down from a cloud with a bag of money, while three hands, one of which holds a long-handled hook, try to grab it.[30] These medals reached a peak in the face of the speculative frenzy of 1720 and the subsequent collapse in the share prices of the South Sea Company in Britain and the Compagnie des Indes in France (cat. no. 8), with Wermuth joining other medallists and printmakers in highlighting the madness. William

Hogarth's 1721 engraving, *The South Sea Scheme*, laments the effect of the bubble on London by means of a carnivalesque scene in front of the 'Devil's Shop', with figures riding a round-about while others are tortured and scourged.[31] This reference to the cyclical tendency of financial speculation is also found in the inscription on the reverse of a portrait medal Wermuth made of John Law, founder of the Compagnie des Indes: 'On Sunday, using banknotes, we empty all the purses [of their coins]; on Monday we buy shares; on Tuesday we have millions; on Wednesday we hire our house staff; on Thursday we set up a horse and carriage; on Friday we go to the ball; and on Saturday to the poor house'.[32] Wermuth's emphasis on the risk attached to such materialism echoes traditional ideas concerning chance, as in the sixteenth-century Italian poet and historian Achille Bocchi's rebus on *Occasio* (the Latin for 'Chance'): 'O is nothing. Two Cs indicate twice a hundred, A nothing, S the fifth, I the first again, and O is nothing. The beginning is worth nothing, two hundred worth much; five is not enough, after which comes nothing.'[33]

The greater constitutional importance of parliament within the British political system led in the eighteenth century to an increase in the production of medals focused on internal politics, including those lampooning prominent statesmen. As a pre-eminent politician of the 1720s and effectively Britain's first prime minister in the following decade, Robert Walpole – satirized in Swift's *Gulliver's Travels*, in John Gay's *Beggar's Opera*, and even in garden design[34] – was inevitably the subject of hostile prints and medals. The charges of bribery and corruption brought against him form the background for a satirical medal that an anonymous individual made out of a struck medal celebrating Walpole as a new Cicero. On the reverse of the original medal are words from Virgil's *Aeneid*, REGIT. DICTIS. ANIMOS. (He governs minds through eloquence), above a statue of the ancient orator Cicero. On the new version, made by taking a cast, one of the words has been changed, so that the inscription now reads REGIT NVMMIS ANIMOS (He governs minds through money). This version inspired a satirical ballad entitled 'The medalist', which claimed that the original dies had broken after only eighty or so medals had been struck and went on to explain the reasoning behind the alteration:

> The Motto's are chang'd to avoid the like Evil,
> And Truth put for Lies, as a Charm 'gainst the Devil.[35]

A similar accusation is made in another anonymous medal, produced shortly after Walpole was forced to resign as prime minister in January 1742, in which the statesman is shown resting his arm on a bag of money (fig. 9).[36] The obverse legend reads,

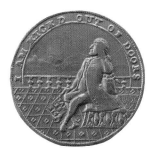

Fig. 9 Unidentified British artist:
The Resignation of Horace Walpole,
1742, struck lead, 36 mm.

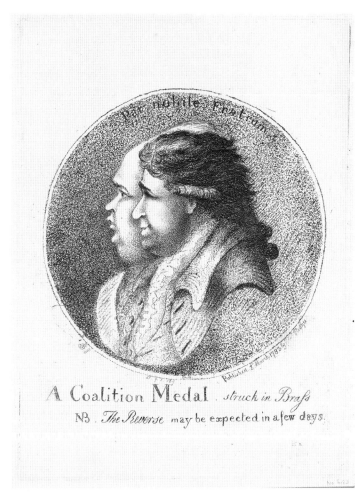

Fig. 10 James Sayers: *A Coalition Medal Struck in Brass*, 1783,
etching, 251 x 186 mm.

I AM KICKD OUT OF DOORS. IAN 18 1741 (18 January 1741),
the year being given according to the custom then in use of
commencing the new year in March. The words on the reverse,
NO SCREEN, refer to Walpole's role in saving members of the
cabinet from impeachment for corruption in the wake of the
collapse of the South Sea Company in 1720, which led him to be
called 'Screenmaster-General'. The head on a pole on a wall is a
rebus based on Walpole's name, and also suggests a link with
criminality, for this was generally the final fate of those crimi-
nals condemned to be hung, drawn and quartered. The demand
of the legend is that Walpole should cease to exercise influence
behind the scenes.

The more usual association of medals with honour meant
that the medallic form came to provide a useful metaphor ready
for exploitation by eighteenth-century graphic artists intent on
making similar denunciations. The portrayal of individuals in
the guise of medallic subjects could suggest that the pretensions
of those individuals to glory were without foundation, and high-
light the contrast between those pretensions and the actual
truth as perceived by the medallist. Cartoonists also played
imaginatively with other characteristics of medals, evoking the
various associations of the metals in which they were made,
their use of gilt to simulate gold, and their two-sided form. In
the 1770s the Whig politician Charles Fox had been one of the

fiercest critics of the Tory prime minister Lord North, persist-
ently censuring his conduct of the American War of Independ-
ence and describing him in the House of Commons as 'the
blundering pilot' who had 'lost a whole continent'; [37] yet in April
1783 the two men formed a coalition government. James
Sayers' *A Coalition Medal Struck in Brass* of 1783 (fig. 10)[38]
responds to this surprising turn of events. The format of con-
joined portraits, more commonly associated with Roman
emperors and royal couples, implies a grandeur that is under-
mined by the caricatured features and the announcement that
the medal is to be struck in a base metal. The sarcasm of the
legend, 'Par nobile Fratrum' (A renowned pair of brothers), is
reinforced by its source, which would have been recognized by
the educated viewer as a satire composed by the ancient Roman

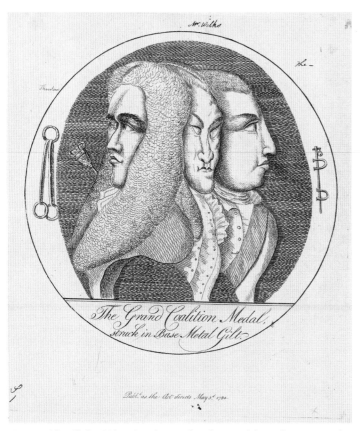

Fig. 11 Unidentified British artist: *The Grand Coalition Medal, Struck in Base Metal Gilt*, 1784, etching, 256 x 219 mm.

Fig. 12 Charles James:
Thomas Spence and George III,
1795, struck copper, 30 mm.

writer Horace, who used the phrase to describe 'the sons of Quintus Arrius ... twins in wickedness, folly, and perverted fancies'.[39] The print's final throwaway comment twists the knife by accusing the two politicians of expediency: 'NB. *The Reverse* may be expected in a few days'. (This turned out to be a false prophecy – although the coalition government lasted no longer than December 1783, this resulted from its dismissal by George III rather than any internal dissension.) Sayers' *Coalition Medal* became sufficiently well-known for it to feature in a cartoon by James Gillray of the same year, showing North and Fox conspiring over a dish of broth, which is being prepared by the devil. The medal hangs on the wall above the fireplace.[40] It may well also have acted as the inspiration behind an anonymous print of the following year featuring three public figures and entitled *The Grand Coalition Medal, Struck in Base Metal Gilt* (fig. 11).[41] The caricatures in this case are of George III and Baron Thurlow (Lord Chancellor, and friend of the king), with the

former radical John Wilkes, now a government supporter, squeezed between them. To the sides are a pair of shackles and a padlocked set of stocks, suggesting the slavery that could result from having such men in power.

The final decade of the eighteenth century saw a rapid rise in the number of British medals attacking government policies. One of many manifestations of the increase in radical activity that followed the French Revolution, this in turn provoked other medals that pilloried the supporters of the revolution.[42] The radical Thomas Spence capitalized on the late eighteenth-century fashion for collecting tokens by issuing medallic pieces of a similar size, on which he placed political messages; these were engraved by Charles James, about whom little is known (cat. no. 10). One is particularly remarkable for its inversion of the usual arrangement of obverse and reverse. The more prominent position is given to Spence, whilst George III is relegated to the reverse, where he is made ridiculous by being paired with an ass (fig. 12).[43] Spence's imprisonment without trial for seven months in 1794 for suspected treasonable practices, made possible by the government's suspension of *habeas corpus*, is recalled in the obverse legend. The guinea pig of the reverse legend is probably intended as the king, whose head appeared on guinea coins, and the million hoggs (young unfleeced sheep) as the public, although hogg was also a slang word for a shilling. This protest against the level of taxation necessitated by the war with France is amplified by another of

Spence and James' designs, an ass laden with rents and taxes, which was sometimes coupled with the king/ass image.[44] The heavily laden ass recurs in a cartoon entitled 'The contrast', issued by Spence in 1796, in which the animal's four panniers are labelled 'Taxes' and 'Rents'. One of two Native Americans standing by the ass is provided with a speech bubble that reads:

> Behold the civilized Ass
> Two pair of Panyers on his Back.
> The first with Rents a heavy Mass
> With Taxes next his Bones do crack.

The ass's own bubble reads, 'I'm doomed to end-less Toil and Care I was an Ass to bear the first pair.'[45] The message is that the so-called 'civilized' British should reject the tax burden imposed by a reactionary government, as the Americans had done in the War of Independence.

British conservatives worked to counter the influence of this sort of radicalism through such organisations as the Association for Preserving Liberty and Property against Republicans and Levellers. Just as the contemporary religious tracts of Hannah More yoked support for the British constitution with traditional Christian virtues to make their argument, so politics and religion meet in medals demonising supporters of the French Revolution and republicanism. This is exemplified by a medal showing Thomas Paine receiving what his opponents regarded as his just deserts (cat. no. 9) and by another in which a harpy with the features of the polymath and nonconformist minister Joseph Priestley suckles a tiny devil (fig. 13).[46] The flag held by the harpy, with its royal crown surrounded by drops of blood, and the cap of liberty above it associate Priestley with revolution and regicide. The devil clinging to the harpy entwines its tail around the flag-pole and holds a scroll inscribed FACTION, whilst another, heading off with a torch and dagger, is evidently intent on arson and murder. The snake in the grass on the other side of the medal brands Priestley as a betrayer of his country and his religion. The legends, OUR FOOD IS SEDITION and NOURISHED TO TORMENT, refer to a dinner held in Birmingham on 14 July 1791 to celebrate the second anniversary of the fall of the Bastille. Although Priestley did not attend, having been warned of the possibility of violence, his house was one of many properties burned down in the ensuing riots and he was forced to leave Birmingham for London. Aware of the government's increasingly robust approach to dissidence, he emigrated to the United States three years later. The medal was evidently produced around the time of the Birmingham dinner as a vehement condemnation of all that Priestley was seen to stand for.

Medals produced in cheap alloys such as pewter contin-

Fig. 13 Unidentified British artist: *Revolution*, 1791, struck bronze, 34 mm.

ued to be ideal vehicles for spreading a political message in early nineteenth-century Britain, and a range of issues were addressed in this form as medallists responded to events in much the same way as the publishers of broadsheets and political cartoonists. Widespread economic hardship resulted in John Gregory Hancock's medal condemning the 'uncharitable monopolizer' of 1800 (cat. no. 11). The raising of admission charges to the Covent Garden Theatre in 1809 led to protests in which medals played an active role and which soon took on much broader political overtones (cat. no. 12). The violent suppression by the local authorities of a peaceful political rally in Manchester in 1819, soon known as the Peterloo massacre, was commemorated in a medal highlighting the savagery of the action (cat. no. 13). A medal of 1842, although humorous in its tone, indicates that the introduction of income tax was a source of infuriation for someone – either the engraver Thomas Halliday or perhaps a commissioner whose identity is now unknown – for it shows the prime minister responsible in league with the devil (cat. no. 14).

Political medals of this sort fell out of fashion in Britain in the second half of the nineteenth century. By contrast, its more eventful history at this time led France to veer between sudden outpourings of political medals and an almost total cessation due to government restrictions. The fast-moving events that succeeded the revolution of 1848 resulted in the production of

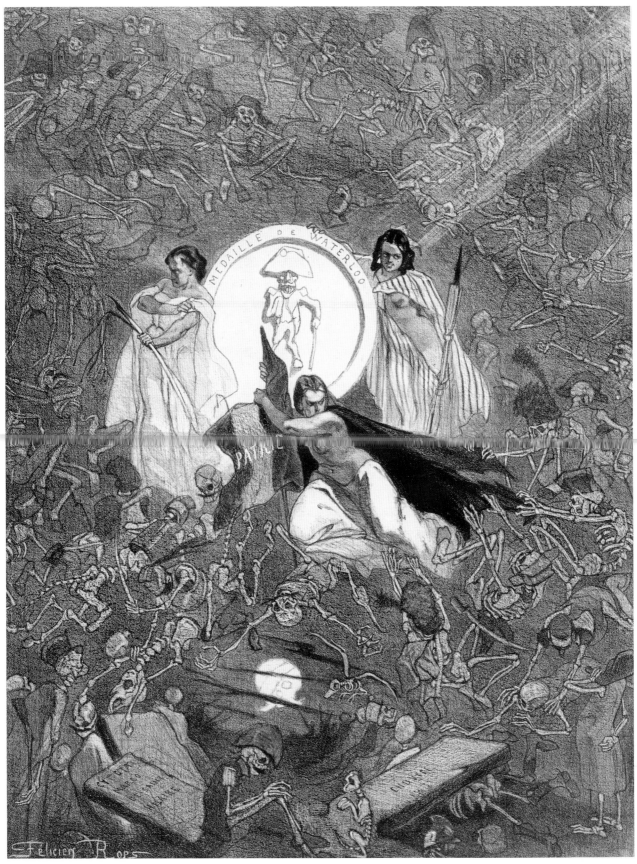

Fig. 14 Félicien Rops: *Waterloo Medal*, 1858, lithograph, 580 x 435 mm.

large numbers of political and satirical medals cast in cheap metals, as well as other more sophisticated pieces[47] – these are the medallic parallels to the political cartoons of Daumier, whose character, the Bonapartist thug Ratapoil, first appeared in 1850. One of the many views represented in these pieces centred on the threat to the republic's existence that the ambitions of Louis-Napoléon Bonaparte, its president from December 1848, were widely believed to pose (cat. no. 15). The increasingly repressive nature of Bonaparte's government led the Republican sculptor and portrait medallist Pierre Jean David, known as David d'Angers, to conceive of a medal lamenting the sorry state into which he believed France had fallen, with its arrests and deportations. In March 1850 he wrote in his notebook:

> I am ... thinking of the republic and of our poor friends who have been deported. All at once the idea came to me of making a dramatic medal for them. I shall represent a deportee tied to the Gonner bridge [pont du Gonner] by a chain, with Justice veiled and holding her dagger in one hand and the scales in the other, but with no intention of weighing anything. With her foot she crushes a child, symbol of innocence; the deported man raises his hands to heaven in prayer, since the justice of men is denied him.[48]

The medal was never made, and after the coup d'état of 1851, which was to result in Bonaparte being proclaimed emperor as Napoleon III, medals were closely monitored by the police and medallic criticism of the government ceased for the duration of the Second Empire for fear of reprisals. Even a medal in honour of the recently assassinated Abraham Lincoln was viewed with official suspicion and attempts were made to hinder its production. Lincoln had disapproved of the French invasion of Mexico in 1861, and the medal was supported by French Republicans hostile to Napoleon's regime – including Victor Hugo, then in political exile in Brussels.[49]

Anxious to suppress dissident voices in Belgium as well as in France, in 1852 the French government had induced its Belgian counterpart to legislate against works that offended foreign governments. However, this step did nothing to prevent the publication in 1858 of the most notorious anti-Napoleonic medal of the Second Empire, the work of the Belgian illustrator Félicien Rops, who was later to become a Symbolist artist and friend of Baudelaire but was then beginning to make a reputation for himself as a satirical commentator on contemporary events. The medal was inspired by the Medal of Saint Helena, a military award that Napoleon I, exiled to the south Atlantic island of that name, had endowed in the will drawn up shortly

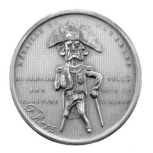

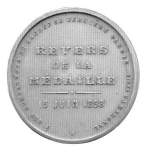

Fig. 15 Félicien Rops: *Waterloo Medal*, 1858, struck gold, 36 mm.

before his death in 1821. The intention was that this should be presented to all those who had served under him in the wars of 1792–1815, but its issue remained in abeyance until the return of a Bonaparte regime allowed the plan to be revived. Napoleon III personally awarded the first medals in August 1857, by which time many of the recipients, among whom were several thousand Belgians, were in their seventies or older. It was on this aspect that Rops focused his parody of what he saw as a symbol of bellicose imperialism.

The first appearance of Rops' medal was in a lithograph produced by the artist, where it is seen against a background of spectral skeletons in military attire marching, fighting and attacking a figure of France (fig. 14).[50] Below, a tomb is inscribed 'Here lies Marco de Saint-Hilaire', a reference to the author of various popular books on Napoleon and the First Empire, whilst to the right a skeletal figure of the emperor, recognizable from his clothing, views the medal from afar through binoculars. Inscribed MÉDAILLE DE WATERLOO (Waterloo medal), this shows a haggard figure wearing a Napoleonic bicorn hat, his infirmities indicated by a monocle, a withered right arm, an artificial right leg, and the stick by which he supports himself. The struck metal version (fig. 15)[51] adds further elements, in the form of the medal worn by the figure, Rops' signature and an acid comment on the recipients of the Medal of Saint Helena: DU DERNIER DES CHAUVINS VOILÀ TOUT

CE QUI RESTE (See what remains of the last of the warmongers). The principal reverse inscription, REVERS DE LA MÉDAILLE (Reverse of the medal), appears to refer to the medal's satiric nature, but the inscription around the edge is less enigmatic: À SES COMPAGNONS DE RACLÉE SA DERNIÈRE PAROLE ... SIGNÉ CAMBRONNE (To his companions in the thrashing, his last word ... signed Cambronne). A parody of the reverse of the Medal of Saint Helena, which included the wording, 'To his [Napoleon I's] companions in glory, his last thought', Rops' version refers to the capture at the battle of Waterloo of Napoleon's general, Pierre Cambronne. Reported to have declared, 'The guard dies but does not surrender', Cambronne himself maintained that his response had been 'Merde!' (Shit!), a response that entered the French language as 'le mot de Cambronne' (the word of Cambronne).

Rops' brutal subversion of French glory caused much outrage, and he was compelled to fight a duel with the son of a former soldier, in which both parties were injured.[52] Only after the cataclysmic French defeat at the battle of Sedan in 1870 had brought about the end of the empire, and forced the emperor into exile in Britain, did similarly vituperative satirical medals appear in France.[53] In the same spirit of angry release, large numbers of circulating coins bearing the former emperor's image were unofficially stamped with the word SEDAN.

The First World War witnessed an extraordinary resurgence of the art of the medal in Germany, with many artists continuing the well-established practice of using the medium to pour scorn on the enemy: Arthur Loewental's medal on British perfidy alludes to an early nineteenth-century French medal on the same subject (cat. no. 17), while a medal by Ludwig Gies portrays the United States as a gluttonous monster (cat. no. 18). The most infamous medal of this sort was Karl Goetz's commemoration of the sinking of the Cunard passenger liner *Lusitania* in 1915 (fig. 16),[54] in which a figure of Death sells tickets to passengers who are ignoring the U-boat warning placed by the German government in American newspapers; 'Business above everything' is the legend above. British copies of the medal were produced and placed on sale as 'proof positive that such crimes are not merely regarded favourably, but are given every encouragement in the land of Kultur', as the wording on their boxes puts it. Goetz's satirical exaggeration, which substituted massive military hardware for the munitions the ship is known to have carried, allowed the British issuers to deflect the German justification for the sinking in their accompanying leaflet: 'The designer has put in guns and aeroplanes, which (as was certified by the United States Government officials after inspection) the *Lusitania* did not carry, but has conveniently omitted to put in the women and children, which the world knows she *did* carry.'

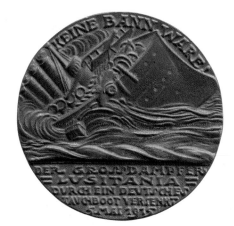

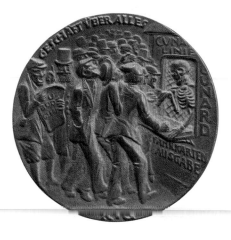

Fig. 16 Karl Goetz: *The Sinking of the* Lusitania, 1915, cast iron, 56 mm.

In a new development running parallel to this sort of propaganda, other German medals revived the old German tradition of moralizing medals by taking as their target the lunacy and barbarism of the war itself. Many of these are made of iron, a metal with militaristic and industrial connotations that distances them from traditional commemorative medals, while macabre imagery and a novel expressionist style combine to convey something of the unprecedented scale of the carnage. Many use the visual language of the medieval Dance of Death (*Totentanz*), the word itself being adopted by Ludwig Gies as the ironic title of a medal made in 1917, the year that it was also used by the painter and printmaker Otto Dix for his print of a tangled heap of dead soldiers.[55] George Hill, the British Museum's keeper of coins and medals at the time, noted this phenomenon, conceding in the 1924 guide to the Museum's display of First World War medals that certain medals by Gies 'rise above the usual level of the journalistic propaganda char-

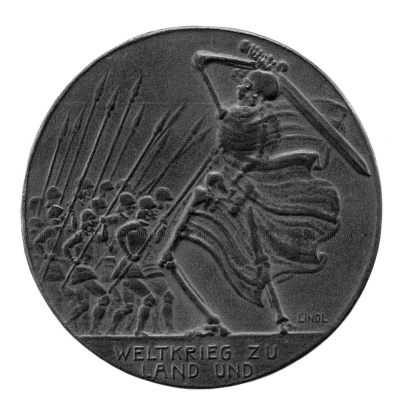

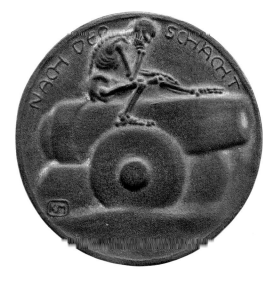

Fig. 18 Karl May: *After the Battle*, about 1916, cast iron, 68 mm.

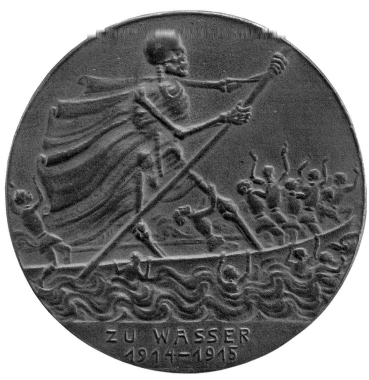

Fig. 17 Hans Lindl: *War on Land and Sea*, 1915, cast iron, 98 mm.

acteristic of the mass of medals produced in this connexion in all countries, and make some attempt to express the colossal scale of the disaster, and of the sufferings of humanity'.[56] The same may be said of such artists as Arnold Zadikow (cat. no. 16), Hans Lindl (fig. 17) and Karl May (fig. 18).

After the war, artists working in Germany, such as Goetz (cat. no. 20) and the Hungarian Erzsébet Esseő (cat. no. 19), continued to make medals critical of political, social and economic conditions in a way that mirrors contemporary cartoons, such as those published in the satirical periodical *Simplicissimus* (of which Goetz was an avid reader),[57] and that was largely unknown in other European countries. The failure of their own artists to produce comparable medals was noted in Britain and France both during and immediately after the war and was a particular source of regret to the French, who were accustomed to pre-eminence in the medallic field. One effect of the absence of any British medals focusing in a negative fashion on the trou-

DESIGN FOR A MEDAL
to commemorate the year of Our Lord 1939.

APPEAL FOR
£100,000 FOR AN
UP-TO-DATE
CENTRAL-HEATED
LABOUR-SAVING
MONASTERY

MILLIONS
IN INDUSTRIAL
SLAVERY
OVER-CROWDED
UNDER-FED
UNTAUGHT

OBVERSE REVERSE

An inscription round the edge reads: *When saw we Thee hungry or naked or sick or in prison?*

"From stately buildings, large houses, and everything fine and beautiful, may God deliver us! Ever remember that all such places must fall at the day of judgement; and who knows how soon that may be? And for a house of thirteen poor women to make a great noise by its fall is not proper, since the really poor are not to make any noise. If with a safe conscience I could wish that on the same day that you build a fine house it may tumble down and kill you all, I do wish it, and pray God it may happen. It looks very bad, my daughters, to build stately houses out of the property of the poor." *Saint Teresa.*

Fig. 19 Philip Hagreen: *Design for a Medal*, 1939, letterpress and coloured ink, 165 x 118 mm.

bled inter-war years was to reinforce the medal's position as a metaphor for honour, which accordingly made it available for subversion to artists working in other media. In 1939 the Roman Catholic printmaker Philip Hagreen, a member of the artistic community founded by the sculptor Eric Gill in Ditchling, Sussex, produced a characteristically simple epigraphic design for a medal to commemorate the year (fig. 19).[58] The legends on the two sides contrast what Hagreen considered to be the inappropriate luxury of modern monastic houses with the hardships suffered by many under modern capitalism. An inscription around the edge underlines the point, by paraphrasing Christ's injunction to his disciples regarding the duty to care for fellow humans,[59] and the proposal is followed by a quotation from an address by Saint Teresa of Avila to a community of nuns,

ending, 'It looks very bad, my daughters, to build stately houses out of the property of the poor'. Hagreen turns Christian teaching against what he saw as contemporary Catholic practice.

If the political medals produced in Germany failed to provoke an immediate response from artists elsewhere in Europe, their influence was to make itself felt on the other side of the Atlantic. The American sculptor David Smith, having seen the British Museum's medal display during his trip to Europe of 1935–6,[60] went on to make his series of fifteen *Medals for Dishonor*, in which he lambasted war and the political system he considered responsible for it (cat. nos 21 and 22). Like Félicien Rops before him, Smith was responding directly to an official war medal, in this case the Congressional Medal of Honor, the United States' highest military award, first presented during the American Civil War. His sketches for two of the medals include a ribbon and bar from which they are suspended, suggesting at least a momentary interest in the idea of having his models reduced mechanically, so that the medals could be struck at a smaller size as if to be presented and worn in the manner of their honorific counterparts.[61] As Smith must have realized, the mass of detail would have precluded this course of action, and the medals were produced as the large cast plaques known today.

Smith's medals represent a new departure in many ways. Although the earliest medals of the fifteenth century served as personal and diplomatic gifts, most of those discussed above represent commodities to be sold alongside coins, prints and books or advertised and dispatched through the post. Smith's medals were also put on sale, but this took place within the very different context of an art gallery, where they functioned as much as works of art, to be viewed aesthetically, as vehicles for political statements. The messages of the earlier medals, although expressed with varying degrees of subtlety, were meant to be more or less immediately accessible, often in the manner of political cartoons. Smith, on the other hand, deliberately introduced an element of obscurity,[62] something that can also be detected in many subsequent medals made by artists. This is in keeping with the more nuanced approach of contemporary art in general, which aims to raise questions rather than provide answers.[63] It also returns the medal to its roots, for the symbolic reverses of the medals of the Italian Renaissance were not intended to be readily decipherable by all.

The *Medals for Dishonor* were exhibited in New York in 1940, and in Kalamazoo and Minneapolis the following year, but with the United States' entry into the Second World War the artist realized that the changed circumstances might lead to their being misconstrued: 'When the medals come back let's take them off the showing for the duration. Their classic value is apt to be misunderstood as unpatriotic at the present time.'[64]

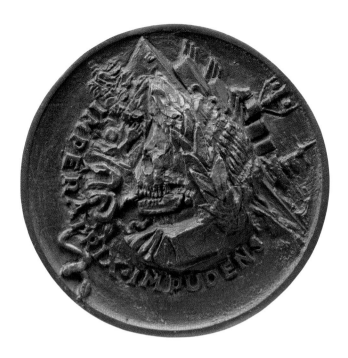

Fig. 20 Michael Sandle: *Belgrano Medal – a Medal of Dishonour*, 1986, cast bronze, 82 mm.

The possibility that their anti-war stance could be used by those sympathetic to Nazi Germany gave Smith cause for concern, and when they were once again exhibited in 1943, despite their use of imagery relating to the United States (including the Statue of Liberty), they were named *Medallions for the Axis*, a title that shifted their primary focus directly onto European Fascism and away from America.[65] The original title given by Smith to his medallic series has continued to reverberate with artists whose works are of a scale more in keeping with the medallic tradition. In the 1980s British sculptor Michael Sandle produced his uniface *Belgrano Medal – a Medal of Dishonour*, in which the then prime minister Margaret Thatcher is described as an IMPERATRIX IMPUDENS (Shameless empress) and portrayed as a death's head spitting snakes and wearing the *Belgrano*, the Argentinian warship sunk on her orders, as a sort of hat (fig. 20).[66] Like Smith, Sandle had seen some of the British Museum's First World War medals and his medal references their vigorous style and grim symbolism. Soon after its appearance its forceful political comment provoked controversy, and even a retaliatory medal entitled *Señora No*.[67] In 1993 the American artist Leonda Finke again adapted Smith's title, producing a group of four *Medals of Dishonor Worldwide* entitled *Famine/Hunger*, *Death by Random Gunfire*, *Rape/Companion of War*, and *Homeless/Nameless*, in which human figures play out these horrific scenarios.[68]

The 1960s saw artists begin to question many of the assumptions underlying the medal in a process that continues to this day.[69] Marcel Duchamp's *Sink Stopper* of 1967 (cat. no. 23) reduces it to a banality far removed from the usual perception of the medal as an indicator of superior status, emphasizing its point by at the same time retaining the tradition of editioning in different metals. More recently, artists have taken different approaches, undermining expectations by producing one-off and transient medals that completely detach the medium from its roles as vehicle for collective celebration and transmitter of information to posterity.[70] Others, like Sandle and Finke, have continued to use the medal to attack or subvert their chosen subjects, employing means that vary from direct statements to more nuanced comments. Depradations on the natural environment have been an important focus, as in a medal by British artist Nicola Moss combining a depiction of insatiable consumption with a hellish vision of the inevitable consequences, its title a Lakota and Dakota Sioux word for a non-Native American that has come to be associated with greed and exploitation (fig. 21). Environmental and socio-economic issues and the waste of war are among the subjects addressed by New Zealander Michael Reed, whose cast medals use a visual language not far removed from that of the German First World War medals, whilst others by the artist respond ironically to the beribboned form of military honours.[71] The collapse of communism in Central and Eastern Europe in the early 1990s led to a surge of medals from artists in those countries, in which the former system was condemned in a way that would have been politically impossible a few years earlier. An ensuing feeling of disillusionment was the subject of medals by a number of German artists including Carsten Theumer, whose *Ex Occidente Felicitas* (Happiness from the West) shows a beneficent God-like hand bestowing a banana, whilst, on the other side, the recipient, incapacitated by the fruit, sits disconsolately, holding a drinks can and a national flag from which the communist emblem has been removed (fig. 22).[72] Other German medals of the time tackled the failure to heal divisions between West and East Germany.

This increased engagement has been further encouraged by the initiative that forms the second part of this exhibition (cat. nos 24–36). Commissioned by the British Art Medal Trust in 2006–8, these medals have now been presented to the British Museum. Belonging to a tradition that stretches back over four hundred years, they also highlight an important shift in the public's perception of the principal function of a medal that has occurred during this time. The notion of medals as symbolic rewards has grown since the eighteenth century, when the asso-

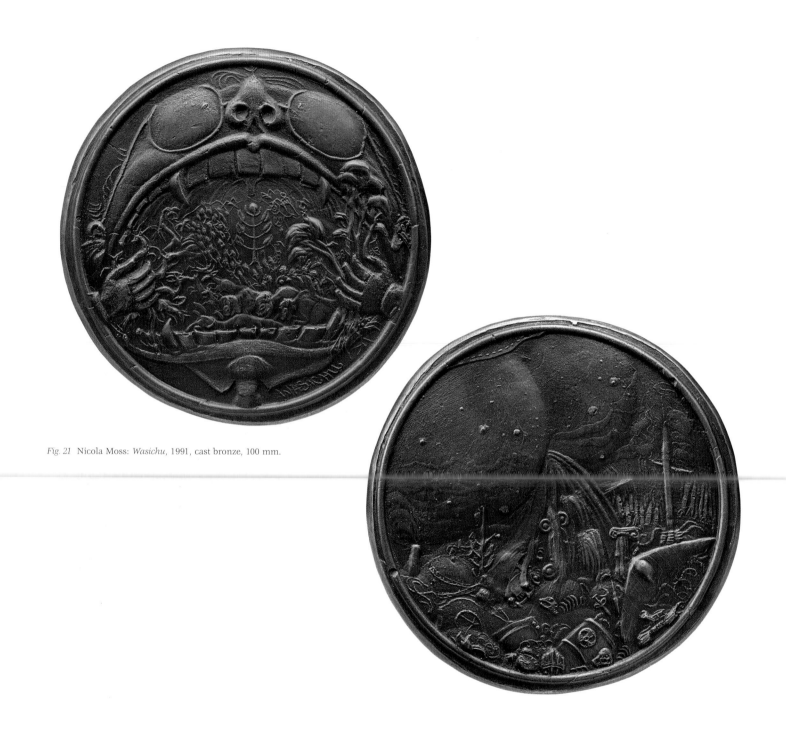

Fig. 21 Nicola Moss: *Wasichu*, 1991, cast bronze, 100 mm.

ciation was generally made in the contexts of learning and sport. It can now be seen in Richard Hamilton's *Hutton Award* (cat. no. 27); Michael Landy's medal, to be 'presented to Dean Rowbotham for breaking his ASBO' (cat. no. 32); and Grayson Perry's *For Faith in Shopping* (cat. no. 35). Similarly, just as the widespread use of medals as military and naval awards in many countries from the nineteenth century on led to Rops' *Waterloo*

Medal and the title David Smith gave to his medallic series, so Steve Bell's *CDM* invites comparison with three-letter British decorations (cat. no. 24), and Cornelia Parker's medal appropriates some of the characteristics of official war medals (cat. no. 34). All, however, hold true to the earlier tradition in that they are best experienced by being turned in the hand, while their subjects are as wide-ranging as those of the historical medals

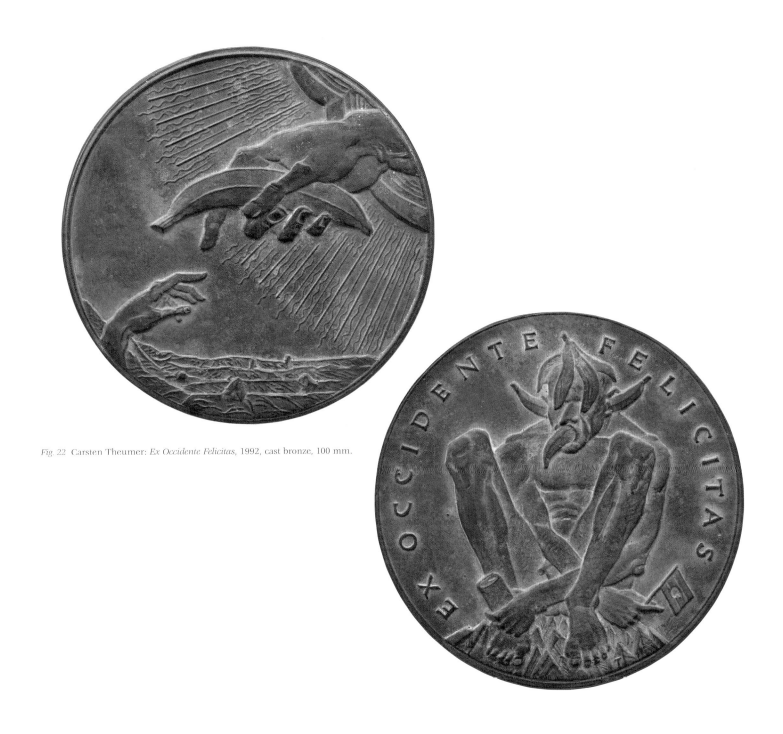

Fig. 22 Carsten Theumer: *Ex Occidente Felicitas*, 1992, cast bronze, 100 mm.

discussed here, with many echoes of what has gone before. War, politics, global security, the environment, finance, race, consumerism, social exclusion – these are some of the issues with which these medals are concerned. The role of the viewer is to decide how to respond.

Overleaf: Mona Hatoum: detail from *Medal of Dishonour*, 2008 (cat. no. 28).

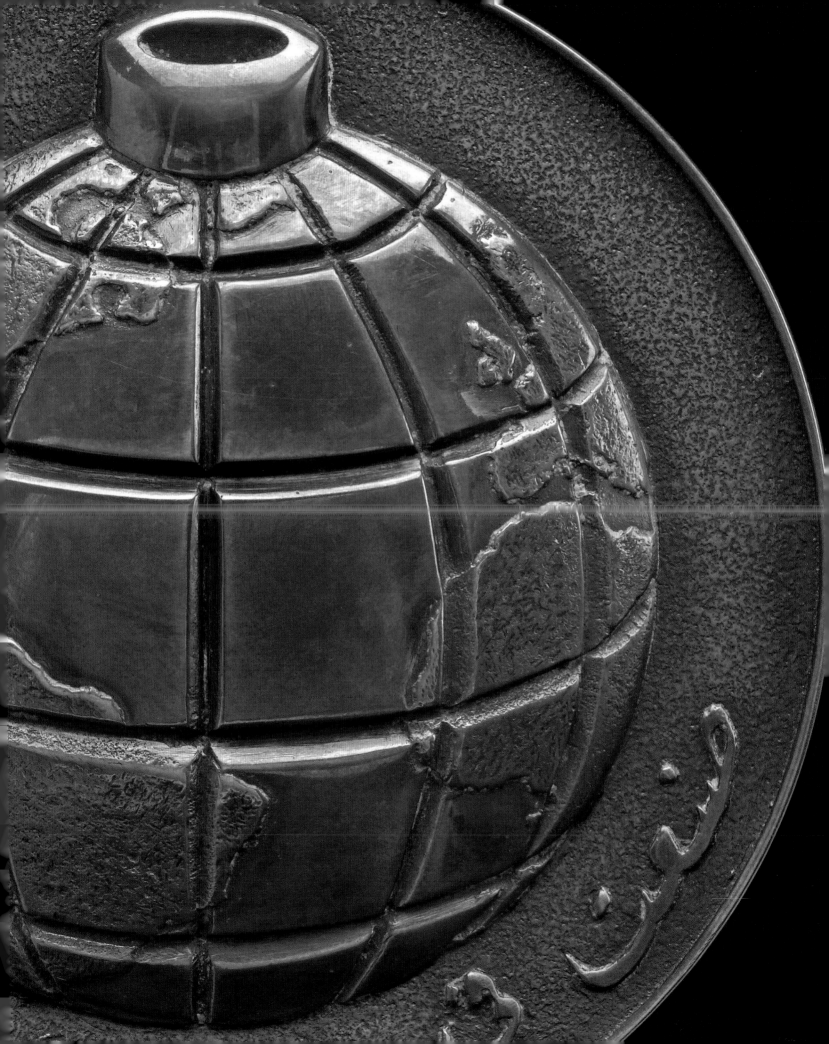

SHOT BY BOTH SIDES

Rod Mengham

The medal as an art form is ideally suited to represent a microcosm of the world. A flat metal disc reflects the circular appearance of the globe, if not its spherical form, while its reversible sides seem tailor-made for alternative, and even contrasting, views of experience. The basic design of every medal thus supplies a pretext for the conceptual division that has marked the history of making and awarding these tokens of praise and blame, permitting the growth of opposite traditions either honouring recipients or else smearing intended or imagined recipients with attributions of dishonour.

The structural reversibility built into the genre from the start has paved the way for the present exhibition, but the antithetical energy that runs so vividly through the exhibits has been generated by the convulsions of history, by specific reminders that there are two sides to every story. Medals can be thought of as aesthetically complex forms of name-calling, deploying both positive and negative terms, as if in line with Winston Churchill's paradoxical statement that 'a medal glitters, but it also casts a shadow' (1941).[73] Churchill is referring to the mixed feelings that may greet the award of a medal, not to any ambivalence in its design, but his motto serves as a formulation of the way in which examples of the genre always carry the potential for a contradiction in terms.

In the hands of Mona Hatoum, the medal is transformed into the indispensable medium for representing the double-sided character of our current ideological environment (cat. no. 28). Hatoum's medal is blank on the reverse, but her design does not need to encompass more than one side, since its depiction of the globe as a hand grenade, juxtaposed with an Arabic inscription, implies a world view that cannot be imagined without reference to its antithesis. For those without Arabic, there is a further reversal of expected meaning in the translation of the inscription, which does not sponsor violence but disowns it, and in doing so offers a check to western assumptions about the distribution of honourable and dishonourable conduct in the so-called 'war on terror'.

Medals are conceptually Janus-faced in their relation to history. They possess both transitory and enduring characteristics, with their origins in a forgotten topicality that art transforms into persistence. The two traditions of honour and dishonour manage the relationship with history in different ways. Medals of honour are more likely to be conventional and stereotypical in form, paradoxically consigning their subjects to oblivion, while the originality of many designs in the dishonour tradition are more likely to preserve in the memory these responses to ignominy. This is nowhere more true than in the Chapman brothers' medal (cat. no. 25), which provides an epitome of the concerns reflected in their recent installation *Fucking Hell* (2008). In both the medal and the larger project to which it refers, the theatre of war does not figure as the principal setting for the kind of behaviour recognized and rewarded in the medals of honour tradition, but is instead the total environment within which both terrestrial and infernal economies have become undivided. The world is not contained within its sphere, nor within the visible circumference supplied by the shape of the medal, but extends beyond imaginative control in a limitless killing field whose iconography is associated with the conflicts of different historical periods and discursive fields – economic, socio-political and cultural, as well as military.

The Chapman's hell is resolutely postmodern in its mixing of registers and in its secularizing and routinizing of the theologian's evil. Grayson Perry's *For Faith in Shopping* (cat. no. 35) is in many ways its perfect complement. It deploys a deliberately archaic style of representation, with aspects of Christian iconography that relate to an historical period when devotional art was, practically speaking, universal in its control of the cultural imagination, and yet substituting as the object of devotion a way of being in the world that is controlled ultimately by the power of the spectacle – no longer in the hands of fine art, but at the mercy of fashion and the media. The technologized sleekness of fashion products is clearly opposed by the palpable craftsmanship with which the worship of fashion has been mod-

Fig. 23 Cornelia Parker: *Moon Landing in the Nevada Mountains*, 2005, relocated lunar meteorite and metal sign, California.

Moon Landing project, she created a series of plaques parodying the conventions of National Trust signs, reproducing the shape and typography favoured by this organization, but producing an effect of contrariety with the introduction of black rather than white backgrounds (fig. 23, left). This negative or alternative universe of heritage refers to an object that has been lost rather than conserved, perhaps commenting on the selective attitude towards history exemplified by heritage organizations whose interpretation of the past may displace the object of scrutiny by the manner in which they seek to retrieve it. The aversion of the two faces in Parker's medal (cat. no. 34) focuses attention even more dramatically on the practice of concealment now identified with the conduct of the Iraq war, highlighting the culpability of politicians whose cover-up operations affect the making and not just the interpretation of history.

Richard Hamilton's medal (cat. no. 27) seems at first glance to offer a counter-example to Parker's twin images of retraction, with its full exposure of smiling faces. However, there is an element of exaggeration in these brazen expressions, a suggestion of strain and artifice, of the erection of a facade. Hamilton is a shrewd observer of the interface between public persona and the individual whose personal motivations for public actions remain inscrutable. The element of performance in political life combines exhibitionism with concealment, requiring an almost contradictory enactment of identity, a suturing together of almost opposite tendencies. This unnatural process of collaging the self is captured brilliantly in Hamilton's well-known painting *Portrait of Hugh Gaitskell as a Famous Monster of Filmland* (fig. 24, opposite) which is partly an *ad hominem* attack and partly a more general indictment of the inauthenticity of the political role, of a mode of operation in public life that resembles the condition of Frankenstein, stitched together from different versions of the self (some of which are more alien than others), grafting sincerity onto masquerade and expediency onto conviction. The distortion of parts of the face in the portrayal of Gaitskell is echoed more subtly in the medal's characterizations of Blair and Campbell, where the careful manipulation of bas-relief effects literally adds a dimension to the artistic expression of Protean mutability. By moving the position of the medal, or moving one's own position in relation to it, the facial expressions of government are seen to change, to be capable of meaning more than one thing at once. Closer inspection of the milled surface reveals an unusual alternation of convexities and concavities that dramatizes the chiaroscuro effects that can be achieved by more conventional modelling. Hamilton has achieved an advance in the capacity of medal-making techniques to embody alternatives and make duplicity seem ingrained, almost putting us in the position of seeing both sides at once.

elled, giving Perry's retrograde artisanal skills the aura of authenticity in an era of virtually infinite reproducibility. Of all the works in the exhibition, his miniature tondo is the most resistant to the medal's habitual gravitation towards two dimensions; it is an anthem against flatness.

Cornelia Parker, on the other hand, is an artist who has experimented enthusiastically with flattened metal in the past, sometimes flattening objects (such as brass musical instruments) whose function requires the preservation of volume. The conversion of a three-dimensional presence into a sheet of metal connoting absence signals her recognition of the extent to which the transfer of any utensil into an art context changes its meaning; the translation of its physical reality into another form is emblematic of its conceptual transformation. Parker has also made relevant use of the disc form, exploiting the ambivalence attached to the binary structure of the medal. For her

The Iraq war has attracted more attention than any other scenario featured on the medals commissioned for this exhibition. The enormous media coverage received by the war has turned it into a twenty-first century Theatre of Cruelty, in which the testimony of sounds and images counts for more than language in any attempt to locate the evidence of honourable or dishonourable conduct. Yun-Fei Ji's medal (cat. no. 29) makes a direct contrast between the hypocrisy of political rhetoric and the carnage that is performed in its name. The obverse seems to illustrate an episode in a beast fable, in which animals are given human attributes in order to make generic points about examples of folly or wisdom, moral or immoral behaviour. But in a world controlled by the interests of those embraced by the phrase 'coalition of the willing', states and their governments revert to violence in mimicry of instinctual predation by animals. The human cost of this militarized feeding frenzy is counted on the reverse of Steve Bell's *Collateral Damage Medal* (cat. no. 24), which encapsulates the effect of the war on civilians in the single figure of a dead child. The distilled pathos of this image jars grotesquely with the monstrous image on the obverse, echoing the concealed and camouflaged heads and faces of the medals by Cornelia Parker and Richard Hamilton. Bell's unmistakeable reference to the head of the sovereign submits the familiar image to a form of deranged swaddling, indicative of an obsessive need to see, hear, smell and taste nothing, precisely because the evidence of the senses is the only thing to be trusted after language has been corrupted by the obscene euphemisms of war.

Fig. 24 Richard Hamilton: *Portrait of Hugh Gaitskell as a Famous Monster of Filmland*, 1964, oil and collage on photograph on panel, 610 x 610 mm, Arts Council collection, London.

The two remaining medals that subvert the genre's traditional iconographic focus on the portrait head are Ellen Gallagher's *An Experiment of Unusual Opportunity* (cat. no. 26) and Michael Landy's *ASBO Medal* (cat. no. 32). The experiment referred to in Gallagher's title withheld medical treatment from American black men suffering from syphilis, between 1932 and 1972, in order to collect data on the progress of the disease up to the point of death. The face of the nurse depicted on the medal is accordingly reduced to the representation of a single cyclopean eye, indicting the substitution of mere observation for the medical duty of care. The ravaged state of the neck subtended to this mutant surveillance device transfers the disease from patient to researcher, in a comment on the psychological morbidity of those responsible. Michael Landy's medal is concerned with another social experiment – one much less vicious, but one whose effects are less easily calculated and less easy to control. The conferring of an Anti-Social Behaviour Order in Britain, intended as a mark of disgrace and dishonour, has been regarded by some recipients as the opposite. The necessarily local scale within which the order has currency changes its value according to the premium placed on celebrity (especially

in the form of notoriety) among those to whom other forms of distinction are unavailable.

In this respect, there is almost a quaintness adhering to the criminal mug-shot displayed on Landy's medal when compared to the inscrutability of the acronyms on the target-like disc of *Virtual World* by Langlands and Bell (cat. no. 33). The ASBO has meaning only within the context of a 'knowable community', and is almost nineteenth century in conception, whereas the criminality associated with some of the organizations behind the acronyms in *Virtual World* can only be assessed within a global context, within which different ideological perspectives would map the world according to diverse criteria of merit and demerit. Warfare in postmodernity is orientated increasingly towards ideological conflict rather than competition for territory, which makes the world-wide web – whose scope reverberates through the domain names on the reverse of the medal – a significant battleground in the war of definitions that has turned the history of medals into an extension of war by other means.

Meanwhile, Felicity Powell's medal *Hot Air* (cat. no. 36) is a satirical reminder of the most significant form of territorial

Fig. 25 William Kentridge: Drawing from the animation *Felix in Exile*, 1994, charcoal, pastel and gouache, 120 x 160 mm.

defeat in a war in which there are only losers. Global warming is widely regarded as the product of an excessively technologized biosphere, but the two sides of Powell's medal are equally unswerving in their denunciation of the source of the problem – in the human condition for which technology is only an aggrandized form of prosthesis, and in the arrogance of a species whose self-indulgence has often been in direct proportion to its talent for self-deception.

The liveliest episodes in the history of satirical medals have almost always involved visual expressions of the right to free speech, or of resistance to censorship, or have trained their focus on banned or taboo subject matter. Among those artists featured in the current exhibition, those who have lived for long

periods of their lives under oppressive regimes exemplify the extremes of direct and indirect forms of challenge to authority. The savage humour of William Kentridge's assault on complicity in political injustice, found also in his animations (fig. 25, above), almost leaps out of the medal (cat. no. 31), literally projecting from its surface, while the coded reticence of the Kabakovs' subversions is folded calmly into its structural ambiguities (cat. no. 30). The unmanageable centre of attention in Kentridge's saw-toothed vision of social and political abuse is an autonomous megaphone, a classic emblem of the means of amplifying one point of view in order to drown out others. The megaphone is the instrument of political oratory, of spokesmanship, the essential prosthesis for those who wish to

speak for the people rather than allow them to speak for themselves. In Kentridge's vision it has been disconnected, uprooted and given a roving commission, no longer transmitting the voice of a human agent, since the conceptual wiring that would sustain the illusion of sincerity has long since decayed, its fundamental message a repetitive confirmation to the listeners that they are, as it were, 'screwed'.

Perhaps the most enigmatic and most powerfully elliptical of the medals on display is that of Ilya and Emilia Kabakov. Their exclusive focus on the image of a single fly, resembling the presentation of a zoological specimen that stands in for an entire species, is also one instance of a thematic preoccupation that they have returned to several times in their work. Each return to this imagery reinforces the terms of a fictional theory that associates the collective behaviour of flies with the social politics of the totalitarian state. That the single fly can be regarded as a synecdoche for this complex of associations is confirmed by the drawing shown as part of the installation *The Life of Flies*, where the anatomical drawing in black is enclosed within a diagram outlined in red representing the sum total of flies in the atmosphere above the Soviet Union (fig. 26, right). The symmetrical shape of this gigantic swarm indicates the highly organized principles that govern the lives of these insects, whose 'civilization' generates patterns that reveal its symbiosis with the fortunes of the Soviet state. It is usually the bee, with its industriousness and co-operativeness, that is chosen as the fabled exemplar of civic responsibility in a well-run community – rather than the fly, with its associations of opportunism, parasitism, abjection and decay. The disjunction between the utopian programming of the communist era and the historical reality of mismanagement and waste is both explained away and mystified by the controlling agency of the fly, whose impact on human society is well in excess of Biblical proportions, since according to the Kabakov's satirical theory, the upper limit of the swarm is 60,000 kilometres above the earth. The medal of dishonour identifies the fly as culprit in the assessment of 'turning-points in our history that are still unexplained from the point of view of human behaviour',[74] an identification whose absurdity is bound to prompt reflection on the role of human agents whose behaviour has resembled that of flies, not in respect of the abstract beauty of their orchestrated movements, but in their scavenging for the rich pickings to be gleaned from a dying carcase. The apparent neutrality of the image belies its conceptual subtext, and provides a telling example of the unique properties of the medal in its ability to compress and encode a host of contingent details, telescoping an astonishing array of polemical issues in its presentation of a world in little.

Fig. 26 Ilya Kabakov: *The Life of Flies*, 1992, ink, feltpen and graphite, 501 x 349 mm.

What this exhibition also provides is a microcosm of the world of art, in its drawing together of the designs of painters, cartoonists, sculptors, installation artists and filmmakers. There can be no other medium in which the limitations placed on size, shape, volume and colour have been so consistent throughout the history of its use. It is the great paradox of the discipline imposed by those limitations that it should have liberated so many artists of radically different traditions, practices and outlooks to be so outspoken in their engagement with issues of general public concern and with a sense of historical urgency, and all within the compass of something that can be held in the palm of the hand. The division of the history of medals into the parallel traditions of rewarding honour and berating dishonour has maintained the tension between dignified restraint and iconoclastic verve, a tension that has guaranteed the vitality of a medal-making culture that shows no signs of abating.

NOTES ON ESSAYS

1 For more on satirical medallic strategies, see Attwood 2009, and for those employed in medals satirizing Louis XIV of France particularly, Jones 1982–83. The similar forms used in satirical prints are usefully summarized in Donald 1996, p. 47: 'personifications such as Fortune and Justice; rides to hell, devils and monsters, symbolic devourings and purges; animal allegories; processions and other figural friezes, mock triumphs, deathbeds and funerals; balances, ships and trees; social inversions (the "topsy-turvy" world) and ritual humiliations of the great.' For a general discussion of the strategies used in the visual arts, see Gombrich 1963 and Keen 1986; Keen's discussion of archetypes of the enemy (pp. 15–88) includes the enemy as enemy of God, as barbarian, as the greedy enemy devouring the world (cf. cat. no. 11), as criminal, as torturer, as rapist (cf. cat. no. 20), as 'beast, reptile, insect, germ' (cf. cat. no. 15), and as a figure of death. For the strategies of literary satire, see Hodgart 1969, ch. 4, and, for humour, pp. 20–27.

2 [...] medal of 1757 showing the empress Maria Theresa kneeling before Frederick the Great, king of Prussia, with the legend THE HAUGHTY QUEEN HUMBLED; Hawkins 1885, vol. ii, p. 684, cat. 402.

3 Hill 1930, p. 240, cat. 915; James David Draper in Scher 1994, p. 129, cat. 41; Luke Syson, 'Bertoldo di Giovanni, republican court artist', in Stephen J. Campbell and Stephen J. Milner, eds, *Artistic exchange and cultural translation in the Italian Renaissance city* (Cambridge: Cambridge University Press, 2004), pp. 96–133, at p. 101.

4 Barnard 1927 and cat. no. 2 below.

5 Habich 1929–25, vol. ii, part 1, p. 324, cat. 2246. In 1524 Schenck had produced a medal of Luther with a reverse allegorizing his struggle against the papacy; Habich 1929–25, vol. ii, part 1, p. 316, cat. 2198. For German and English anti-papal prints continuing into the seventeenth century see, for example, O'Connell 1999, pp. 129–31, 210–13.

6 Van Loon 1732–7, vol. ii, p. 395; Hawkins 1885, vol. i, p. 420, cat. 60.

7 Stephens and George 1870–1954, vol. i, cat. 894.

8 Jonathan Swift, *The battle of the books* (1697), in *Minor works* (Oxford: Oxford University Press, 2003), pp. 1–22, at p. 10.

9 This was published posthumously. Joseph Addison, *Miscellaneous works, in verse and prose,* 3 vols (London: Jacob Tonson, 1726), pp. 3–233: 'Dialogues upon the usefulness of ancient medals', at p. 151. For a recent study of this work, see David Alvarez, '"Poetical cash": Joseph Addison, antiquarianism, and aesthetic value', *Eighteenth-Century Studies*, vol. xxxviii, part 3 (Spring 2005), pp. 509–31.

10 Addison 1726, p. 152. He later adds that 'Wit or Satyr' is especially pleasing in an inscription (p. 158).

11 Evelyn 1697, p. 176; Marcia Pointon, *Hanging the head. Portraiture and social formation in eighteenth-century England* (New Haven and London: Yale University Press, 1993), p. 63.

12 Evelyn 1697, p. 154; Van Loon vol. iii, p. 340; Hawkins 1885, vol. i, p. 621, cat. 36.

13 Evelyn 1697, p. 175; Hawkins 1885, vol. i, p. 583, cat. 259; Peter Barber, 'London in miniature: medallic panoramas of London 1633–1795', *London Topographical Record*, vol. xxix (2006), pp. 22–42, at pp. 28–31, with a discussion of Dryden's reaction.

14 Marjan Scharloo, 'A peace medal that caused a war?', *The Medal*, no. 18 (1991), pp. 10–22, at pp. 17–19. For the Peace of Breda medal, see Van Loon 1732–37, vol. ii, p. 534; Hawkins 1885, vol. i, p. 528, cat. 176.

15 Van Loon 1732–7, vol. iii, p. 377; Hawkins 1885, vol. i, p. 656, cat. 16; Woolf 1988, p. 24, cat. 9:1; G.P. Sanders, *Koning-stadhouder Willem III een leven in penningen en prenten* (Utrecht: Het Nederlands Muntmuseum, n.d. [2003]), p. 55.

16 Van Loon 1732–7, vol. iii, p. 376; Hawkins 1885, vol. i, p. 651, cat. 6; Woolf 1988, p. 22, cat. 8:1. The oak tree remained a symbol of the Stuart family as, for example, in a print of 1715; Stephens and George 1870–1954, vol. i, cat. 747; Neil Guthrie, '*Unica salus* (1721): a Jacobite medal and its context', *The Georgian Group Journal*, vol. xv (2006), pp. 88–120, at p. 108, fig. 13. See Eirwen E.C. Nicholson, '"Revirescit": the exilic origins of the Stuart oak motif', in Edward Corp (ed.), *The Stuart court in Rome. The legacy of exile* (Aldershot and Burlington, VT: Ashgate, 2003), pp. 25–48.

17 Van Loon 1732–7, vol. iv, p. 10, Hawkins 1885, vol. i, p. [...] 1988, p. 36, cat. 11:6.

18 Stephens and George 1870–1954, vol. i, cat. 1215.

19 Juvenal, *Satires*, Book 10, lines 63–4, in *Juvenal and Persius*, ed. and trans. Susanna Morton Braund (Cambridge, Mass., and London: Harvard University Press, Loeb Classical Library, 2004), pp. 370–71.

20 Van Loon 1732–7, vol. v, p. 145; Hawkins 1885, vol. ii, p. 361, cat. 200; Jones 1979ª, p. 87, fig. 214; Jones 1983, p. 210; pl. 37, no. 53.

21 Jones 1983, p. 204; pl. 37, no. 50.

22 Romeyn de Hooghe's satirical illustration in a Dutch publication of 1701 also responds to the French medal and may have been known to Brunner. Here Louis is shown in a rickety chariot, driven by his morganatic wife, Madame de Maintenon, and attacked by the Dutch lion. The etching appears on the title-page of *Ptolomeus, Copernicus, en Merkuur op de Parnas over de Zon en de Waereld (Ptolemy, Copernicus, and Mercury on Parnassus, speaking about the Sun and the World)*, published by Sebastian Petzold (Amsterdam, 1701). Stephens and George 1870–1954, vol. ii, cat. 1364; Jones 1983, p. 210; pl. 41, no. 76.

23 Van Loon 1732–7, vol. v, p. 149; Hawkins 1885, vol. ii, p. 363, cat. 203; Jones 1983, p. 210; pl. 40, no. 77.

24 Hawkins 1885, vol. ii, p. 99, cat. 324; Wohlfahrt 1992, p. 151, cat. 94 025.

25 Suggested in Hawkins 1885, vol. ii, p. 99. The quotation is from Horace, *Ars poetica*, verse 139.

26 Adams 2005, p. 26. For Wermuth, see Wohlfahrt 1992.

27 Wohlfahrt 1992, p. 15.

28 Kirschner 1968, p. 54, cat. 18; Friedenberg 1970, p. 3; Wohlfahrt 1992, p. 153, cat. 94 035.

29 Hawkins 1885, vol. ii, p. 451, cat. 59; Wohlfahrt 1992, p. 207, cat. 01 021; Adams 2005, p. 60, cat. S-9.

30 Wohlfahrt 1992, p. 267, cat. 07 054; Adams 2005, p. 61, cat. S-12.

31 Stephens and George 1870–1954, vol. ii, cat. 1722; Klingender 1944, p. 6, pl. 10; George 1959–60, vol. i, pp. 75–6; pl. 20a; David Bindman, *Hogarth and his times: serious comedy*, exh. cat. (Berkeley and Los Angeles: University of California Press, 1997), p. 148, cat. 83; Guthrie 2006, p. 101; fig. 12; Mark

Hallett and Christine Riding, *Hogarth*, exh. cat. (London: Tate, 2006), p. 57, cat. 16. The most substantial volume of prints was the Dutch *Het groote tafereel der dwaasheid* (*The great mirror of folly*), first published in 1720, which included Law among its targets; see Cole 1949, who gives references to Stephens and George 1870–1954.

32 Hawkins 1885, vol. ii, p. 448, cat. 55; Wohlfahrt 1992, p. 371, cat. 20 008; Adams 2005, p. 43, cat. 21.

33 Elizabeth See Watson, *Achille Bocchi and the emblem book as symbolic form* (Cambridge: Cambridge University Press, 1993), p. 108.

34 The most celebrated instance was Lord Cobham's garden at Stowe where, in contrast to the perfection of the Temple of Ancient Virtue, the Temple of Modern Virtue was created as a ruin with a headless statue in contemporary dress identifiable as Walpole; Tim Richardson, *The Arcadian friends: inventing the English landscape garden* (London: Bantam Press, 2007), pp. 316–17. For satirical prints of Walpole, see Paul Langford, *The English satirical print 1600–1832. Walpole and the Robinocracy* (Cambridge: Chadwyck-Healey, 1986).

35 Hawkins 1885, vol. ii, p. 563. For the medals, Hawkins 1885, vol. ii, p. 562, cat. 193 (the original struck medal by Lorenz Natter), cat. 194 (the altered medal). The original quotation is from Virgil, *Aeneid*, Book 1, verse 153. In a similar subversive vein, the edge of an example of the original medal (now in the British Museum) is engraved with a legend translating as 'He governs minds by money, and by money is himself governed'; Hawkins 1885, vol. ii, p. 563, cat. 195.

36 Hawkins 1885, vol. ii, p. 566, cat. 200.

37 Speech of 26 October 1775; J. Wright (ed.), *The speeches of the Right Honourable Charles James Fox in the House of Commons*, 6 vols (London: Longman *et al.*, 1815), vol. i, p. 44.

38 Stephens and George 1870–1954, vol. v, cat. 6183; Donald 1996, p. 62.

39 Horace, *Satire*, Book II, part 3, verses 243–4, in *Satires, Epistles and Ars poetica*, trans. H. Rushton Fairclough (London and New York: William Heinemann and G.P. Putnam's Sons, Loeb Classical Library, 1926), pp. 172–3.

40 Stephens and George 1870–1954, vol. v, cat. 6219.

41 Stephens and George 1870–1954, vol. vi, cat. 6571.

42 Bindman 1989.

43 Dalton and Hamer 1910–17, vol. ii, p. 166, cat. 686; Bell 1987, pp. 216, 227.

44 Dalton and Hamer 1910–17, vol. ii, p. 168, cat. 721; Bell 1987, pp. 227, 238; Bindman 1989, p. 202, cat. 206l.

45 Bound into Spence's periodical, *Pig's Meat*, British Museum, Department of Coins and Medals.

46 Dalton and Hamer 1910–17, vol. iii, p. 264, cat. 34; Brown 1980, p. 83, cat. 360; Bindman 1989, p. 116, cat. 67a. A flyer for this medal is reproduced in Brown 1995, p. 275, along with other flyers contrasting Britain and France.

47 Collignon 1984.

48 Notebook entry for 2 March 1850; Andrée Bruel, ed., *Les carnets de David d'Angers*, 2 vols (Paris: Librairie Plon, 1958), vol. ii, pp. 329–30; T.J. Clark, *The absolute bourgeois. Art and politics in France 1848–1851* (London: Thames and Hudson, 1973), p. 119.

49 William Eisler, 'The Bovy medal workshop and the American Civil War', *The Medal*, no. 47 (2005), pp. 42–59, at p. 50. The medal was struck in Switzerland. For a general survey of satire produced in the face of governmental restrictions, see David Baguley, *Napoleon III and his regime. An extravaganza* (Baton Rouge: Louisiana State University Press, 2000), ch. 10: 'Parody, caricature, satire'. Baguley summarizes the techniques employed as 'reductiveness, exaggeration, emphasis on bodily functions and on sexual practices, associations with animals and animal behaviour, juxtaposition of pretensions and the actions of the targets of the satire' (p. 256).

50 Erastène Ramiro, *L'oeuvre lithographié de Félicien Rops* (Paris: Librairie L. Conquet, 1891), p. 118, cat. 172; Camille Lemonnier, *Félicien Rops: l'homme et l'artiste* (Paris: H. Floury, 1908), p. 28; Maurice Exsteens, *L'oeuvre gravé et lithographié de Félicien Rops*, 4 vols (Paris: Editions Pellet, 1928), vol. i, n.p., cat. 167. Rops' original drawing for the lithograph is in the Musée Curtius, Liège (information from Luc Engen).

51 R. Chalon, 'Numismatique de Waterloo', *Revue Belge de Numismatique*, vol. xxxv (1878), pp. 421–43, at p. 436, cat. 42; Eduard Holzmair, *Katalog der Sammlung Dr. Josef Brettauer. Medicina in nummis* (Vienna: Brettauer, 1937), p. 310, cat. 4537. The artist's original plaster model was also used to produce

large medals cast in bronze, with additional legends on the obverse ('Although they are good in plaster, they would be better in the ground') and reverse ('To those who wear without shame a medal that reminds them of their former servitude'); Chalon 1878, p. 437, cat. 43; reproduced as a lithograph in Exsteens 1928, vol. i, n.p., cat. 168.

52 Alfred Delvaux, in *La Tamise* (London), 14 July 1858, quoted in Ramiro 1891, p. 118, n. 1. Also Lemonnier 1908, p. 28; Robert L. Delevoy *et al.*, *Félicien Rops* (Brussels: Lebeer Hossmann, 1985), p. 73.

53 *Katalog* 1885, pp. 70–72.

54 Hill and Brooke 1924, p. 133, cat. 111; Kienast 1967, p. 65, cat. 156; Jones 1979[b], p. 17, figs 28, 29; Philip Dutton, '"Geschäft über alles": notes on some medallions inspired by the sinking of the *Lusitania*', *Imperial War Museum Review*, vol. 1 (1986), pp. 30–42, at pp. 30–35; Lewison 1991, p. 23; Brown 1995, p. 104, cat. 4118; Steguweit 2000, p. 35, cat. 79.

55 For the medal, see cat. 16; for the print, Griffiths, Wilson-Bareau and Willett 1998, p. 77, pl. 19.

56 Hill and Brooke 1924, p. 13.

57 Markus Wesche, 'Karl Goetz, medallic artist and businessman', *Médailles* (Helsinki: FIDEM, 2005), pp. 55–9, at p. 57.

58 *Philip Hagreen: the artist and his work* (Rochester [NY]: At the Sign of the Arrow, 1975), p. 100, pl. 193.

59 Matthew 25:44.

60 See cat. 22. Smith had also studied ancient Greek coins during his stay in Greece in 1935; Lewison 1991, p. 22; Wisotzki 1988, p. 51.

61 For these sketches, see Wisotzki 1988, pp. 84–5; fig. 1. Since the nineteenth century the standard method of producing a die for a struck medal, as for a coin, has been to place a version of the artist's model on a pantographic reducing machine.

62 This is discussed in Wisotzki 1988, pp. 103–7. Smith was concerned that his works should be 'discussed aesthetically' as well as politically: Wisotzki 1988, p. 159.

63 In the context of printmaking, Jeremy Lewison writes of the 'ambiguity and ambivalence' of contemporary art, whilst at the same time asserting: 'Art is more engaged than ever in the politics of life. It can question, comfort, distract, problematize, undermine, lampoon, dissect, or simply provide escape'; Lewison 2006, pp. 27, 35.

64 Letter to Marian Willard, 16 December 1941; Wisotzki 1988, p. 221.

65 Wisotzki 1988, pp. 228–31, 250–52, 274.

66 John McEwen, *The sculpture of Michael Sandle* (Much Hadham: Henry Moore Foundation, 2002), p. 126, cat. 57; Attwood 2002, p. 24, cat. 39. A drawing by Sandle based on the medal is in the British Museum's collections. Sandle's political comment has since continued, notably in his *Iraq Triptych*, exhibited at the Royal Academy's summer exhibition in 2007 (cat. 639).

67 *The Medal*, no. 12 (1988), pp. 61–4.

68 *Leonda Finke* (New York: Ruder Finn Press, 2006), pp. 221, 238–45.

69 For a summary of the 1960s and 1970s, see Jones 1979, ch. 18, and for the 1990s, see Syson 1999. The catalogues of the international exhibitions held every two or three years by the Fédération Internationale de la Médaille d'Art (FIDEM) provide an overview.

70 For example, Danuta Solowiej's sand *Medals for Passers-By* (Philip Attwood, 'Medallic art in Britain now', *Médailles* (Lisbon: FIDEM, 1995), pp. 37–44, at p. 42), Andrew Griffiths' cast-away medals (Marcy Leavitt Bourne, 'Andrew Griffiths makes, shoots and leaves', *The Medal*, no. 49 (2006), pp. 53–8), or Elly Baltus's forged steel and earth *Dust to Dust* (*The Medal*, no. 51 (2007), p. 88).

71 John Freeman-Moir, '"Neither shall they learn war any more"; Michael Reed's medals of protest', *The Medal*, no. 47 (2005), pp. 60–73.

72 Syson 1999, p. 9, cat. 9; Steguweit 2000, p. 257, cat. 409.

73 Winston Churchill, speech, 22 March 1944.

74 Ilya Kabakov, *Installations 1983–2000: catalogue raisonné*, vol. i, *Installations 1983–1993* (Dusseldorf: Richter Verlag, 2003), p. 368.

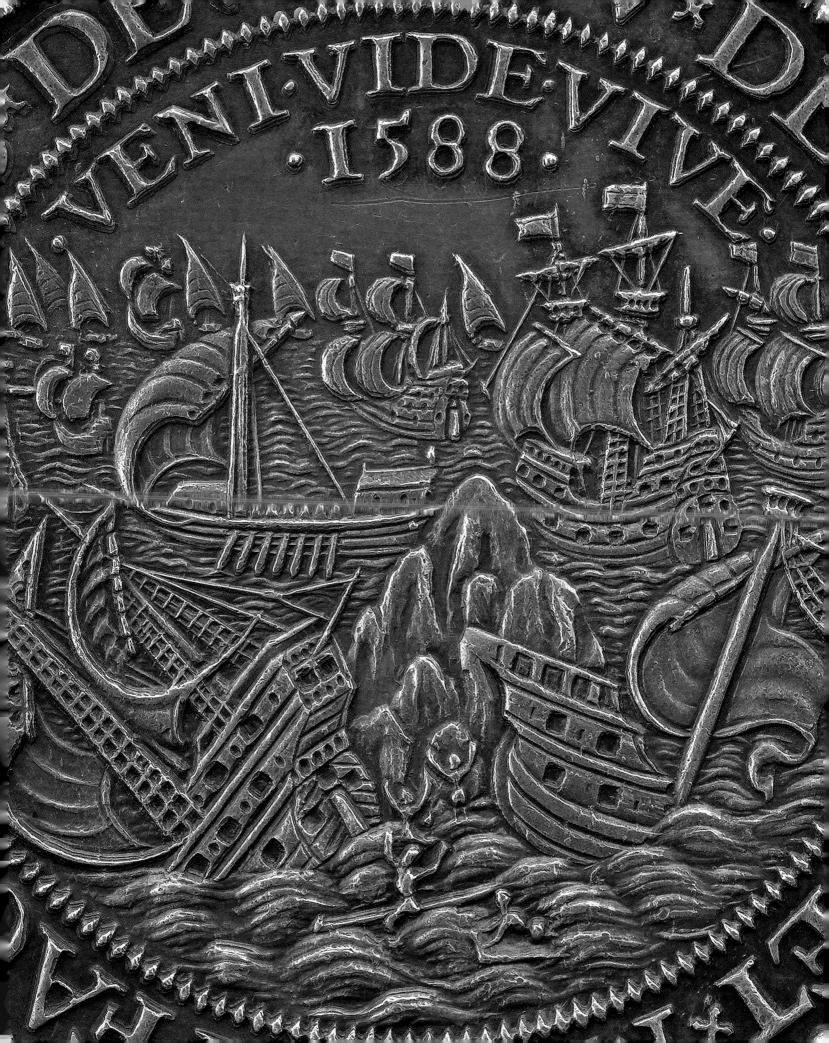

VENI·VIDE·VIVE·
·1588·

1

THE DESTRUCTION OF THE SPANISH ARMADA, 1588

Gerard van Bijlaer (active 1577–1617)

Struck silver, 51 mm

1950,0805.3

Bequeathed by J.H. Hogan

Evelyn 1697, p. 94; Van Loon 1732–7, vol. i, p. 384; Hawkins 1885, vol. i, p. 144, cat. 111; Roovers 1953, p. 22, cat. 22

OBVERSE:
TV. DEVS. MAGNVS. ET. MAGNA. FACIS. TV. SOLVS. DEVS
(You are great, God, and you do great things; you alone are God).
VENI. VIDE. VIVE. 1588 (Come, see, live. 1588).

REVERSE:
DVRVM. EST. CONTRA. STIMVLOS. CALCITRARE (It is hard to kick against the pricks). O. COECAS. HOMINVM. MENTES. O. PECTORA. COECA (Oh, the blind minds of man, oh, the blind hearts)

This is one of the earliest medals to focus on the loser of a battle rather than to celebrate the victor. Whereas English medals responded to the defeat of the Spanish Armada by celebrating the invincibility of Queen Elizabeth, this Dutch medal revels in the defeat and discomfiture of the United Provinces' enemy, Philip II of Spain, and his allies. One side of the medal illustrates the destruction of the fleet in the manner of contemporary prints (below, right). In the foreground two Spanish ships have been driven against rocks, forcing their occupants, with arms outstretched, to abandon ship. The words above parody Julius Caesar's triumphant 'I came, I saw, I conquered', whilst the main inscription (from Psalms 86:10) claims that it was through God that this defeat was inflicted. On the reverse the Catholic powers are shown in conference, including Pope Sixtus V on the left, identified by his triple tiara, and on the right, wearing crowns, Philip II and his cousin, the emperor Rudolph II. All are blindfolded and rest their bare feet on a floor of spikes. The principal legend uses the words Christ directed against Saul (Acts 9:5) to reinforce the medal's point. The other legend laments Catholic 'blindness'. It was in vain, the medal suggests, that these men conspired against a representative of the true religion.

The United Provinces formally deposed Philip as sovereign of the Netherlands in 1581, but the new state's independence remained in the balance until the decisive military victories of the early 1590s. The destruction of the Spanish fleet, celebrated throughout Protestant Europe, was therefore particularly welcomed by the Dutch, who had begun to strike so-called *triumfpenningen* (triumph medals) in the 1580s.[1] These were presented to those who had participated in the various engagements, and could also be used as diplomatic gifts. When in 1592 the Dutch proposed to give an example of the present medal to an ambassador sent by Rudolph II,

it is hardly surprising that the offer was declined.[2] Some *triumfpenningen* feature military commanders, but more usually they carry a plan of the site, a representation of the battle, an allegorical scene or an inscription. A similar disinclination to focus on individual glory is found in the medals of other sixteenth-century republics – such as Venice and the Swiss confederation – but to devote a whole medal to the vanquished, as here, was unusual. For the Dutch medallist, what was important was that the Spanish had been defeated, not that the English had been victorious.

The Defeat of the Spanish Armada, about 1588–90, engraving, 135 x 190 mm.

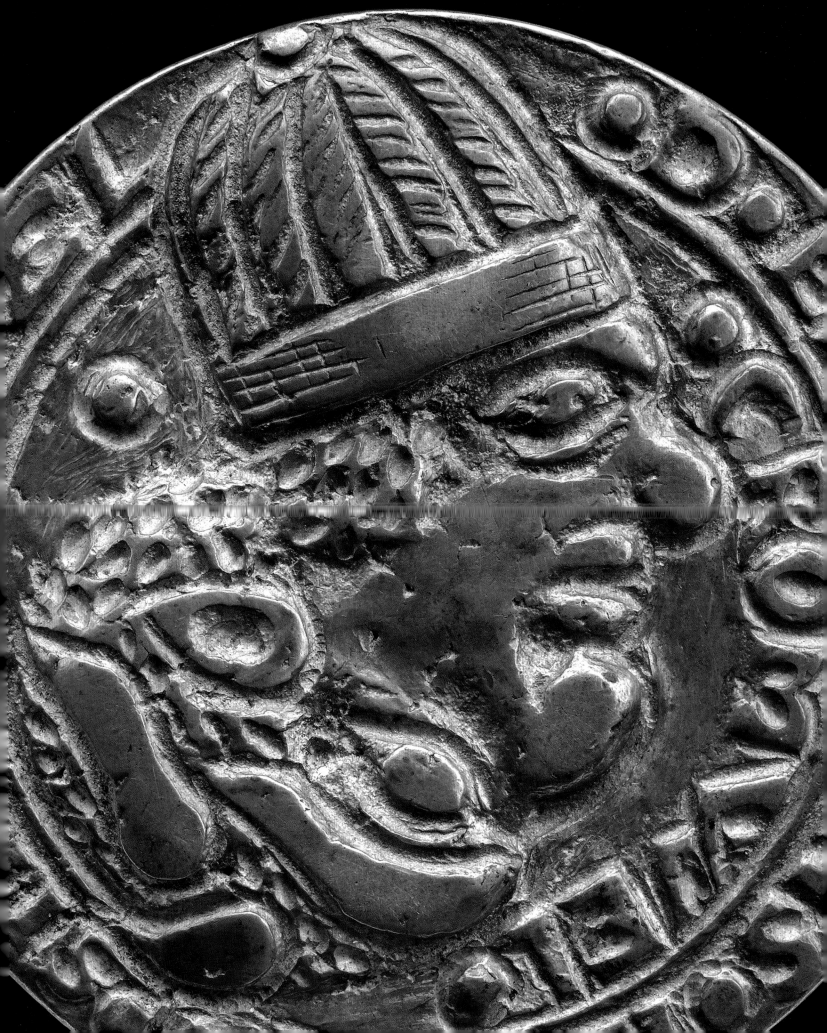

2

THE DEVIL CROMWELL AND THE FOOL FAIRFAX, 1650

Unidentified Dutch artist

Cast silver, 32 mm

1879,0711.1

Presented by Sir Augustus W. Franks

C.Piot, 'Médaille satirique sur Olivier Cromwell et Fairfax', *Revue de la Numismatique Belge*, ii (1846), pp. 407–10; Henry William Henfrey, *Numismata Cromwelliana: or, the medallic history of Oliver Cromwell* (London, 1877), pp. 27–8; Hawkins 1885, vol. i, p. 388, cat. 9

OBVERSE:

D. EEN. MENS. IS. D. A. SIIN. DVIVEL (The one man is the other's devil). CROMWEL (Cromwell).

REVERSE:

D. EEN. SOT. IS. DEN. A. S. GECK (The one sot is the other's fool). FARFAX (Fairfax).

The events of the English Civil War were closely followed in the rest of Europe. This crudely executed medal, made in the Netherlands (where the future Charles II was in exile), lampoons two English parliamentary leaders, suggesting that Oliver Cromwell was devilish and Thomas Fairfax foolish. By turning the medal 180 degrees Cromwell, shown wearing a cap, becomes a horned devil with pointed ears, while on the other side Fairfax is transformed into a fool wearing a cap with bells. In June 1650 Fairfax resigned as commander-in-chief of the parliamentary forces, to be succeeded by Cromwell, and the suggestion is that a gullible Fairfax has been duped by an evil Cromwell into relinquishing his post.

The conjoined heads motif had previously been used mostly to attack popes and cardinals. It first appeared in the wake of the Reformation, in German medals of the 1540s, in which a pope and a horned devil appear on one side and a cardinal and a fool on the other.[3] It was soon adapted to other contexts, with religious reformers and Turkish sultans among those paired with the devil in both medals and prints, but its most common manifestation was as an attack on the Catholic church. Nicholas Murford's poem, 'The Picture', published in 1650, refers to these medals:

> Look one way here, and there a Pope you see,
> And but revers't the Devill a Pope is he...[4]

The format of the present medal therefore not only links the two men with evil and stupidity, but adds to the insult by paralleling them with figures long viewed by Protestants as the Antichrist. The curious form of Cromwell's headgear may be intended to reinforce this idea by suggesting a papal tiara, although it has also been interpreted as an imperial crown, alluding to political ambition.[5]

The devil/pope motif was later used by the English medallist George Bower for the reverse of a medal commemorating the murder in 1678 of the magistrate Sir Edmundbury Godfrey, which was widely believed to have been the outcome of a Roman Catholic plot.[6] It continued into the eighteenth century as a decorative device for such diverse objects as pipe-stoppers and tobacco boxes, and in more modern times has been the inspiration behind a humorous advertisement.[7] By contrast, the humour in the present medal is placed at the service of a serious political message.

3

THE FRENCH PERSECUTION OF PROTESTANTS, about 1686

Unidentified Dutch artist

Struck silver, 58 mm

George III FD 247

Presented by George IV, 1823

Van Loon 1732–7, vol. iii, p. 312; Jones 1982,
p. 121; pl. 31, no. 14

OBVERSE:
SUPRA DEUM POST PERNICIEM (Above God,
then destruction). CONCILIA DECRETA
(Councils. Decrees).

REVERSE:
EX MARTYRIIS PALMAE (From martyrdoms, palms).

This medal condemns Louis XIV's revocation of
the Edict of Nantes, which had given official toleration

to French Protestants (known as Huguenots)
since 1598. Under Louis' Edict of Fontainebleau of 1685,
the Protestants' churches were to be destroyed and their chil-
dren were to be brought up in the Catholic faith. Protestant priests
who would not convert were ordered to leave France immediately.
However, severe punishments, including service on galleys, were
introduced for others who tried to emigrate as Louis did not want
to risk losing a large number of his people. Nevertheless, many
Huguenots succeeded in finding refuge in nearby countries. In
order to prevent their being received by the Waldensian Protestants
in the neighbouring state of Savoy, French troops entered the area
in early 1686. The outnumbered Waldensians soon turned to guer-
rilla tactics against the French and Savoyard forces. Protestants
carrying arms were summarily executed, and within a few weeks
they were defeated and the countryside laid waste. The medal
appears to allude to the horrors of this campaign, whilst also
making a general point about the situation in France.

Underneath an inscription indicating that those who presume
to place themselves above God are heading for destruction are
various representatives of Catholicism – a pope, not only holding
the keys of St Peter but also brandishing a thunderbolt in a manner
usually reserved for a divinity; a French soldier with sword and
leg-irons; and a Jesuit priest, with a dragon's feet and tail, holding
a decree. In the centre of this group is the Catholic host, from
which a seven-headed Beast of the Apocalypse emerges to attack
the unfortunate Protestants below: 'And I stood upon the sand
of the sea, and saw a beast rise up out of the sea, having seven
heads … and upon his heads the name of blasphemy' (Revelation
13:1). The message is that the Catholic church and the Antichrist
are one.

The other side of the medal abandons allegory in favour of
what appears to be brutal reportage. Next to what remains of the
wall of a destroyed Protestant church, adherents of that faith suffer
a variety of unpleasant fates – drawn naked by the feet behind a
sword-wielding horseman, hung by the neck from a gibbet, left to be
devoured by wild animals, and bound and led towards a distant gal-
ley. Seemingly unaware of these atrocities – but, the medal implies,
intimately connected with them – a Catholic procession continues
on its way. The canopy under which the host is carried indicates
that this is the festival of Corpus Christi, which celebrates the
transubstantiation of the actual body of Christ into the host
during Mass, a defining belief that was rejected by Protestants.
The legend indicates that ultimately it will be the martyrs who
will be victorious.

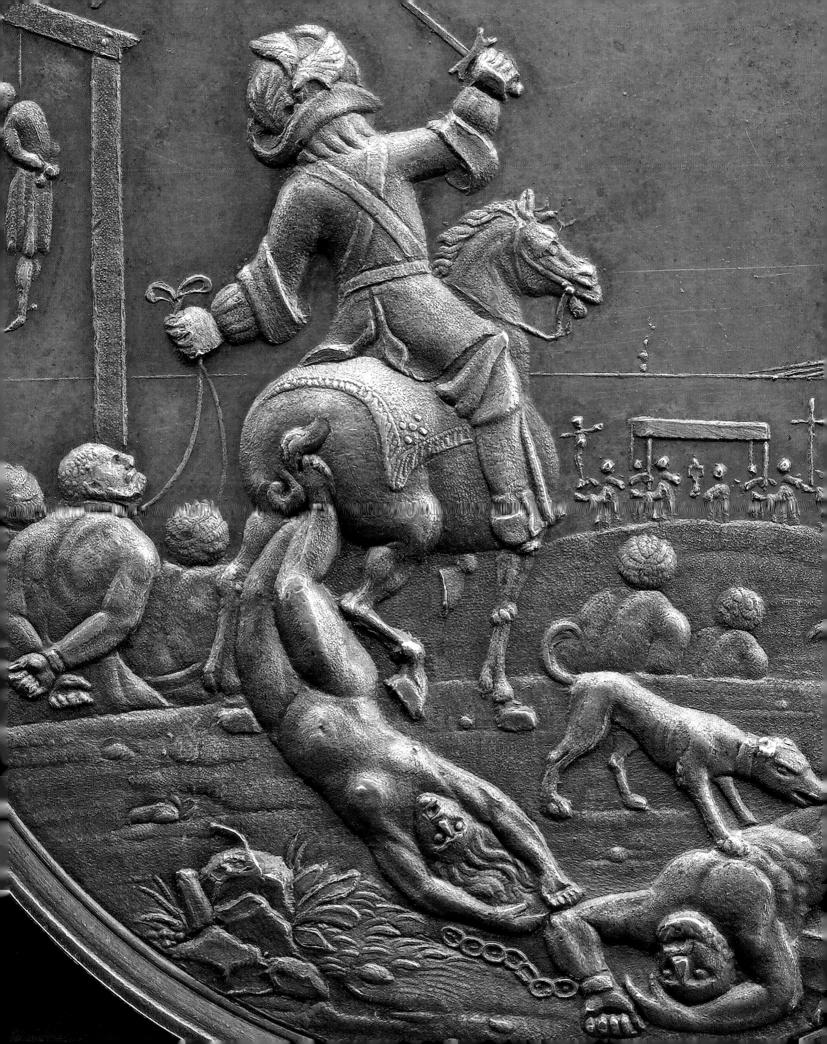

4

THE FLIGHT OF JAMES II, 1689

Jan Smeltzing (1656–93)

Struck silver, 49 mm

George III EM 136

Presented by George IV, 1823

Van Loon 1732–7, vol. iii, p. 370; Hawkins 1885, vol. i, p. 649, cat. 3; Woolf 1988, p. 20, cat. 7:2

OBVERSE:

IACOBUS II BRITAN: REX FUGITIV (James II, king of Britain, fugitive).

REVERSE:

NON ICTV HVMANO, SED FLATV DIVINO (Not by a human blow, but by a divine blast). SPONTE FUGIT IACOB: II ANG: REX L. 20 DEC: CAPTUS 23 D. 1688. ITERUM FUGIT 2 IAN: 1689 (James II, king of England, voluntarily fled from London on 20 ~~December, was captured on 23 December 1688, and fled again on 2~~ January 1689). S.N. (Smeltzing of Nijmegen).

At first sight the front of this medal appears honorific, but closer inspection soon reveals its satirical intent. The legend describes James as king of Britain, but adds the word 'fugitive', and his long hair is contained in a bag in the manner of travellers – this is a king on the run. Having failed in his attempt to flee the country, which ended with his being recognized and returned to London, James left for France with the agreement of his successor William III on 2 January 1689. The lower legend of the reverse condenses these momentous events into a brief, almost farcical narrative, which echoes the new regime's argument that James' initial departure was voluntary and effectively left the throne vacant; William is thereby exonerated from any accusation of aggression. The principal reverse inscription claims that it was also the will of God, a message that is reinforced by the depiction of the former king as a broken column struck by a bolt of lightning emanating from the heavens, where the Almighty is represented in the form of the Hebrew word for Jehovah. It is implied that the religious difference between the Catholic James and the Protestant William is the key factor in their contrasting fates. London, the city that James has lost, forms the background to the column; its various landmarks, including London Bridge, St Paul's cathedral (anachronistically

shown as the old medieval building), the Monument and the Tower are carefully delineated.

It has been plausibly suggested that the following anonymous verse, 'On the departure of King James y^e 2^d 1688', may have been a riposte to this medal:

> The Great Good man whom fortune does displace
> May fall for Want, but never to Disgrace,
> His Sacred Person, none will dare profane,
> He may be poor, but never can be Mean.
> He holds his Value with the Wise & Good,
> And Prostrate, Seems as Great, as when he Stood.
> So ruin'd Temples do an Awe dispense
> They loose their Height, but keep their reverence,
> The Pious Croud the fallen Pile deplore,
> And, what they cannot raise they Still adore.[8]

The Dutch artist Smeltzing went on to combine the present obverse with two new reverses commenting on the continuing misfortunes of the deposed king (figs 4 and 5, p. 18). He also produced medals hostile to William III (see cat. no. 5).

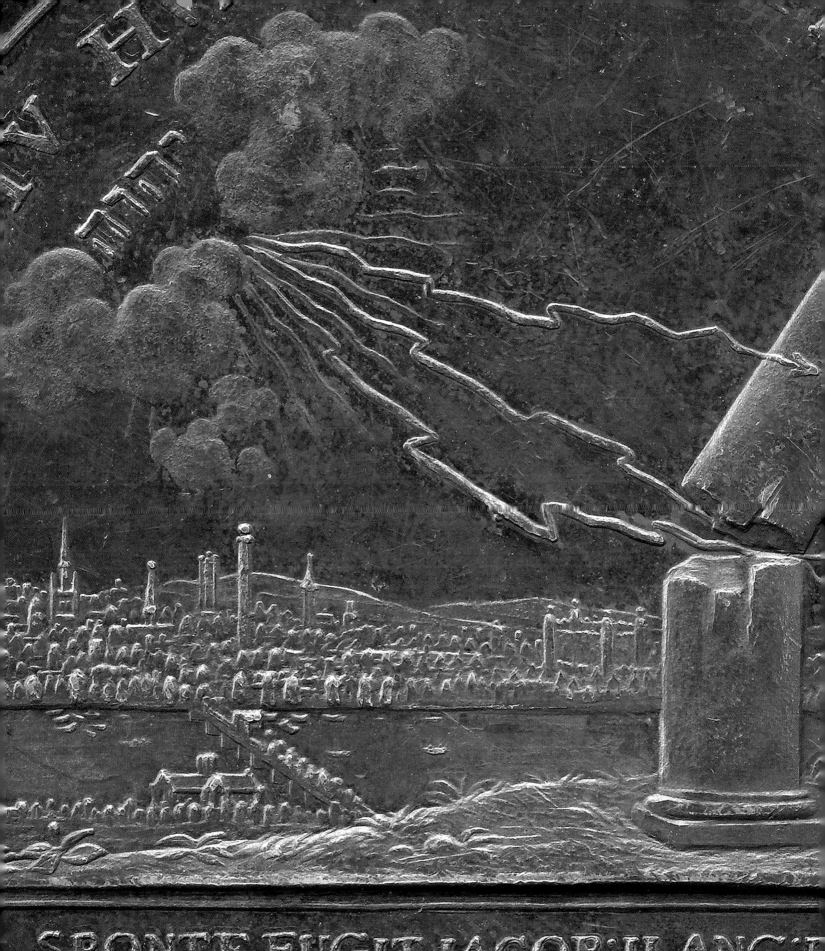

SPONTE FUGIT IACOB:II ANG:
20 DEC: CAPTUS 23 D. 168

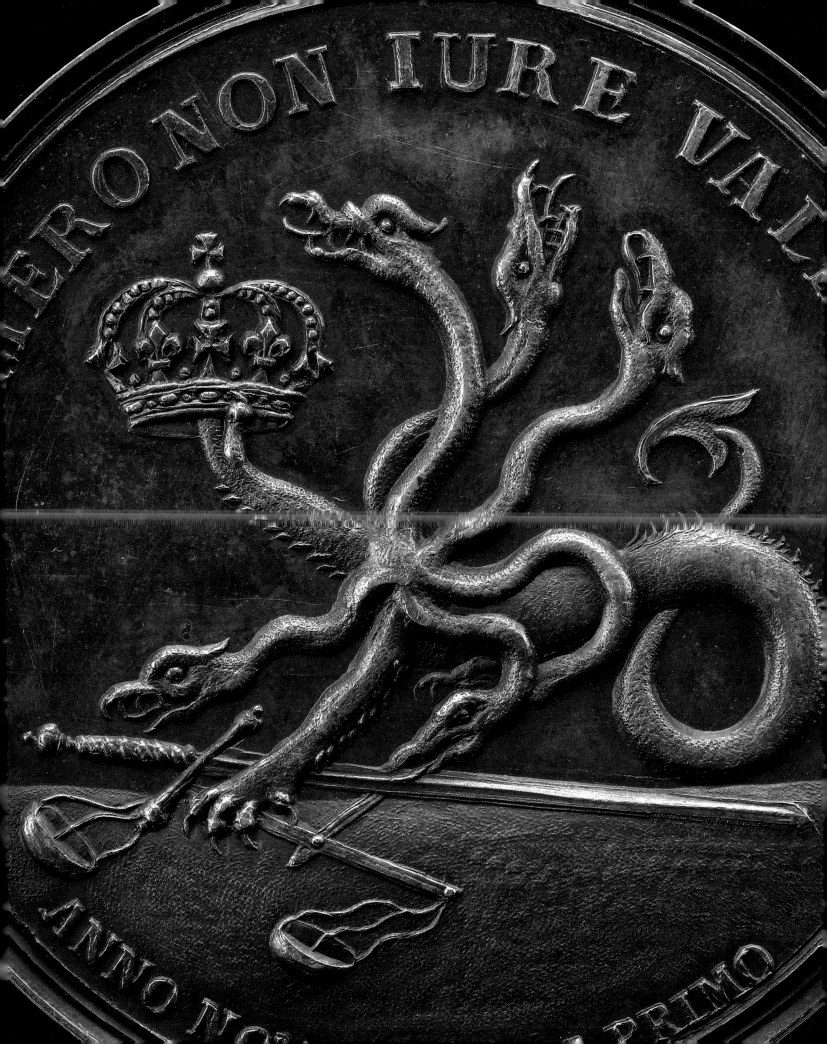

5

THE GOOD FORTUNE OF WILLIAM III, 1689

Jan Smeltzing (1656–93)

Struck silver, 49 mm

M7778

Van Loon 1732–7, vol. iii, p. 402; Hawkins 1885, vol. i, p. 698, cat. 99

OBVERSE:
NUMERO NON IURE VALEBAT (He prevailed by numbers, not by right). ANNO NOVI DOMINI PRIMO (In the first year of the new master).

REVERSE:
ILLE CRUCEM HIC DIADEMA TULIT (That one attained a scaffold, this one a crown). 1684 1689.

In this medal, Smeltzing attacks William III with the claim that his victory over James II of England resulted from the greater strength of his armed forces rather than any moral or legal superiority. Represented as a hydra-like monster, William's supporters grasp the crown while at the same time trampling on symbols of justice. The other side contrasts William's accession to the throne with the failed rebellion of the duke of Monmouth and earl of Argyll of 1685 (the date given by Smeltzing is incorrect). A figure of Fortune, identified by the globe on which she stands, faces in two opposing directions – the face of a boar (a reference to the Argyll arms) holds an axe and looks towards the Tower of London, scene of Monmouth's execution, whilst a human face resembling William holds a crown and looks to the royal palace of Whitehall. At the time Monmouth's defeat had given rise to medals scornful of his attempt, including one in which the duke falls backwards into the sea as he reaches in vain towards three crowns, with the legend 'The Gods derided', and another that uses the decapitated bodies of Monmouth and Argyll to illustrate the inscription, 'Ill-advised ambition falls'.[9] Four years later, however, he is presented here as the unfortunate victim of circumstance.

Smeltzing's primary motivation was commercial, and he addressed different markets by offering a range of views on his medals. At the same time as he was producing medals suggesting that William was doing God's work in invading England (see cat. no. 4), he was also making the present medal, which directly questions William's right to the English crown. William's absence in England led to a growing feeling among the Dutch that he was neglecting their affairs. Another medal by Smeltzing combines the present reverse with a portrait of William, shown with his hair in a bag in the manner in which only a few months earlier he had shown James II.[10] The implication here is that William has deserted his country. This portrait was again used by Smeltzing in medals of 1690, one of which has on its reverse the Dutch lion chained to an orange tree, symbol of William, and of 1693, when William's forces suffered defeat at the battle of Neerwinden. 'It is my fortune to be beaten' is the legend here, and the hand of God, emerging from a cloud and sporting French fleurs-de-lis, is now on the side of William's enemies as the Dutch flee the field.[11]

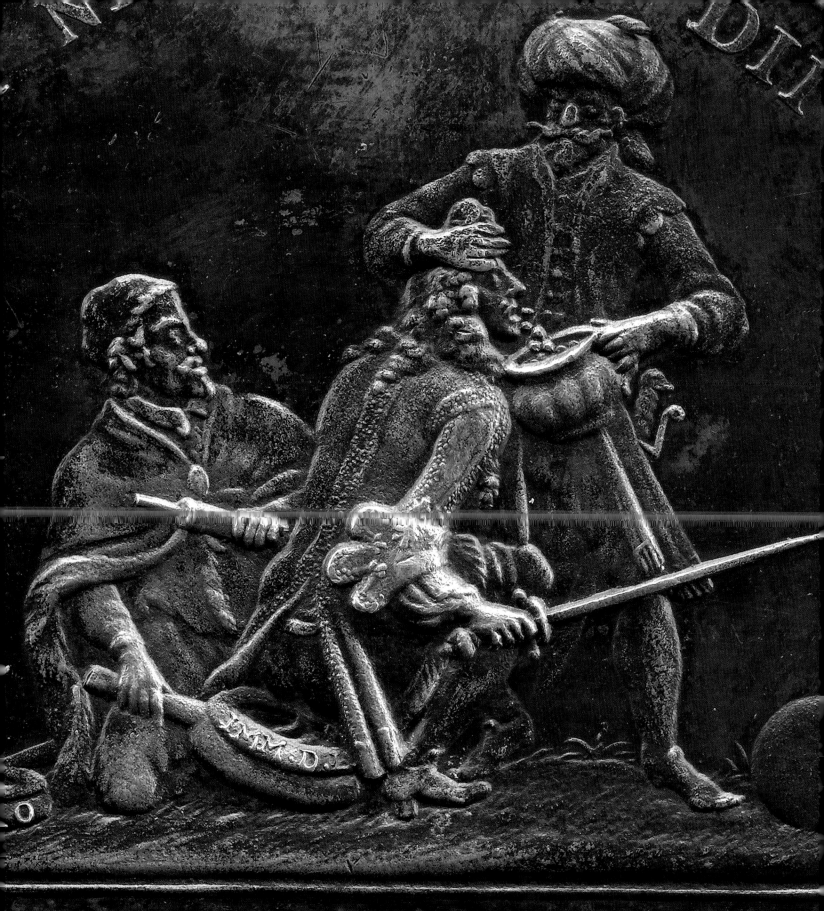

M. XIV DIT. LEGAT. IMMUNI
AVINIONE P. AL. VIII CEDEN

6

THE HUMILIATION OF LOUIS XIV, 1689

Unidentified Dutch artist

Struck silver, 49 mm

George III FD 264

Presented by George IV, 1823

Van Loon 1732–7, vol. iii, p. 428; Jones 1979ᵃ, p. 85,
fig. 209; Jones 1982, p. 125; pl. 32, no. 22; pl. 34, no. 35

OBVERSE:

SE IPSISSIMO (Of its own accord). IMP: GALLIC (The French
empire).

REVERSE:

NECESSITATI NE QUIDEM DII RESISTUNT (Even gods do
not resist necessity). LUD: XIV DIT: LEGAT: IMMUNITA: ET AVINIONE
P. AL: VIII CEDENTE ETIAMQ: AURO PACEM AB ALGER: PETENTE.
1689 (Louis XIV ceding to Pope Alexander VIII the immunity of his
ambassadors' powers and Avignon and seeking peace from the Algerians
with gold, 1689). IMM.D.L. (Immunity of his ambassadors' powers).
AVENIO (Avignon).

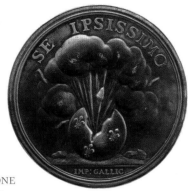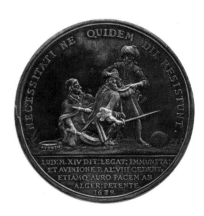

Using allegory on one side and ridicule on the other, this medal
attacks France and its king. The explosion of the French world
(identified by the fleurs-de-lis) is mirrored by the humiliating
image of Louis XIV ejecting the contents of his stomach and bowels.

In 1688 French troops had attacked the German Palatinate in
a devastating campaign, which included mortar attacks that gutted
Koblenz and the deliberate destruction by fire of many other towns
and villages. Louis had previously used bombardments on Algiers
and Genoa and, as the medal indicates, the French had come to be
particularly associated with this new way of prosecuting a war, in
which civilians were as likely to be victims as soldiers. The
implication of the medal is that France had now over-stretched itself
but, although Louis had not anticipated a long war when he
embarked upon his German campaign, his country was hardly in
the process of self-destructing in the way suggested here. It was,
however, necessary to yield in certain areas – Louis made conces-
sions to the dey of Algiers in return for a guarantee of freedom from
attack for the French coast, and also with Pope Alexander VIII con-
cerning the rights of his ambassadors and the status of the papal
city of Avignon (which had been occupied by French troops in
1688). The medal shows the dey holding a pot in which to catch the
money vomited by Louis, while a bomb by his feet is a reminder of
France's very different policy towards Algiers of a few years earlier.
Meanwhile the pope holds in one hand the enema he has just
administered and in the other a pan in which to catch the desired
result. This pan and its companion are labelled with the two con-
cessions forced out of the king.

The present medal was among the satirical medals included at
the end of a pirated Dutch edition of 1691 of Claude Menestrier's
celebratory *Histoire du roy Louis le Grand*, which had been published
in Paris two years earlier (below). The anonymous author wrote:

'THE FIVE PLATES OF
MEDALS That follow are
no less curious for THE
HISTORY OF LOUIS
THE GREAT than the
preceding ones: but
Father Menestrier had
his reasons for not
having them included
in this work.'[12]

A plate from a pirated
Dutch edition of Claude
Menestrier's *Histoire du roy
Louis le Grand*, 1691,
216 x 138 mm.

7

DISCONTENT WITH THE PEACE OF UTRECHT, 1713

Christian Wermuth (1661–1739)

Struck lead, 44 mm

M8144

Hawkins 1885, vol. ii, p. 409, cat. 273; Wohlfahrt 1992, p. 328, cat. 14 010

OBVERSE:

CONCORDIA RES PARVAE CRESCVNT (Through concord small things increase). I AM PLEASE. SI VOUS PLAIT (If you please). IK MAEK MEE (I do it also). NOOT BREEKT ISEN PAX OU TREC. 1713 (Necessity breaks iron. Peace or excrement [or Peace of Utrecht]. 1713).

REVERSE:

DISCORDIA MAXIMA DILABVNTVR (Through discord the greatest things will fall apart). FIE, WHAT IS THAT! SANS REGARD (Without regard). WAT! BEHAEGT U DAT? (What! Does that please you?). DAT SOL IE HIR BEWISN. PAX IN TREC. 1714 (That I will prove here. Peace in excrement 1714).

 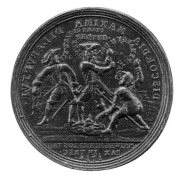

Whilst wars have often given rise to medals attacking the opposing side, a peace perceived as unfair may also result in medals disparaging those involved.

After more than ten years of war between Louis XIV's France on one hand and Britain, the Netherlands and the Habsburg empire on the other, the opening of a peace conference in Utrecht in January 1712 was greeted by Dutch medals satirizing the king who had prosecuted so many wars. One of these, addressed 'To Louis XIV, the vanquished and the acceptor of peace', portrayed him on the reverse as a naked figure of Discord heading for the city with a palm branch and a lighted torch, with the ironic legend, 'He labours to pacify the world' (below, right).[13] Medals made around this time by the German artist Christian Wermuth also voiced concern as to the chances of an equitable peace.[14]

After over a year of talking, in April 1713 the Treaty of Utrecht ended hostilities between France and most of her enemies, including Britain and the Netherlands, and Dutch medallists now joined their British and French counterparts in celebrating the treaty through medals replete with olive and palm branches, figures of Peace, and ploughshares forged from arms.[15] The Habsburg emperor, however, was not a signatory, and French and imperial forces continued to fight each other in the German Rhineland. The German medallic reaction was accordingly very different. In the present medal an angry Wermuth uses scatological imagery to suggest that the former enemies have colluded to produce a treaty that is unsustainable and that they will all resume hostilities before the following year is out. On the side bearing the date 1713, an Englishman, a Frenchman and a Dutchman defecate amicably together, but on the other side, labelled 1714, the three are hurling

at each other the excrement they have produced. The pun on the word Utrecht underscores the theme, whilst the mirror writing is perhaps intended to suggest the perverse nature of the treaty – or of the medal. Other medals by Wermuth expressed a similar scepticism, with one scornfully demanding, 'What news? Is there peace? Are they tired of war? Who has brought it up for discussion, that so feeble and unfortunate a treaty has been concluded?', while also quoting Christ's prophecy, 'All these are the beginning of sorrows' (Matthew 24:8).[16] By contrast, when the French and Austrians made peace eleven months later, Wermuth associated the two powers with the heroic biblical friends David and Jonathan.[17]

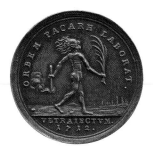

Unidentified Dutch artist:
Louis XIV Approaching Utrecht
(reverse), 1712, struck silver, 35 mm.

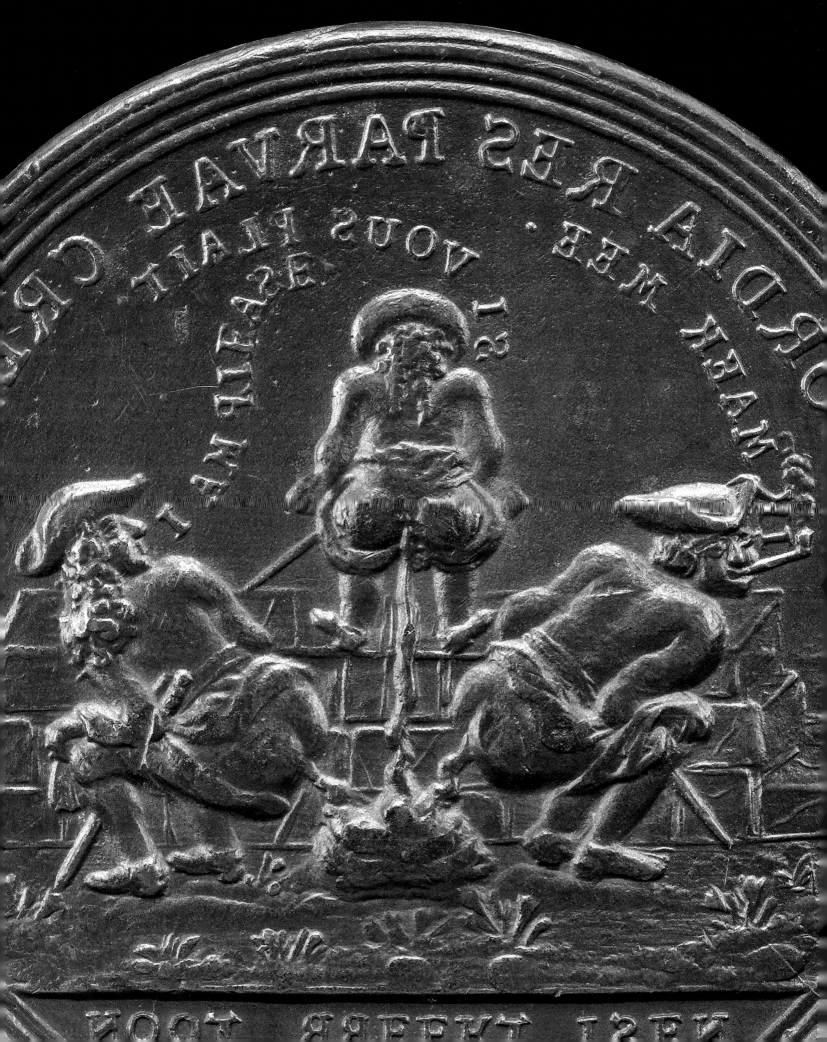

8

FINANCIAL SPECULATION, 1720

Unidentified German artist

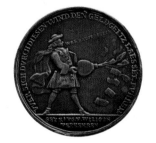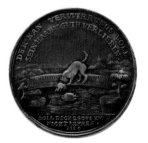

Struck pewter, 34 mm

1905,1206.9

Hawkins 1885, vol. ii, p. 451, cat. 58; Adams 2005, p. 41, cat. 18

OBVERSE:

WER SICH DVRCH DIESEN WIND DEN GELDGEITZ LAESSET
FVHREN (Who in the desire for money will allow himself to be led by
this wind?). WER KAVFT ACTIEN (Who will buy shares?). SEY KLVG. V.
WIZIG IN VERKEHREN (Be prudent and cautious in commerce).

REVERSE:

DER KAN VERWIRRVNGS VOLL SEIN HAAB. V. GVTH VERLIEREN
(He who gets confused may lose his goods and possessions).
SOLL DICH ESOPI HVND NICHT LEHREN. 1720 (Will you not learn
from Aesop's dog? 1720).

The financial scandals that beset western Europe in 1720 provided ready material for medallists in Germany, where there existed a longstanding tradition of moralizing medals. The frenzied speculation in the Compagnie des Indes, popularly known as the Mississippi Company, and its subsequent collapse were particular targets, for the company's shares had been bought avidly in Germany and other European countries as well as in France. The present medal shows shares being created out of the air by a figure who is very probably to be identified as John Law, the Scottish economic theorist who had set up the French company. The use of wind imagery to suggest the dangerous insubstantiality of speculative ventures was common in satirical prints of the time.[18] The reverse refers to Aesop's fable, in which a dog, catching sight of its reflection in a river, loses hold of its piece of meat in its attempt to grab one that seems to be larger.[19] The subjects of the medal are the iniquity of financiers such as Law and the greed of those who bought the shares as the price was rising.

Although Christian Wermuth has been suggested as the author of this medal, it does not appear to be in his style. However, many other medals of this period, condemning Law and the French as well as human greed and gullibility, are certainly his work. Some show the Scotsman defecating money that then flies away, with the legend, 'Better in the wide world than in the narrow womb or coffin' (right),[20] whilst in another, entitled 'The riches of France', a windmill's sails suck in coins and jewellery and blow out notes and shares.[21] Others by the same artist indulge in blatant xenophobia: FURIAE GALLIARUM NATURA (Madness is natural to the French) declares one,[22] and another looks back over thirty years to call Law the new Mélac, a reference to the French commander who had led Louis XIV's forces in the torching of towns and villages in the

devastating German Palatinate campaign of 1688–9: 'Mélac revived, marching, without fire or wood, upon the purses of Europe, emptying them and totally cleaning them out'.[23] Another medal quotes from Sebastian Brant's popular allegorical poem *The Ship of Fools* of 1494, which satirized contemporary folly: 'Because the world wishes to be deceived'.[24] A medal by another German artist shows one of the results of the madness – two suicides, one of whom has thrown himself into a river whilst another hangs from a tree.[25]

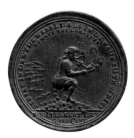

Christian Wermuth:
John Law (obverse), 1720,
struck pewter, 32 mm.

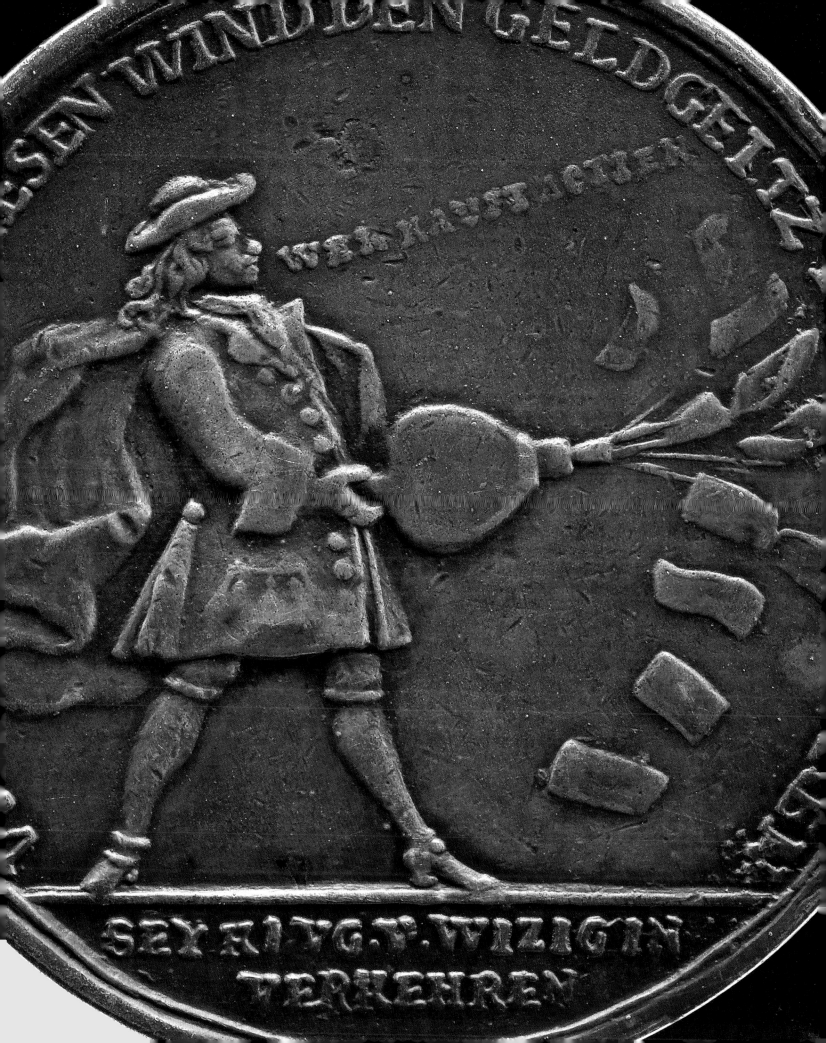

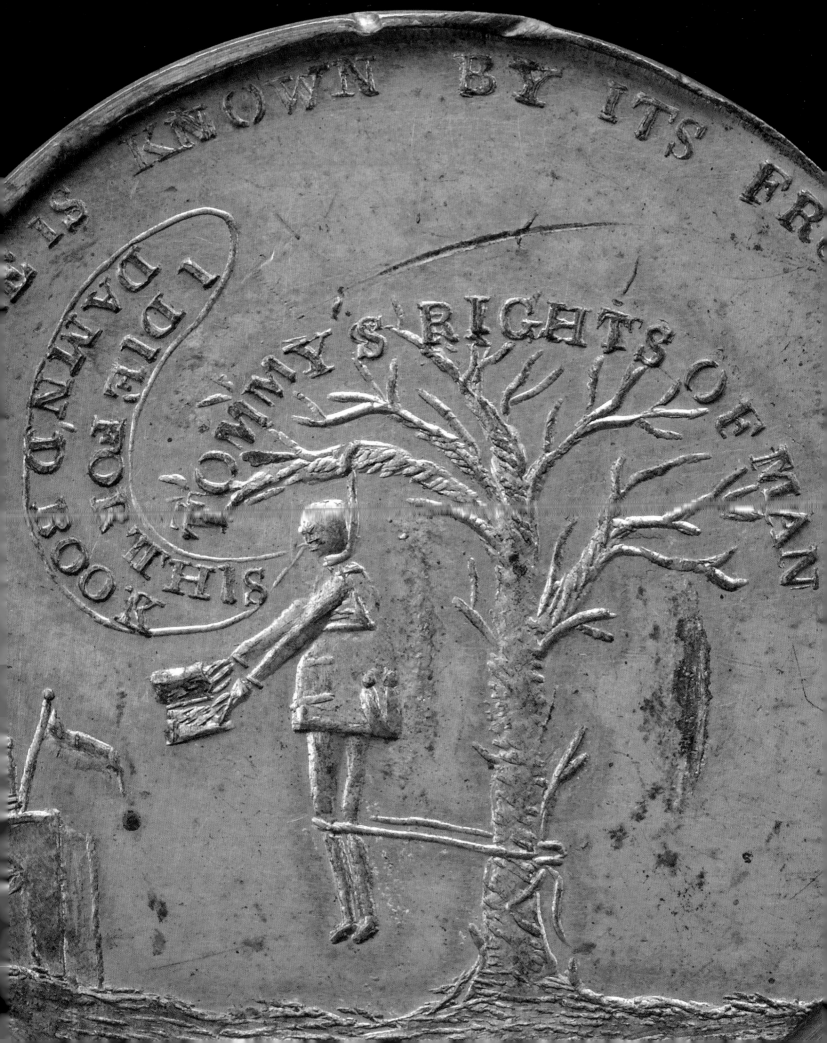

9

A TREE IS KNOWN BY ITS FRUIT, about 1792

Unidentified British artist

Struck pewter, 31 mm

M5000

Brown 1980, p. 85, cat. 366; Bindman 1989, p. 110, cat. 54b

OBVERSE:
A TREE IS KNOWN BY ITS FRUIT. TOMMY'S RIGHTS OF MAN.
I DIE FOR THIS DAMN'D BOOK.

REVERSE:
MAY THE TREE OF LIBERTY EXIST TO BEAR TOMMY'S LAST
FRIEND.

British medallists produced a large number of works, both sympathetic and hostile, in response to the French Revolution. The opponents of the Revolution were particularly vituperative in their attacks on its British supporters, such as Joseph Priestley (fig. 13, p. 23) and Thomas Paine. *Rights of Man* (1791–2), in which Paine defended the French Revolution and advocated the establishment of a democratic republic in Britain, caused the author to be indicted for seditious libel. His trial was to take place on 18 December 1792, but by then he had left for France, where he became a deputy in the National Convention. He died in the United States in 1809, aged seventy-two. The present medal, which shows Paine hanging from a tree, therefore expresses an earnest wish rather than a commemoration. The distant church and flag allude to the piety and patriotism that, it is implied, he so lacked, while in his hands he holds a copy of *Rights of Man*, the cause of his 'downfall'. The reference to the tree of liberty evokes also the American Revolution, which Paine had advocated in his 1776 pamphlet, *Common Sense*. The unsophisticated composition, uneven placing of the letters and crude engraving and striking of the medal combine to suggest that it was of provincial manufacture. The speech bubble shows the influence of contemporary cartoons.

The exasperation felt by many at Paine's escape showed itself in various forms. His effigy was hung in various west-country towns to mark the trial that did not happen. A printed broadside of late 1792 from Taunton, Somerset, has him hanging from a gibbet, below which is an account of his life and the death of which his opponents had been robbed.[26] According to this text, Paine 'was executed on a Gibbet thirty Feet high, on the Parade in the Town of TAUNTON, in the County of Somerset, for High Treason, the 18th of December, 1792, and afterwards publicly Burnt'. At this point the 'many

thousands of spectators' exclaimed, 'May every Traitor to his King and Country thus perish'. The obverse of a medallic token shows Paine hanging from a gibbet very similar to that of the broadside, accompanied by the punning inscription END OF PAIN, one of the reverses associated with this obverse has a book inscribed THE WRONGS OF MAN.[27] He is also depicted as a hanged man on the cover of a printed leaflet of 1793, entitled *The End of Pain. The last speech, dying words, and confession of T.P*, where the words beside him read RIGHTS OF THIS MAN and the devil looks on in dismay (below).[28]

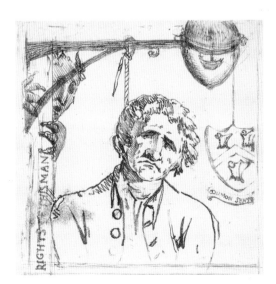

The End of Pain, 1793, etching, 157 x 157 mm.

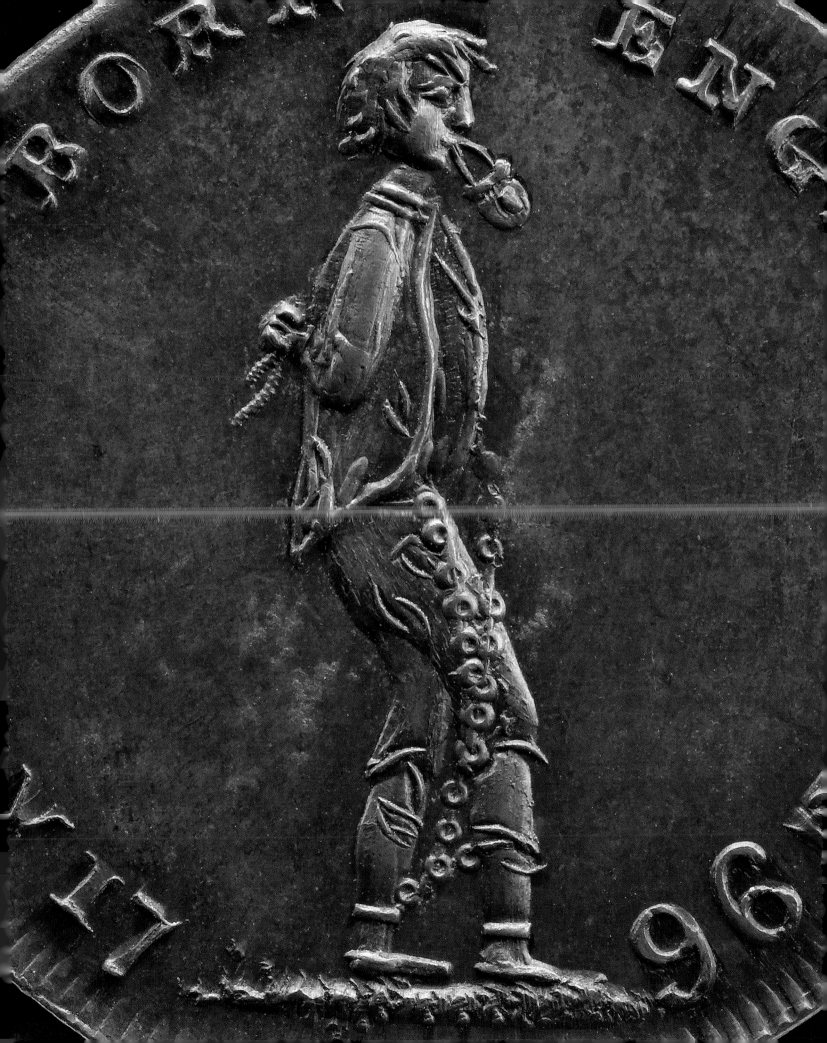

10

BRITISH LIBERTIES UNDER ATTACK, 1796

Charles James (active 1788–1801)

Struck copper, 30 mm

T6498

Dalton and Hamer 1910–17, vol. ii, p. 169, cat. 730; Bell 1987, pp. 225, 232; Bindman 1989, p. 202, cat. 206k

OBVERSE:

A FREE-BORN ENGLISHMAN. 1796.

REVERSE:

BRITISH. LIBERTY. DISPLAYED. 1795.

EDGE:

SPENCE. DEALER. IN. COINS. LONDON.

The subject of this piece is the erosion of British freedoms. On one side, the 'free born Englishman' has a padlock over his mouth, leg-irons attached by a chain to his waist and neck, and his arms tied behind his back. On the other side, 'British liberty' is shown to include the possibility of being forcibly press-ganged into the navy. The different dates reveal that the two sides were made at different times, but were combined together by the issuer, Thomas Spence, to make a 'new' piece. Production of private tokens had begun in the late 1780s as a result of the scarcity of small change, but Spence's tokens were aimed at the collectors' market that had developed around these issues and hence were wholly medallic in their function. Sold from his shop in Holborn, London, they acted as convenient vehicles for the dissemination of his radical political views.[29]

The figure with padlocked mouth is Spence and James' response to the Treasonable Practices and Seditious Meetings Acts, known as the 'Gagging Acts', which became law in December 1795. Passed by a government anxious about the spread of radical ideas into Britain from revolutionary France, these new laws extended treason to include speaking and writing and restricted public meetings. The imagery used here by Charles James also appears in contemporary prints including one, seemingly by T. French, ironically captioned, 'A freeborn Englishman, the admiration of the world, the envy of surrounding nations, &c &c' (right).[30] It was to be revived by George Cruikshank in 1819 in response to further restrictive Acts introduced after the Peterloo massacre (cat. no. 13), with the ground around the figure now littered with Magna Carta, the Bill of Rights and a cap of Liberty.[31] The padlock appeared as the principal motif in another of James' and Spence's tokens protesting against the 1795 Acts, accompanied on this occasion by the sole word MUM and the date 1796.

Other tokens issued by Spence suggested that things were much better in France. The British lion cowers with its tail between its legs while the French cock crows (LET TYRANTS TREMBLE AT THE CROW OF LIBERTY). A man sits in chains in prison (BEFORE THE REVOLUTION), whilst on the reverse others eat and dance (AFTER THE REVOLUTION). On another the dance is around a maypole, on which is impaled the head of the British prime minister William Pitt (TREE OF LIBERTY). A piece showing a pig trampling on a royal crown and a bishop's mitre refers to Spence's periodical, *Pig's Meat; or, Lessons for the Swinish Multitude*, begun in 1793. Just as Thomas Paine's *Rights of Man* was a response to Edmund Burke's attack on the French Revolution in *Reflections on the Revolution in France*, published in 1790, so Spence's publication took its title from Burke's forecast that learning would be lost 'under the hoofs of a swinish multitude'.

T. French: *A Freeborn Englishman*, about 1795, etching, 159 x 110 mm.

THE UNCHARITABLE MONOPOLIZER, 1800

John Gregory Hancock (active 1775–1821)

Struck pewter, 36 mm

1906,1103.469

Presented by Dr Frederick Parkes Weber

Dalton and Hamer 1910–17, vol. ii, p. 120, cat. 239; Klingender 1944, p. 68, pl. 111; Brown 1980, p. 122, cat. 497; D.W. Dykes, 'The uncharitable monopolizer', *Numismatic Circular*, cxiii (2005), pp. 309–12

OBVERSE:
THE UNCHARITABLE MONOPOLIZER WILL. STARVE. THE. POOR. MORE WAREHOUSE ROOM. WHEAT IS BUT 22 SHILLINGS A BUSHEL. POSSESSION. TAKE. NOT. WHAT. WAS. MADE. FOR. ALL. 1800. IN DISTRESS.

REVERSE:
THE CHARITABLE HAND. WELL DONE. COME. ALL. YE. DIS-
TRESSED.

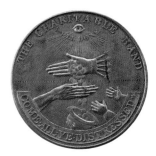

The engraver John Gregory Hancock worked in Birmingham, where this medal was struck, probably by Peter Kempson (a local manufacturer of buttons, tokens and medals). It was almost certainly issued locally for, although it refers to a national situation, events in the expanding industrial city of Birmingham gave its message a particular immediacy.

The years 1799 and 1800 both saw poor harvests, with the consequence that the price of wheat rose to unprecedented levels, almost doubling in 1799 and rising even further in 1800. It was widely believed that certain farmers and other food suppliers were seeking to profit from the situation by hoarding food stocks in order further to raise prices. Birmingham, where the price was particularly high, saw food riots in 1800, leading the local magistrates to order the lowering of food prices and offer rewards for information about anyone buying up food stocks for later resale. Elsewhere suspected monopolizers were prosecuted.[32] The medal supports these efforts by castigating those who would hold onto food supplies while others went hungry. A label that accompanied it when it was placed on sale described the obverse as, 'An insatiable MONOPOLIZER endeavouring to swallow the Globe, with a Demon in his Brain, prompting him to engross what Providence has so liberally given'.[33]

The horned demon is shown embracing a sheaf of wheat in the name of POSSESSION, while the outline of the British Isles makes it clear which part of the globe is in question. Prices rose again in the autumn of 1800, leading to further rioting around the country, including Birmingham, and the situation remained uneasy until the autumn of 1801.

The present medal is unusual among those catalogued here in using the reverse to indicate the honourable alternative to the iniquitous behaviour referred to on the obverse. The label accompanying the medal explained: 'The benevolent Hand, supplying the Wants of the Poor, whilst the Monopolizer oppresses them.' This 'charitable hand' pours money in the direction of an emaciated hand, a hat and a child's outstretched hands and, in doing so, is observed by the all-seeing eye of God, who congratulates it on its magnanimity: WELL DONE. Although the use of obverse and reverse is but one way in which such contrasts may be suggested (see p. 12), it is a highly effective device and is often used – as, for example, in a medal of 1919 by the German artist Karl Goetz, where a ration queue and a fat farmer tucking into a large meal in his cosy parlour exemplify STADT UND LAND (Town and country).[34] Nicola Moss's *Wasichu* of 1991 uses the motif of an all-consuming head to very different ends (fig. 21, p. 30).[35]

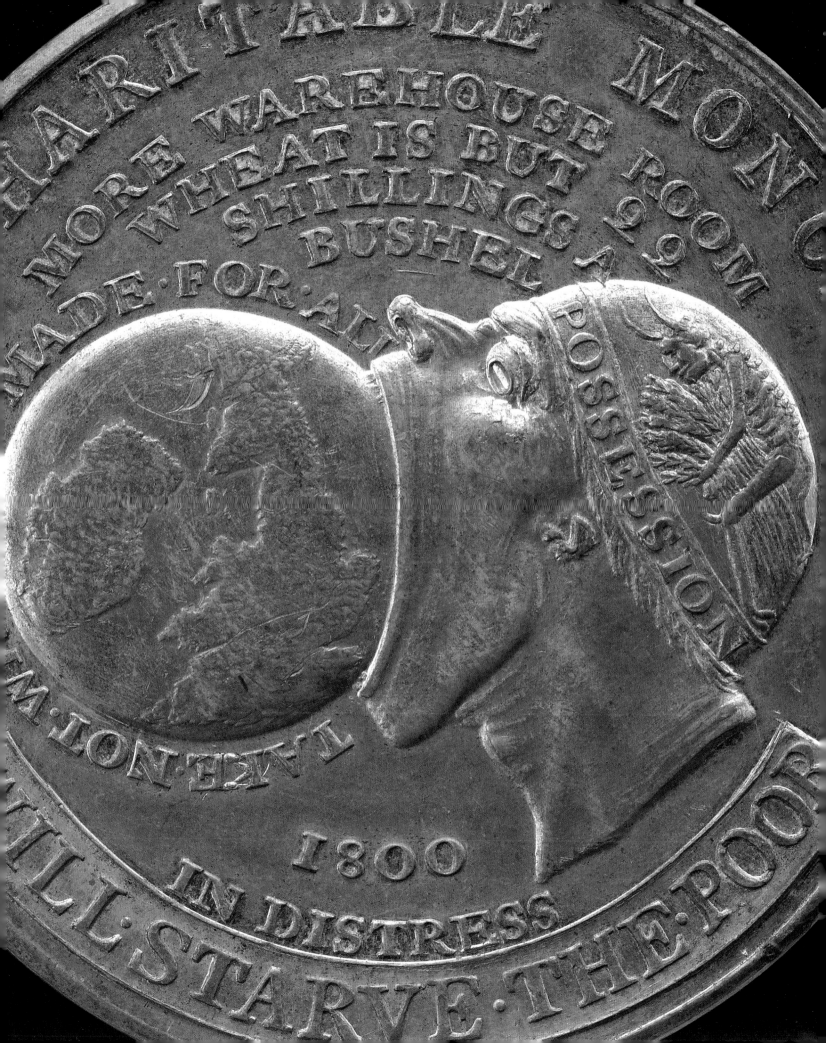

12

THE COVENT GARDEN THEATRE OLD PRICE RIOTS, 1809

Unidentified British artist

Struck pewter, 42 mm

M5324

Davis and Waters 1922, p. 17, cat. 184; Brown 1980, p. 166, cat. 675

OBVERSE:
OP. GOD SAVE THE KING. MAY OUR RIGHTS & PRIVILEG REMAIN UNCHANGED.

REVERSE:
FROM N, TO O, JACK YOU MUST GO. OLD PRICE'S. OPEN BOXES. JOHN BULL'S ADVICE TO YOU IS, GO: 'TIS BUT A STEP FROM N, TO – O.

The issuer of this medal makes it very clear that he is no revolutionary republican in the French mode but a loyal subject of the king. The lyre and trumpet indicate the area of concern, which arose with the reopening of London's Covent Garden Theatre on 18 September 1809 after a disastrous fire. The higher admission prices and the smaller public gallery, necessitated by the new building's larger number of private boxes, provoked riots, which continued at the theatre on a nightly basis for two months and soon took on a political dimension, in which individual liberty was set against privileges for the few. Popular songs, prints and medals contributed to a campaign waged against a management anxious to maximize its revenues, with the theatre's manager, the actor John Kemble, the principal target of abuse and ridicule:

> Your displeasure and groans he regards as mere trash,
> And he spits in your face while he pockets your cash.[36]

The protestors made great use of acronyms. While the present medal restricts itself to the OP monogram for 'Old prices' and the letters N for 'New' and O for 'Old', another also had OB, DPO and VP, for 'Open boxes', 'Deference to public opinion' and 'Vox populi' (The voice of the people).[37] They also evoked John Bull, a symbol of the British people from the early eighteenth century, who was juxtaposed with Kemble as 'King John' – the illustration to a broadside ballad entitled 'King John and John Bull' has Magna Carta and the Bill of Rights in tatters on the floor (right).[38] On the present medal Bull is shown astride Kemble, depicted as an ass, whose stance indicates that he is altogether averse to moving in the desired direction. The form of his nose is intended to suggest Jewishness and therefore avarice. In the medal with the many acronyms mentioned above, Kemble is similarly associated with both the stubbornness and stupidity of an ass, and the meanness of Shakespeare's Shylock by being shown with an ass's ears and

the words, THIS IS THE JEW, WHICH SHAKESPEARE DREW. The identification of the protestors with John Bull recurs in the verse:

> Do you think we'll submit, says John Bull, no never,
> Not while we are supported by Clifford, for ever;
> We fear not your Boxers, nor your Bow Street rats,
> Who arrest people who wear O.P. in their hats.[39]

The many protestors who appeared at Bow Street magistrates' court included one of their leaders, Henry Clifford, who was charged with incitement to riot and displaying the O.P. symbol. The piercing indicates that the present medal was intended to be worn. In mid December 1809 the old prices were restored.

Isaac Cruikshank: *King John and John Bull*, 1809, hand-coloured etching, 187 x 256 mm.

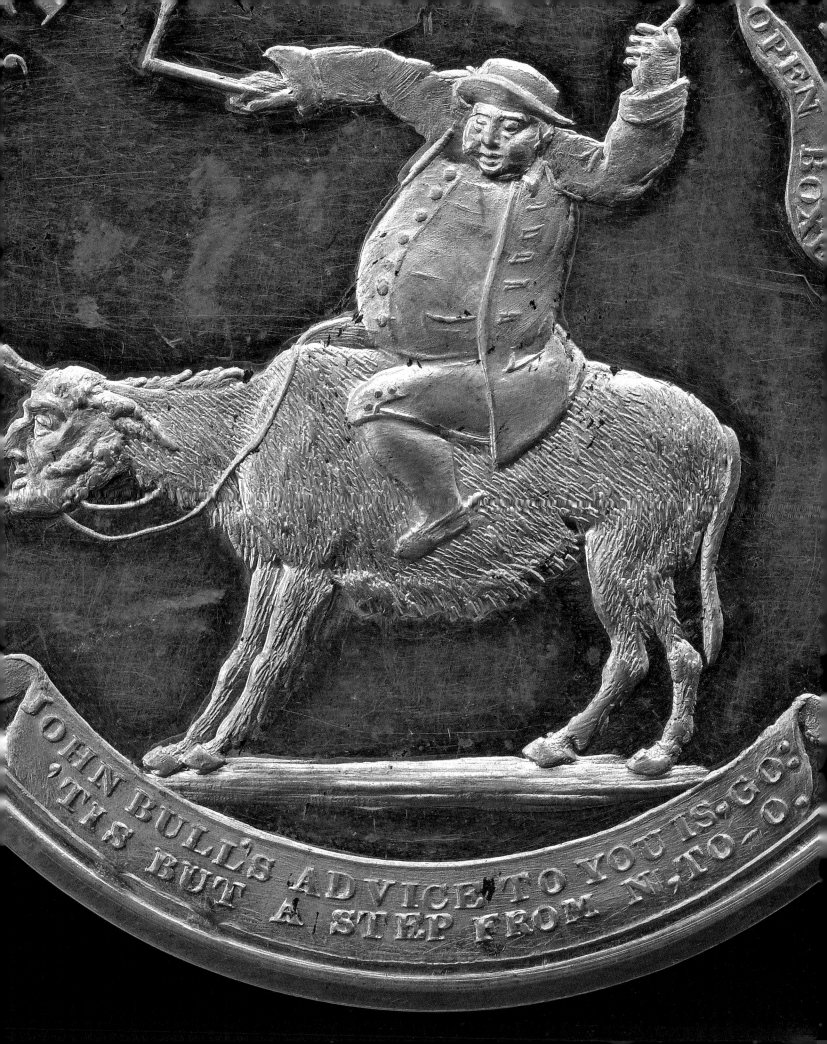

JOHN BULL'S ADVICE TO YOU IS-GO: 'TIS BUT A STEP FROM N-TO-O.

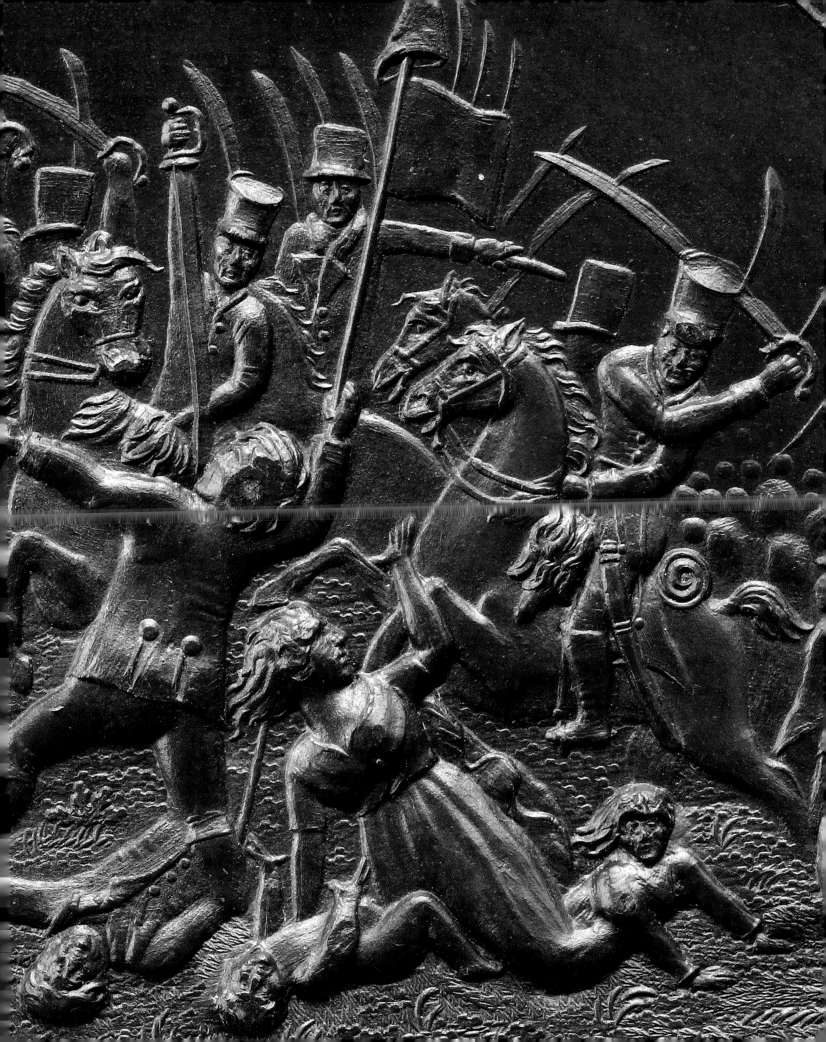

13

THE PETERLOO MASSACRE, 1819

Unidentified British artist

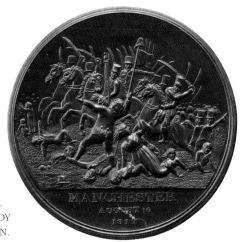

Struck pewter, 62 mm

M5625

Brown 1980, p. 240, cat. 989

OBVERSE:

MANCHESTER AUGUST 16 1819.

REVERSE:

THE WICKED HAVE DRAWN OUT THE SWORD.
THEY HAVE CUT DOWN THE POOR AND NEEDY
AND SUCH AS BE OF UPRIGHT CONVERSATION.
PSALM XXXVII XIV.

This medal commemorates the peaceful gathering of some sixty thousand people at St Peter's Fields on the edge of Manchester, held to demand economic reform and the vote for adult males, which was broken up by the local yeomanry after magistrates had failed to persuade the crowd to disperse. Eleven people were killed, including two women, and four hundred were injured in what, in a reference to the battle of Waterloo of four years earlier, soon came to be known as the Peterloo massacre. The medal shows the mounted yeomanry attacking the unarmed crowd – one is about to drive his sabre into the neck of a man holding a cap of Liberty, while beside him a woman tries to protect her children and other figures lie motionless or attempt to crawl out of the soldiers' path on all fours. The psalm of David, from which the inscription is taken, forecasts the ultimate destruction of those who commit acts of evil, despite the temporary prosperity their acts may bring them. In the meantime, the psalmist writes, 'A little that a righteous man hath is better than the riches of many wicked' (Psalms 37:16).

In its graphic representation, the medal is similar to the many prints commemorating the event,[40] with the horror of the scene left to speak for itself without recourse to explanatory inscriptions or (apart from the cap of Liberty) symbols. Similar crouching women, one arm raised in anguished protest and with a baby in the other, also appear in the prints.[41] The medallist has contrasted the armed yeomanry and their defenceless victims through the emphasis placed on the bristling sabres, the division of the scene into those above (the yeomen) and those below (the civilians), and the prominence given to the woman and children.

The caricaturist George Cruikshank made his own proposal for a Peterloo medal in William Hone's satirical newspaper, *A Slap at Slop* (below).[42] The savagery is emphasized by the use of skull and crossbones as a decorative border and the image of a soldier wielding a cleaver and a figure lying dead. The protesting civilian on his knees recalls the anti-slavery movement's emblem of a kneeling slave in chains with the words, AM I NOT A MAN AND A BROTHER,[43] a connection underlined by the text surrounding the cartoon, which gives the same slogan along with a newly devised response: 'No! – you are a poor weaver'. The medals were to be made by melting down the Manchester yeomanry's trumpet and, the newspaper reported sarcastically, were to be 'distributed among the warriors who distinguished themselves on the occasion, and to be worn by each as A PETERLOO MEDAL'. This is a direct reference to the Waterloo medal, instituted in 1816, the first medal awarded by the British government to all those who participated in a military or naval action.

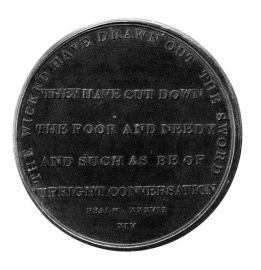

George Cruikshank:
A Peterloo Medal, 1821,
wood-engraving,
65 x 62 mm.

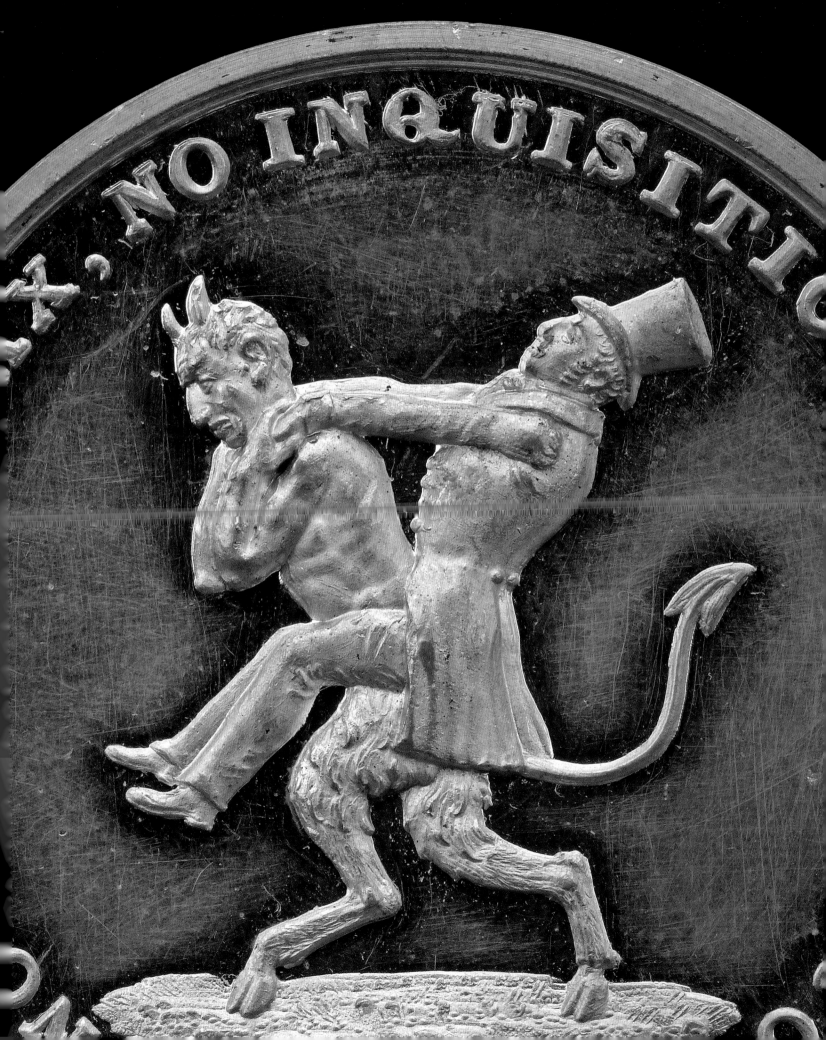

14

THE REVIVAL OF INCOME TAX, 1842

Thomas Halliday (1771–1844)

Struck pewter, 32 mm

Bank collection EM 446

Brown 1987, p. 72, cat. 2059

OBVERSE:
VICTORIA QUEEN OF GREAT BRITAIN. BORN MAY 24, 1819.
H (Halliday).

REVERSE:
NO INCOME TAX, NO INQUISITION, NO PEEL & CO. JUSTICE.
H (Halliday).

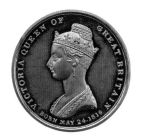 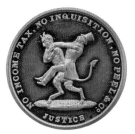

Income tax had first been introduced in Britain in 1799 as a means of helping to finance the war against Napoleon's France, but was abolished after the British victory at Waterloo. It was brought back in Sir Robert Peel's budget of 1842, again as a temporary measure. Part of a major fiscal reform, the revived tax applied to those with annual incomes over £150, while duties on articles of mass consumption were reduced. The reverse of this medal protests against the proposed reintroduction of the tax and the 'inquisition' into personal finances involved in its implementation, for annual returns were to be required in order to calculate each person's payment. The tax of 1799 seems not to have resulted in the production of medals, but satirical prints of the time showed John Bull assailed by taxes, including income tax, in the form of devils.[44] In the present medal of 1842 the tax is again shown as a devil, on this occasion carrying Peel on his back.

The obverse showing Queen Victoria may appear to have little relevance to the medal. Indeed, it was originally produced by the Birmingham medallist Halliday four years earlier, for one of several medals he made to celebrate the young queen's coronation.[45] Its reuse here, like the inclusion of the GOD SAVE THE KING inscrip-

tion on cat. no. 12, is intended to give a clear indication that this political medal is not revolutionary or unpatriotic in its purpose but is confined to the single issue in question. This practice of circumscribing criticism by including the ruling monarch's portrait on the obverse has a long history, stretching back to the medals of the Dutch 'beggars' party' of the 1560s, which carried a portrait of Philip II of Spain on their obverse, although the aim of the nobles who wore them was to bring very substantial changes to the policies of their Spanish overlord.[46] Failure to take such a precaution might lead to accusations in which the actual political point made by a medal such as Halliday's could get lost.

In spite of much opposition in Parliament and in the country – as evidenced by the present medal, a smaller version also produced by Halliday,[47] and cartoons portraying Peel in such guises as an oriental despot[48] – the tax was introduced. Nineteenth-century politicians of both major parties vowed to abolish it, but none ever fulfilled that promise, and in the twentieth century it came to be accepted as a standard part of the country's financial structure, albeit remaining a temporary tax renewed annually by a Finance Act.

15

BONAPARTISM AS A COCKCHAFER, about 1850

Unidentified French artist

Struck copper, 44 mm

1906,1103.1390

Presented by Dr Frederick Parkes Weber

REVERSE:

ARRÊTEZ DONC C'T' HANNETON! (So stop this cockchafer!).

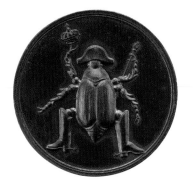

Through the inclusion of the distinctive hat and spurred boots, the author of this medal has created an instantly recognizable satirical image of the Bonaparte family, embodied at this time principally by Louis-Napoléon Bonaparte, nephew of the former emperor Napoleon I. The crown and sceptre reveal Bonaparte's imperial aspirations, as do the hat and boots, the attributes of his uncle, who had crowned himself emperor of the French in 1804. The medallist suggests that the true nature of Bonaparte and his family was malign by portraying him as a cockchafer, a beetle that periodically devastated agricultural production in France.

The exact date of the medal is uncertain. Following the revolution of February 1848, Louis-Napoléon Bonaparte was elected to the national governing assembly of the new republic in June, but resigned almost immediately after facing opposition; he was re-elected in September. Two months later the assembly resolved that a president should be elected by universal male suffrage for an unrenewable four-year term, and Bonaparte was the surprise winner in the presidential election held in December. The signs that his ambitions did not stop there appeared almost immediately, increasing notably from autumn 1850. In July 1851 the assembly voted against amending the constitution to allow him to run for a second four-year term, removing any possibility that he would be able to retain power legally. Following his coup d'état of December 1851, Bonaparte's position as prince-president was confirmed in a national plebiscite tainted by irregularities. A further plebiscite resulted in the establishment of the Second Empire in December 1852, with the president declared emperor Napoleon III.

The present medal was probably made around 1850, when the prospect of a Bonaparte emperor was becoming increasingly likely. The image suggests not only Bonaparte's potential as a destructive force but also his personal insignificance, especially when compared to his illustrious uncle. This emphasis on smallness was taken up by Victor Hugo in his polemical essay *Napoléon le petit*, published (in Belgium) in 1852, and is apparent also in prints. One of these shows him as a diminutive figure surmounting a column, but rather than the triumphal column erected by Napoleon I in Paris's Place Vendôme to mark the battle of Austerlitz of 1805, this structure points derisively to the nephew's foreign upbringing in Switzerland,

the failed attempts he staged in Strasbourg in 1836 and Boulogne in 1840, and his role as a voluntary policeman in London (below).[49] Other medals of the time compare Bonaparte unfavourably with his uncle and show Liberty encircled by chains,[50] but such medals diminished in the face of growing state authoritarianism – until the emperor's fall in 1870 brought a flood of new satirical pieces.

How Proud One is to be French When One Looks at the Column!, 1848, hand-coloured lithograph, 285 x 226 mm.

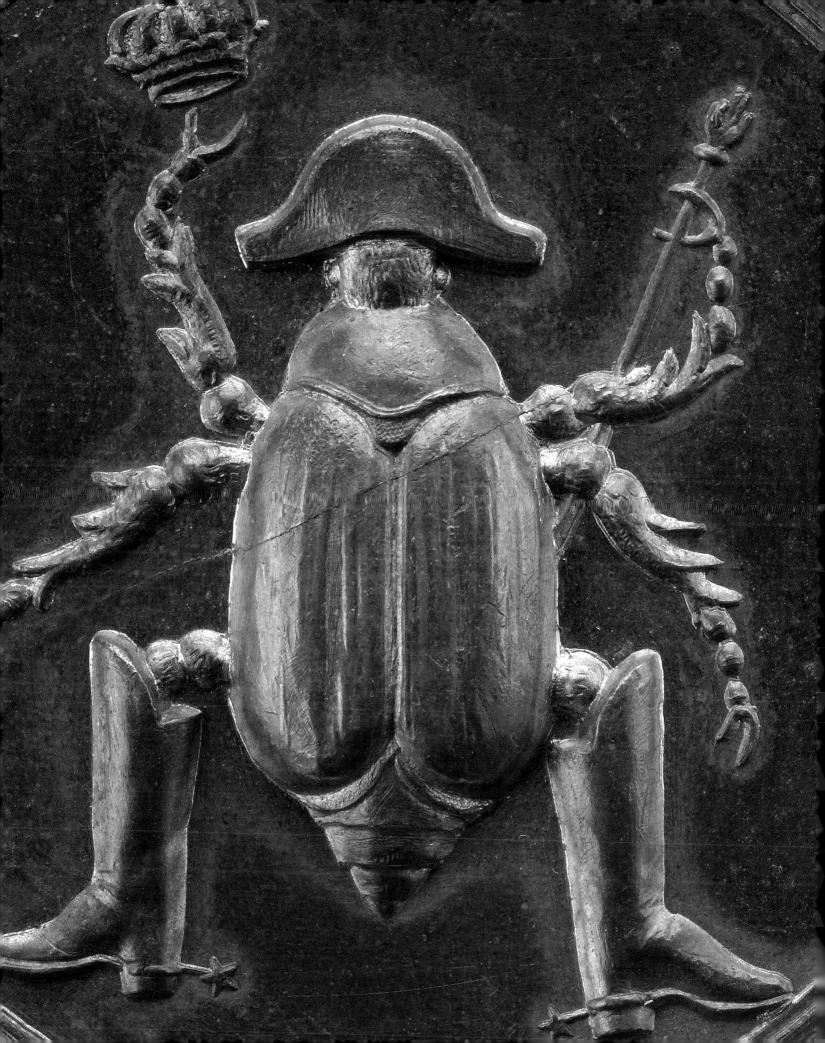

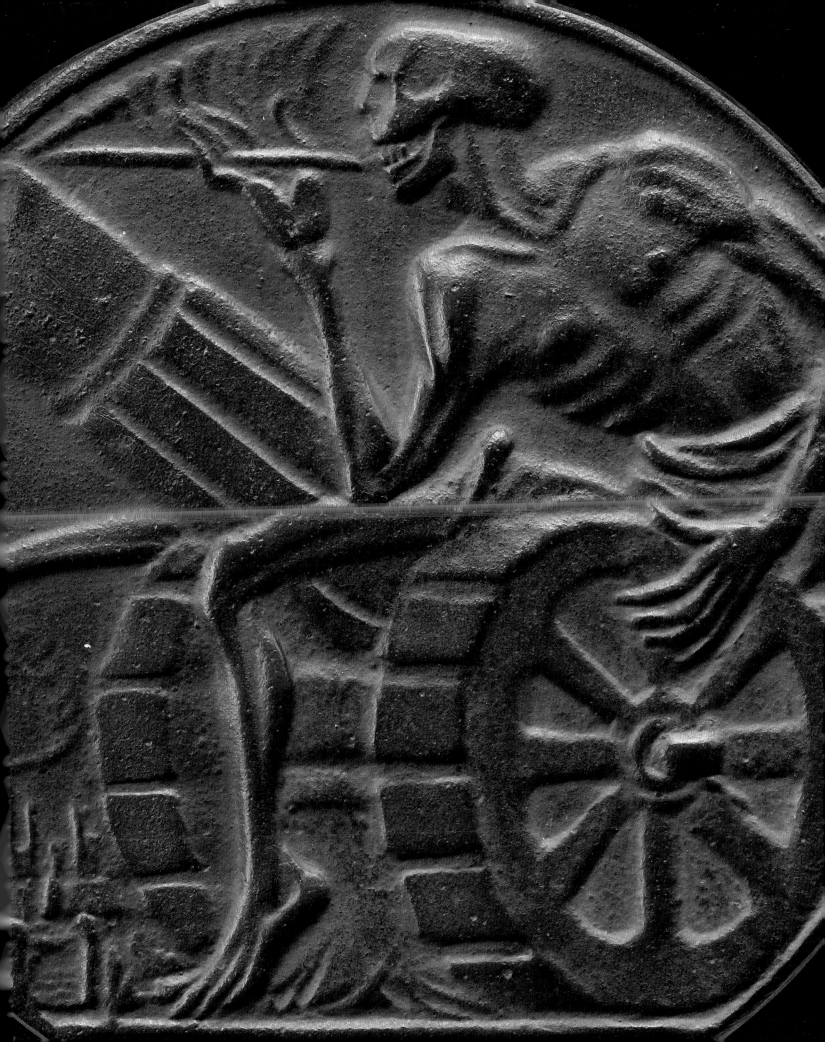

16

WAR, 1915

Arnold Zadikow (1884–1943)

Cast iron, 73 mm

1919,0610.75

Presented by Mr M. Frankenhuis

Jones 1979ᵃ, p. 148, fig. 402; Daniel Fearon, '"Out of the barbed wire": a newly discovered medal design by Arnold Zadikow', *The Medal*, no. 54 (2009), fig. 3

OBVERSE:

1915. AZ (Arnold Zadikow).

German artists active during the First World War continued to make medals that attacked the enemy by accusing them of a broad range of iniquities, but in other medals they expressed horror at the brutality of war itself without attaching blame to a specific side. This stance, although longstanding in other media, was quite new to the medal – whereas the medals targeting enemy nations followed a tradition that had been in existence for three hundred years, those that saw the conflict itself as the enemy were without precedent. While still focused on what the artists considered undesirable, these works saw the role of the medal as a servant of a particular local or national interest replaced by one in which it was conceived as a medium through which broader issues facing humanity could be addressed. This was to constitute a distinctively twentieth-century contribution to the development of the medal.

In this grimly sardonic one-sided medal, a figure of Death nonchalantly smokes while seated on a cannon; in the background a city is in flames. On other medals by the artist similar skeletal figures act out various roles relating to war – accompanying a column of soldiers with the sound of the flute, playing bagpipes before a battle as airplanes attack, or reining in airships as if they were toy balloons.[51] The figures display either complete indifference to the carnage or an air of gaiety that contrasts with and therefore emphasizes the horror of the war. Other German artists worked along similar lines, finding in the medieval idea of the Dance of Death imagery wholly appropriate for the war. Like

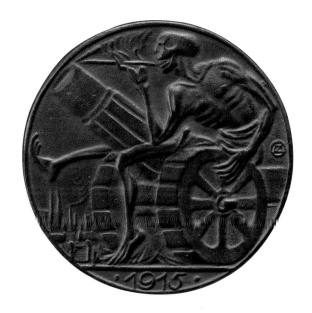

Zadikow, Karl May showed a skeleton astride a cannon (fig. 18, p. 27), Hans Lindl depicted skeletons in action on land and on sea (fig. 17, p. 27), and Ludwig Gies had a skeleton leading a group of soldiers to their death in his medal of 1917 entitled *Totentanz* (*Dance of Death*).[52]

Zadikow had trained in Berlin and Munich and was working as a sculptor in Munich when he made this medal. At this time he had had no direct experience of the hardships of war, but this was soon to change, as he embarked on his military service. Badly wounded and captured by the British, he spent two years in a prisoner-of-war camp. After the war he went on to have a successful career as an artist. In 1938 he moved to Prague, but three years after the outbreak of the Second World War he and his family were sent to the Theresienstadt concentration camp, where he died in 1943.

17

BRITISH PERFIDY, 1916

Arthur Loewental (1879–1964)

Cast iron, 73 mm

1919,0610.33

Presented by
Mr M. Frankenhuis

Frankenhuis 1919, p. 174,
cat. 1453

OBVERSE:
BRITISCHE VERTRAGSTREUE
(British fidelity to treaties).
A LOEWENTAL.

REVERSE:
HONI SOIT QVI MAL Y PENSE (Shamed be he who
thinks evil of it). DEM 'EHRENWERTEN' HERRN ASQVITH ERNEUERT
NACH DENON-GEVFFROY 1916 (To the 'honourable' Mr Asquith
Revived after Denon-Geuffroy, 1916).

Loewental uses the traditional notion of 'perfidious Albion' to attack Britain in a medal heavily laden with sarcasm. The image on the obverse of a dog tearing up a treaty is copied from a French medal from the time of the Napoleonic wars, which accused the English of breaking the Treaty of Amiens (below, right).[53] This treaty, signed in 1802, had brought to an end nine years of war between the two countries, but British discontent with its terms and Napoleon's continuing expansionist policies led to a renewal of hostilities the following year. The reverse of Loewental's medal acknowledges the debt to the earlier medal, which was engraved by Romain Jeuffroy (the name is misspelt by Loewental) and was the first in a medallic series celebrating Napoleon's achievements. This series was issued under the auspices of Baron Dominique Vivant Denon, Napoleon's advisor and, from 1804, his director-general of museums.

Loewental provides his medal with a scornful dedication to Herbert Henry Asquith, British prime minister from 1908 until his resignation in December 1916. The irony implicit in the word 'honourable', placed within quotation marks, and even in the use of the word 'Mr', is underscored by the use around the edge of the reverse of the motto of the Order of the Garter, Britain's oldest and most prestigious order of knighthood. Loewental also replicates the garter and buckle as it appears on the order's insignia. The medal's central reference point is Asquith's Irish Home Rule Act of 1914, which had given self-government to much of Ireland but was suspended for the duration of the First World War. The Easter Rising of 1916, in which Irish republicans tried to gain independence by force, received some support from Britain's enemy, Germany, and its failure was noted with dismay by German medallists, with Walter

Eberbach depicting on one of his *Totentanz* medals a skeletal figure of Death smoking on a monument inscribed HOME RULE R.I.P.[54] In the present medal Loewental equates Britain's failure to implement home rule for Ireland with its attitude to the treaty with the French of just over a century earlier. The Irish song, 'Down the glen', recounts the events of the Easter Rising with a reference to 'perfidious Albion'.

In the 1930s Loewental was to move to Britain, settling in Lincoln. His medallic subjects in Britain included Sir George Hill, director of the British Museum and, in a victory medal of 1945, Winston Churchill.[55]

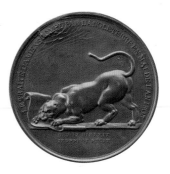

Romain Jeuffroy: *England's Breaking of the Treaty of Amiens* (reverse), 1803, struck bronze, 40 mm.

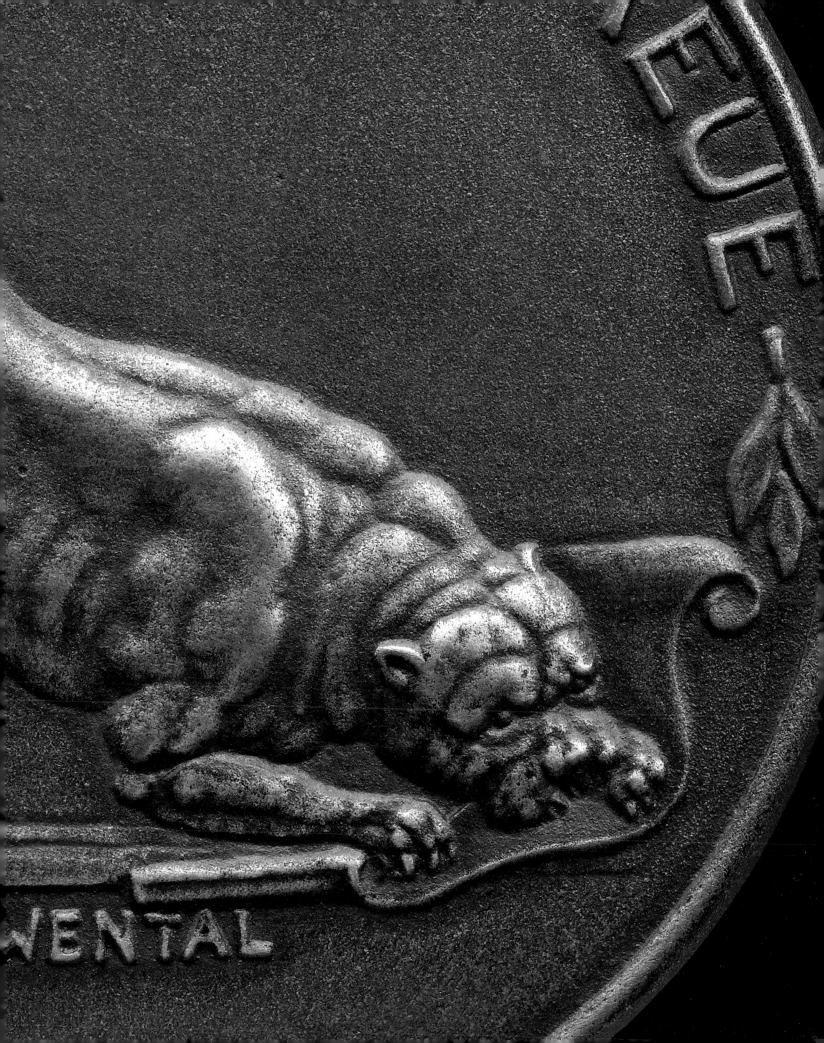

AMERICA IN THE WAR, 1917

Ludwig Gies (1887–1966)

Cast bronze, 99 mm

1918,1105.1

Frankenhuis 1919, p. 157, cat. 1320; Hill and Brooke 1924, p. 135, cat. 113; Jones 1979[b], p. 23, fig. 37; Ernsting 1995, p. 218, cat. 161; Steguweit 2000, p. 35, cat. 77

OBVERSE:
1914 1917. L.G. (Ludwig Gies).

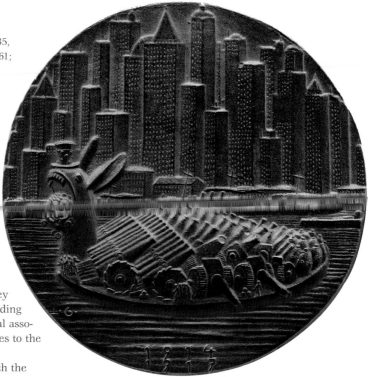

The claim of this uniface medal is that American businesses had made substantial profits by providing the allied powers with armaments over the previous three years, to help them in their war against Germany. A grotesque raft is shown against a backdrop of docks and skyscrapers evoking the New York skyline, with its 'Uncle Sam' hat confirming that this is intended to represent the United States. The massive guns on the raft tower over the small groups of human beings, the serried ranks of their barrels combining to provide the ludicrous head with a spiny animal-like body. At one end coins spill out of the open mouth and, at the other, large bags of money nestle beside the guns. The creature's large ears and protruding teeth suggest a possible allusion to the ass and its traditional association with stupidity. A more general interpretation ascribes to the United States a monstrous and irrational power.

The US entered the war in April 1917, the year in which the present medal was made, and the medal is almost certainly a response to that development. From 1914 President Woodrow Wilson had firmly maintained American neutrality, and a key pledge of his successful re-election campaign of 1916 was that the country would stay out of the conflict. In spite of this official stance, large quantities of munitions were exported to the allies. The *Lusitania*, the Cunard passenger liner sunk by a German submarine in May 1915 on its way from New York to Britain, was shown in a notorious medal of the time by Karl Goetz (fig. 16, p. 26) as having its deck laden with an aeroplane, a gun similar to those of the present medal and other arms. This was not true, but its cargo did include shells, rifle cartridges and other armaments. German anger over the sale of weaponry for use against its soldiers continued to be voiced, and President Wilson's reluctant decision to abandon his policy of non-involvement and the subsequent US declaration of war offered an opportunity for further comment.

Gies' medal pours scorn on Germany's new enemy for what was seen as three years of duplicity.

The present example of this medal was bought by the British Museum from an Amsterdam dealer, J. Schulman, in November 1918, the month the armistice was signed. George Hill, the keeper of coins and medals, reported to the Museum's trustees: 'Gies, whose medals are very difficult to obtain, owing to the fact that they are produced in limited numbers, is the most original and powerful of the German medallists now working'.[56] Placed on public display, this is one of the medals the American sculptor David Smith would have seen during his visit to the Museum in 1936 (cat. nos 21 and 22).

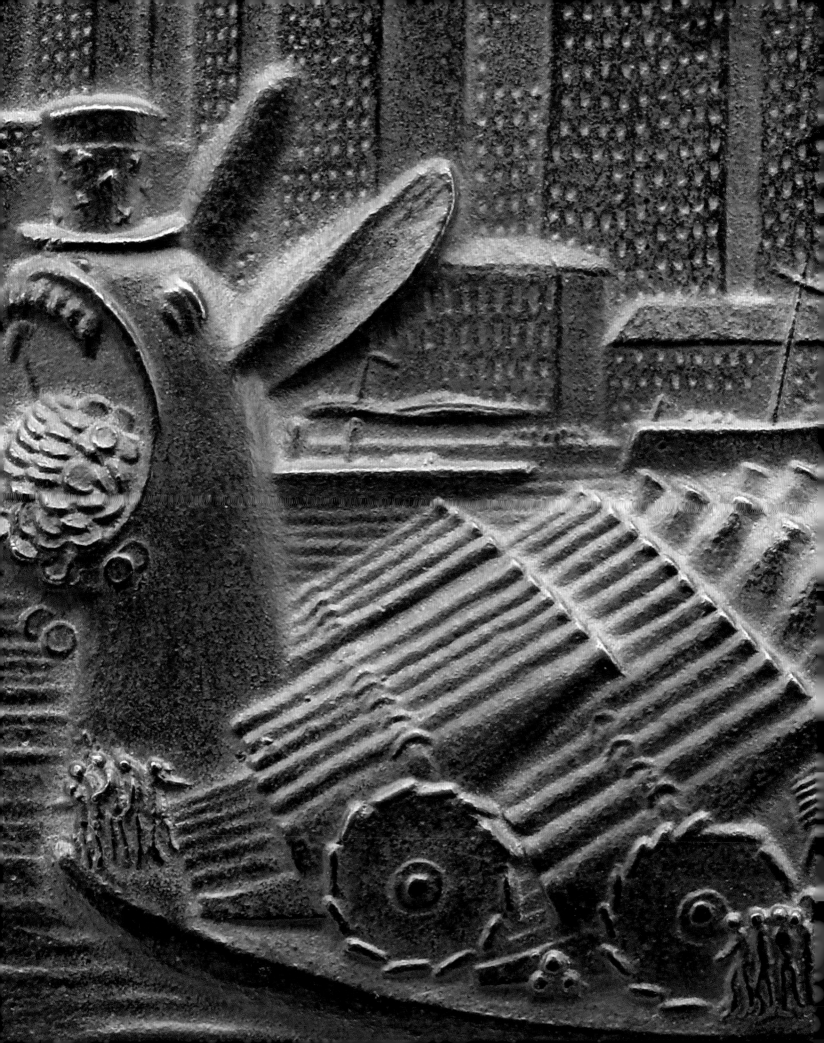

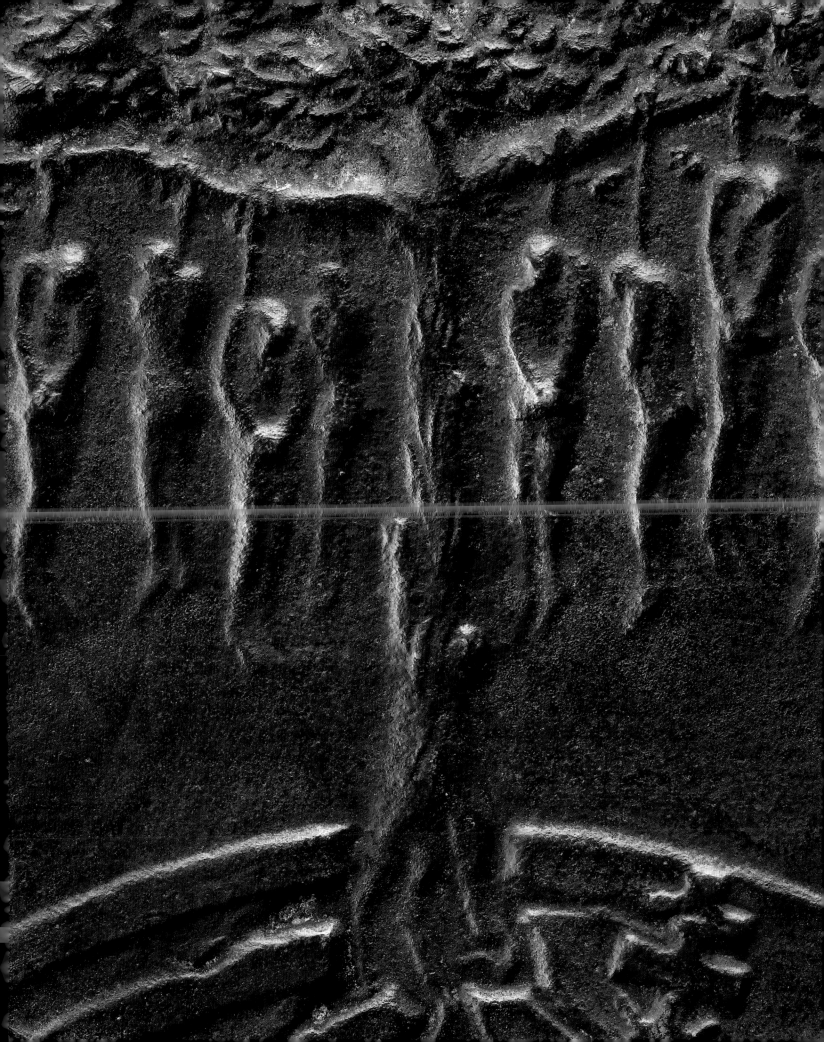

19

THE HUNGARIAN SOVIET REPUBLIC, 1919

Erzsébet Esseő(1883–1954)

Cast bronze, 70 mm

1978,1206.1

Mark Jones, *Acquisitions of medals (1978–1982)*, *British Museum Occasional Paper 42* (London: British Museum, 1985), p. 66, cat. 13

OBVERSE:
SOVIET REPUBLIKA. HUNGARIA. III. VII. 1919 (Soviet Republic, Hungary, 3 July 1919).

REVERSE:
EE (monogram) (Erzsébet Esseő).

With the collapse of the Austro-Hungarian Empire at the end of the First World War, Hungary became a separate republic with a democratically elected government. After less than six months, in March 1919 the Communist Party seized control and established the Hungarian Soviet Republic, formed on the model established in Russia two years previously. An abortive coup against the Communists of 24 June 1919, brought about by a faltering foreign policy, was ruthlessly suppressed, and the executions of many suspects were instrumental in turning many against the government. The Communist failure to meet its commitment to reclaim Hungary's imperial pre-First World War territories in Czechoslovakia and Romania led to the regime's downfall at the beginning of August 1919.

Esseő was an Hungarian artist, who had studied in Berlin and Munich. The obverse of her medal represents the Republic as an evil creature of the night, with a grimacing face, its features contorted by rage, devilish pointed ears and the wings of a bat. The snakes that writhe all around it give it the appearance of a twentieth-century Medusa, the hideous monster of Greek legend traditionally associated with anarchic uprisings and mob rule. The reverse shows bodies hanging from a tree, with the context being set by the horizontal stripes of the ground and nearby double cross, two principal features of Hungary's coat of arms. This image is almost certainly a deliberate allusion to a plate from Jacques Callot's well-known *Les misères et les malheurs de la guerre* (The Miseries and Misfortunes of War) of 1633, where the accompanying text likens the figures to 'wretched fruits hanging from a tree' (right).[57] Although David Smith cannot have seen it when he visited in 1936, as the present example of this medal was not acquired by the

British Museum until 1978, he may have known it, for a similar image of a tree laden with corpses appears in his *Private Law and Order Leagues* medal (cat. no. 21).

The artist's opposition to Communism shows itself in another medal she made in 1919, in which a horned and bat-winged devil, as hideous as the creature on the present medal, presides over a mêlée of fighting figures, the representatives of Medusa. The reverse simply reads 'Bolshevism', written in the Cyrillic letters used in Russia, and the dates '1918 1919'.[58] After the Second World War, when Hungary was again governed by Communists, the artist lived in Munich, where she died in 1954.[59]

Jacques Callot: *The Hanging*, 1633, etching, 81 x 185 mm.

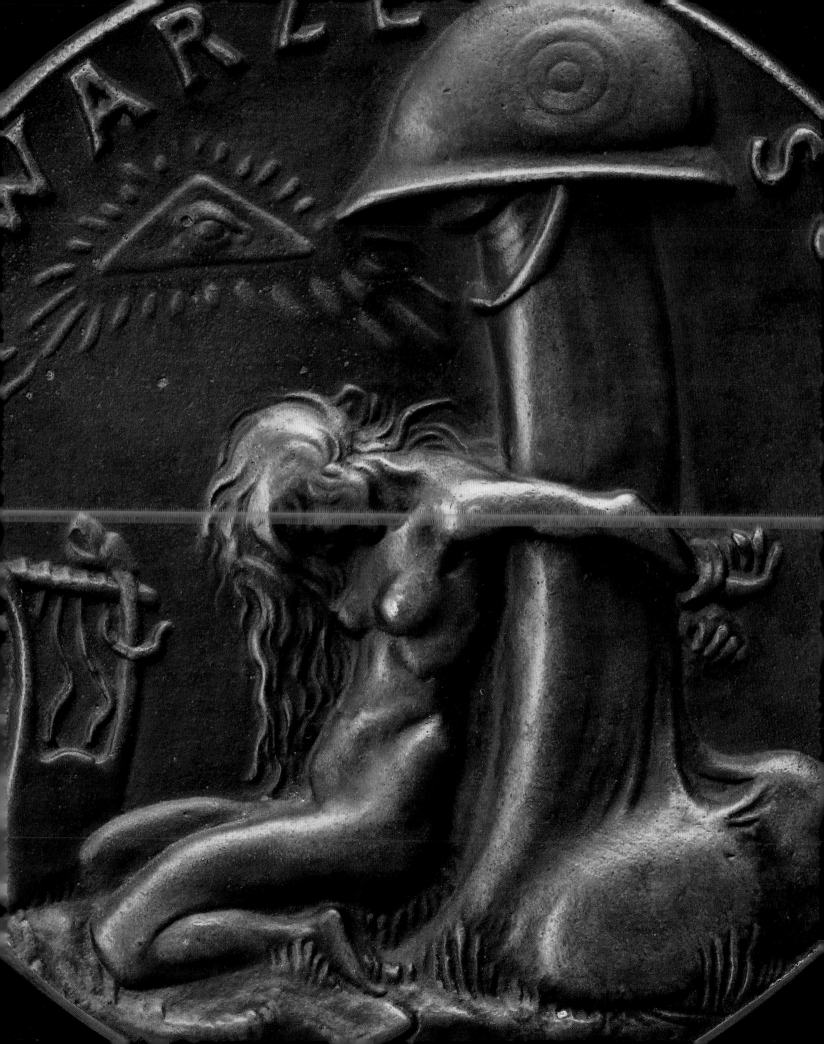

20

THE WATCH ON THE RHINE, 1920

Karl Goetz (1875–1950)

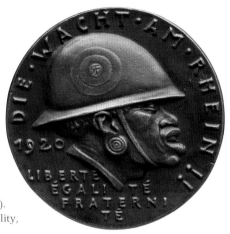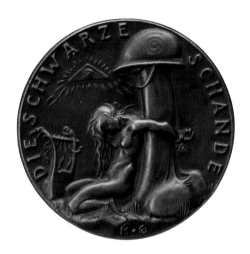

Cast bronze, 59 mm

1949,0302.5

Presented by Air Commander E.A. Masterman

Kienast 1967, p. 79, cat. 262; Jones 1979[a], p. 146,
fig. 399; Jones 1979[b], p. 31, fig. 52

OBVERSE:

DIE. WACHT. AM. RHEIN!! (The watch on the Rhine!!).
LIBERTE ÉGALITÉ FRATERNITÉ (1920. Liberty, Equality,
Fraternity).

REVERSE:

DIE SCHWARZE SCHANDE (The black shame). K.G (Karl Goetz).

Racism is one of the strategies employed in this medal, which
deliberately sets out to shock.

Following the First World War, the victorious allies continued
to occupy the area of Germany lying to the west of the river Rhine
and other pockets of land to the east, including the city of Cologne.
The treaty of Versailles of 1919 stipulated that these foreign troops
were not finally to leave until 1935. Among the French troops were
black soldiers from the country's African colonies, against whose
presence the German press led a vociferous campaign, printing
grossly exaggerated reports and unfounded accusations of wide-
spread sexual and other crimes.[60] It is on these that Goetz built in
the present medal.

The otherness of the caricatured black man is stressed by his
decorative ear-ring, while his association with France is made clear
by his helmet's RF monogram – for 'République française' (French
Republic) – and the ironic use of the official French motto which,
Goetz seems to imply, is at odds with a widely held historical
European view that saw themselves as the colonial masters of
Africans. The reverse shows the same helmet surmounting an erect
phallus, to which is bound a nude female figure. The broken strings
of the lyre give a further indication of violence, which is observed
by the all-seeing eye of God. A variant of this medal duplicates
each of the letters of the reverse inscription, to give DDIIEE SSCCH-
HWWAARRZZEE SSCCHHAANNDDEE and thereby creating the
effect, as Kienast writes, 'of a long, painful cry'.[61] In yet another
the phallus is replaced by a post with a baby lying at its base.[62]
Both this and the present medal were also issued in smaller
struck versions.

Goetz had worked for private mints in the Netherlands and
Switzerland, and also spent five years in Paris, before settling in
Munich in 1904. Over the succeeding decades he made several
hundred medals, a large proportion of which are of a political or

satirical nature – many of the First World War medals attacked
Germany's enemies, but a few point to the senselessness of the
war itself, contrasting the huge death toll of the battle of Verdun
with the quietly flowing river Rhine and pointing to the snail-like
pace of advances in Flanders, in medals illustrated here through
the artist's sketches (below). After the war Germany's treatment at
the hands of the allies and economic hardship were major themes.
Nationalist propaganda reasserted itself in his medals from 1939.

Detail of a page from Karl Goetz's sketchbook, 1917,
graphite on paper, 235 x 357 mm.

PRIVATE LAW AND ORDER LEAGUES, 1939

David Smith (1906–65)

Cast bronze, 273 mm

Lent by the Estate of David Smith

Krauss 1977, p. 17, cat. 99; Wisotzki 1988, pp. 121–4; Lewison 1991, p. 38, cat. 5; Marks and Stevens 1996, p. 55, cat. 5; Giménez 2006, p. 345, cat. 111

OBVERSE: ΙΔΙΩΤΙΚΟΣ ΝΟΜΟΣ ΚΑΙ ΣΥΝΔΕΣΜΟΣ ΣΥΣΤΗΜΑΤΟΣ (Private law and order leagues). Φου (Light) [*sic*]. Με[σ]οφόρια (Girdles). οι σόλες ειναι λιγο χονδρές (the soles are a bit thick). 1939 ΔΣ (David Smith).

This and cat. no. 22 are two of a series of fifteen large uniface *Medals for Dishonor* made by the American sculptor David Smith between 1937 and 1940, which he described as a series of 'bronze ▓▓▓▓▓▓▓▓▓▓▓▓▓▓▓▓▓▓▓▓▓▓▓▓▓▓▓▓▓▓▓▓▓▓▓▓▓▓ inspire and lead it, its resulting destruction. These medals are dedicated [to] the perpetrators'.[63] They were, he wrote, 'of a surrealist and symbolic nature'.[64] Smith's targets were Fascism and capitalism, the political and religious leaders whose activities promoted hatred and laid the ground for war, and the industrialists, scientists and media who colluded with them.

The present medal, which includes inscriptions in modern Greek,[65] focuses on paramilitary groups within America that espoused prejudice and intolerance, and in particular the racist Ku Klux Klan, which had been particularly strong in the 1920s and used murder and violence to further its belief in white supremacy. An army of figures wearing the Klan's distinctive conical mask appears menacingly over the horizon of a nightmarish landscape replete with hangings and crucifixions, scenes of shooting and torching, and the Klan's symbolic burning cross metamorphosing into a Nazi swastika. The American flag serves as the backdrop for a Nazi salute and the Statue of Liberty rides backwards on a pig. In the foreground a robed Klansman, seen also in a preparatory drawing (top, right), seems to step out of the medal to point a gun directly at the viewer. In the notes that Smith wrote to accompany this medal (right), he conflated this figure with the armed warrior emerging beside it: 'the superamerican rises from the pit of medievalism and by the grace of modern industrialism is aiming directly at you'.

The figures hanging from the tree recall Jacques Callot's etching of 1633 and the reverse of Erzsébet Esseő's medal of 1919 (cat. no. 19). They also bring to mind Abel Meeropol's poem, *Strange Fruit*, written after seeing a photograph of a lynching in an American civil rights magazine and first published in 1937. The poem begins:

David Smith: Sketches for *Private Law and Order Leagues*, 1938–39, graphite on paper, 349 x 318 mm, the Estate of David Smith.

David Smith: *Private Law and Order Leagues*, 1938–39, ink on tracing paper, 235 x 292 mm, the Estate of David Smith.

Southern trees bear a strange fruit,
Blood on the leaves and blood at the root,
Black body swinging in the Southern breeze,
Strange fruit hanging from the poplar trees.

Set to music, the poem (which shares its central metaphor with cat. no. 3 – victims of intolerance in a very different context) was made famous by the recording by Billie Holiday released in 1939, the year of the present medal.[66] In his description of the medal, Smith wrote: 'the tree had roots and bore fruit for vultures'.

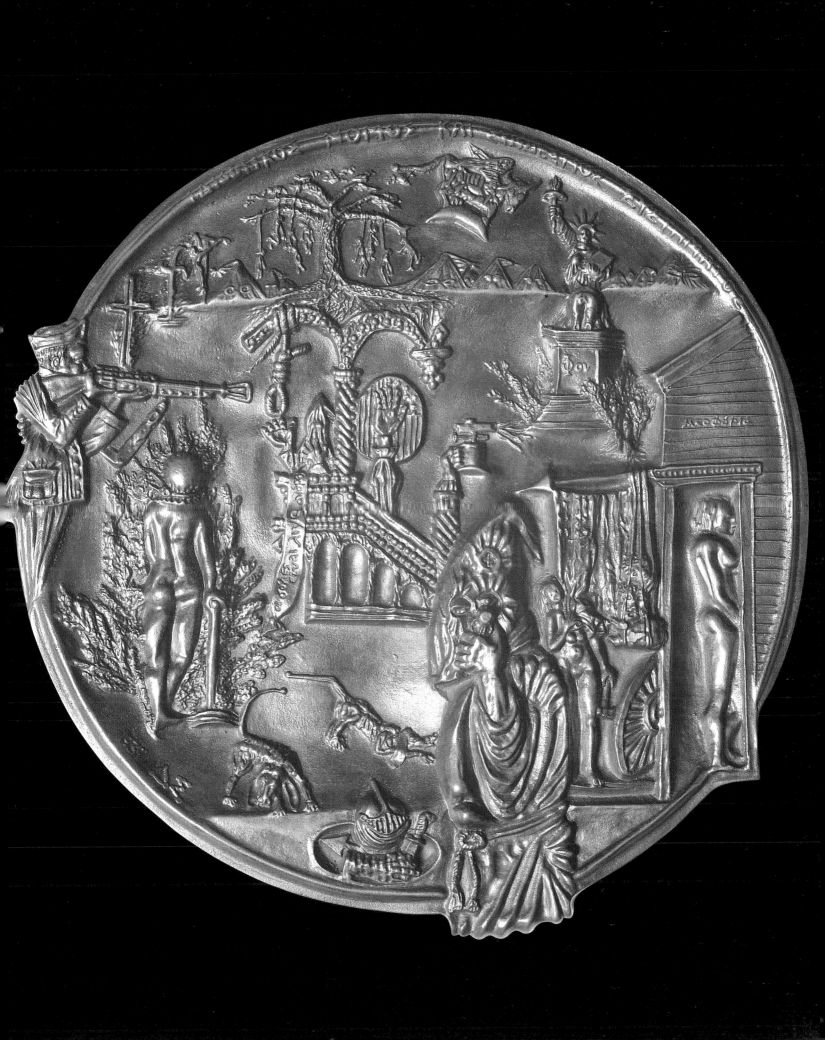

COOPERATION OF THE CLERGY, 1939

David Smith (1906–65)

Cast bronze, 267 x 260 mm

Lent by the Estate of David Smith

Krauss 1977, p. 17, cat. 101; Wisotzki 1988, pp. 129–30; Lewison 1991, p. 42, cat. 7; Marks and Stevens 1996, p. 61, cat. 7; Giménez 2006, p. 345, cat. 112

OBVERSE:

Δ.Σ. (David Smith). 19 39.

This work, from Smith's series *Medals for Dishonor* (see also cat. no. 21), lambasts those religious leaders who use their position to incite hatred and war. Smith also reproaches the church in cat. no. 21, where a crucifixion is juxtaposed with a swastika and a noose hangs from the central pulpit. In a study for the present medal (right) the hand of God points accusingly, as it does in another medal from the series entitled *Propaganda for War*.[67] However, in the medal itself the members of the different religious sects, identifiable by their various costumes, are untroubled by a divine presence, as they 'incite the lame in mind', as Smith writes in his notes on the medal (right). Smith also notes that the angel Gabriel, who flies through the sky above, his tuba blaring, is wearing spectacles modelled on those worn by Charles Coughlin, a Roman Catholic priest who used his popular radio broadcasts to propound his controversial anti-semitic and pro-Nazi views. On an altar to the right a sinister octopus uses its tentacles to hold down the cloth and keep open the 'holy book'.

 Smith had learned 'the artist's position as a rebel or as one in revolt against status quo'[68] from the painter and printmaker John Sloan, under whom he had studied in the 1920s. During his trip to Europe of 1935–6 he witnessed the growth of fascism. It was after this trip that he was inspired to make his medals, having seen German First World War medals, such as cat. no. 18, on display at the British Museum in May 1936. He later wrote: 'From 1936 after I came back from Europe I was impressed by Sumerian Seals – Intaglio concept in general – a collection of war medals I had seen in British Museum. I decided to do a series of Anti-war medallions called "Medals for Dishonor"'.[69] He worked on the medals at night for the next few years, carving intaglio into plaster. When they were exhibited in New York in 1940, they were generally well received by the critics, provoking positive reactions: 'Here is a lively idea which is developed in a caustic satirical spirit – the idea of commemorating triumphs of allegedly negative achievement'; 'These commentaries upon our society have an almost breath-taking bitterness, a mordant humor not unlike that of a Jonathan Swift and a Rabelaisian broadness to which neither the catalogue nor this review can do justice'.[70] However, they did not find buyers, perhaps because, by this time, they could be misinterpreted as unpatriotic.

David Smith: *Cooperation of the Clergy*, 1938–39, ink and chalk on tracing paper, 349 x 418 mm, the Estate of David Smith.

David Smith: *Cooperation of the Clergy*, 1938–39, ink on tracing paper, 235 x 292 mm, the Estate of David Smith.

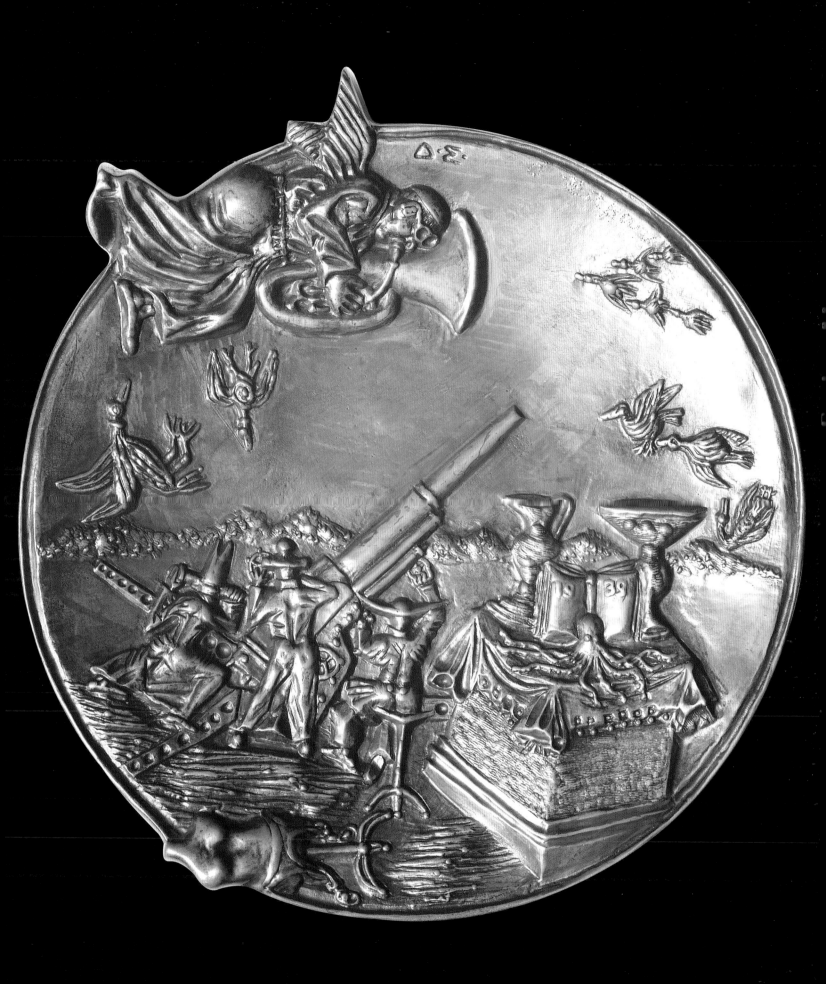

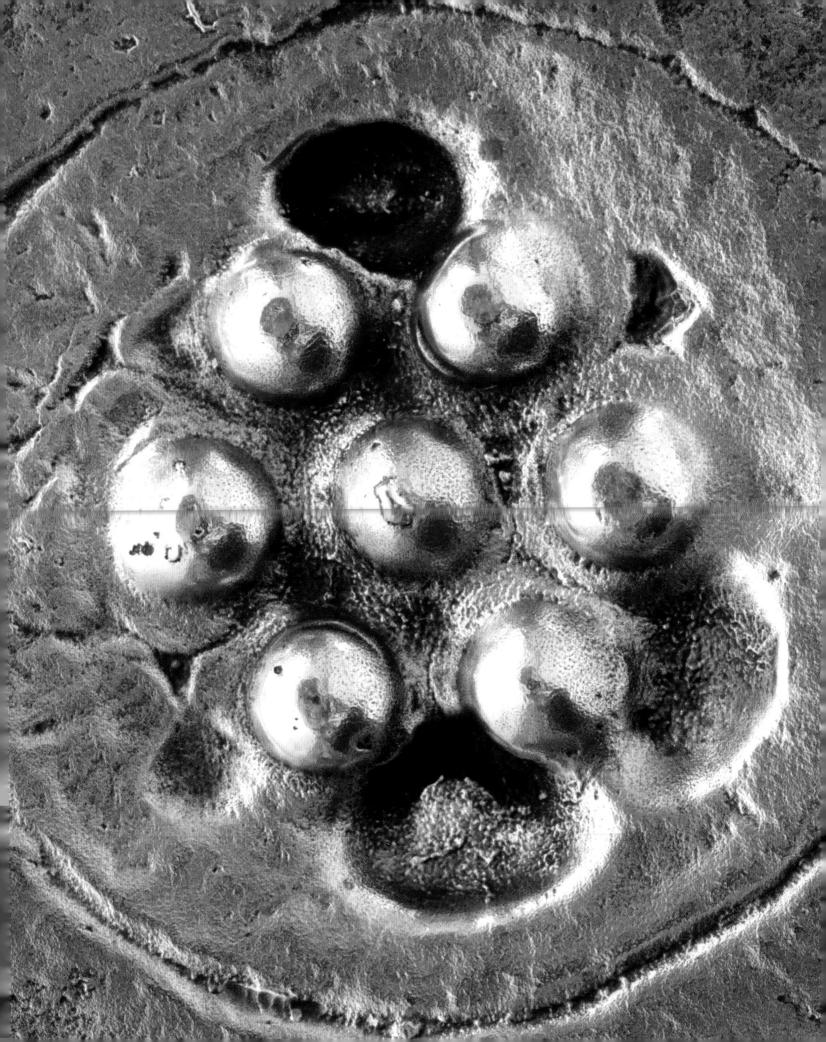

23

SINK STOPPER, 1967

Marcel Duchamp (1887–1968)

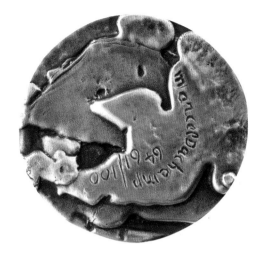

Cast silver, 63 mm

Lent by Richard Hamilton

Schwarz 1997, vol. ii, p. 843, cat. 608b

REVERSE:

Marcel Duchamp 64 61/100.

From the 1960s artists have questioned the validity of the medal itself and the traditional, generally celebratory roles associated with it. One of the first to do this was Marcel Duchamp, whose earlier readymades, as he called them, had a seminal influence on the development of twentieth-century art. His thumb medal belongs to some fifty years later. His friend Richard Hamilton (for whose medal see cat. no. 27) explains how it came about:

> Marcel had a problem with the plumbing in his holiday home in Cadaqués. The porcelain tray in the shower on a landing outside his rented apartment didn't have a stopper. If it had a plug, water might have accidentally flowed down the stairs and made a mess. But Marcel thought, 'I'd like to wash my feet, so if I could put a stopper in there it would make life easier'. He was there for three months every summer and each year he applied himself to the problem. He tried rubber things but they floated away. Nothing did the trick until finally he made a cast of the perforated cover to the drain by pressing clay over the opening and making a plaster mould from the clay. He melted lead in a saucepan in the little kitchen and poured it into the mould. I suspect it didn't work too well, but he liked to have problems to solve in between his chess games. Then somebody came along from a company in America with plans to get artists to design medallions. What does Marcel do? He hands him this lead stopper and says, 'Perhaps you could use this'. They cast editions … I've got a silver one. It's a beautiful object and I love it.[71]

Hamilton's example is exhibited here.

The original lead version was made in 1964,[72] and was replaced in 1965 with a thicker, heavier version that functioned better in the shower. The edition of 1967, cast in silver, bronze and stainless steel from the original work, was issued by the International Collectors Society of New York, which announced proudly: 'Mr Marcel Duchamp, eighty years old, and recognized throughout the world as one of the greatest living artists has created his first original limited edition Medallic Sculpture.' The medal is unlike Duchamp's readymades in that it is based on a model that the artist fabricated himself and was produced in an edition, thereby following standard medallic practice, but its importance lies in the status it shares with the readymades as a work of art created out of a practical everyday object – the medal, generally associated with honour and glory, is here more closely connected to plumbing. And yet, as Hamilton observes, its beauty is undeniable.

Marcel Duchamp holding *Sink Stopper*, 1967.

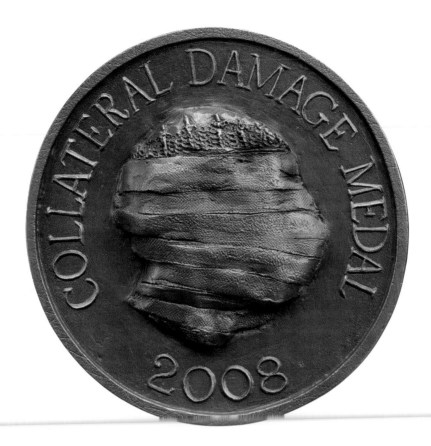

24

CDM, 2008

Steve Bell (b. 1951)

Cast bronze, 104 mm

Cast by Danuta Solowiej, London, and Niagara Falls Castings (UK) Ltd, Warwick

Edition: 3

2009,4066.5

Presented by the British Art Medal Trust

OBVERSE:
COLLATERAL DAMAGE MEDAL 2008.

REVERSE:
SUFFER LITTLE CHILDREN.

Steve Bell is one of Britain's best-known cartoonists, having for many years regularly produced the *Guardian* newspaper's principal political cartoon as well as its political strip 'If......', launched in 1981. An admirer equally of the absurd and often sexual and scatological humour of the contemporary American comic book artist Robert Crumb, and of the political incisiveness and visual wit of the eighteenth-century British caricaturist James Gillray, Bell often combines into one cartoon several layers of visual reference derived from historical sources as well as the day's news. Bell's practice is to work to the scale of the published piece, and this is the case with this medal, his first three-dimensional work as a professional artist.[73] Modelled by the artist himself, it translates the immediacy of his graphic style into the permanence of cast relief. The dialogue between the sides is reminiscent of the narrative connections between cartoon cells and yet, in the format of the medal, the two cannot be seen simultaneously – the full implications of the obverse are revealed only when the medal is turned over.

Like cat. nos 27 and 29 and, to an extent, cat. no. 34, this medal relates to the allied invasion of Iraq in 2003. The obverse shows the Queen's head in profile, an image familiar from coins, but here bandages obscure the entire face and the battered crown is only partially visible. Historical medals that have subverted the traditional profile head of the monarch include Jan Smeltzing's medal marking the flight of James II in 1689 (cat. no. 4), where the fugitive king's hair is tied back for travel, and the juxtaposition of George III with an ass in 1795 (fig. 12, p. 22). The present example has a less personal significance, the implication being that the 'collateral damage'[74] from the war extends to the reputation of Britain as a whole. Justice is traditionally represented as a blindfolded female figure, but in Bell's medal this indication of impartiality is transformed into an all-encompassing eradication of not only sight but also hearing and speech. The blindfold is also a gag.

Steve Bell: *The Invasion of Iraq*, 2003, ink, chinagraph pencil and watercolour, 230 x 310 mm.

The reverse has the prone figure of a small child seen in perspective, with the feet in the foreground and the body stretching back into space. The image is taken from a photograph of a child killed in Baghdad in the military action. Submitted to the *Guardian* news desk but not published, it was selected by Bell for his leader-page cartoon of 17 April 2003, where it appears as one of many images of a gruesome and poignant nature coming out of Iraq (above).[75] In the medal the splayed bare feet and wool suit are individualized, but the facial features are obscured as a result of the low viewpoint, making the image at once both particular and universal. The biblical text, SUFFER LITTLE CHILDREN, is from Luke 18:16: 'But Jesus called them unto him, and said, Suffer little children to come unto me, and forbid them not: for of such is the kingdom of God.' Bell's use of the phrase brings out the more common modern usage of the word 'suffer', while recalling its original context of spiritual salvation.

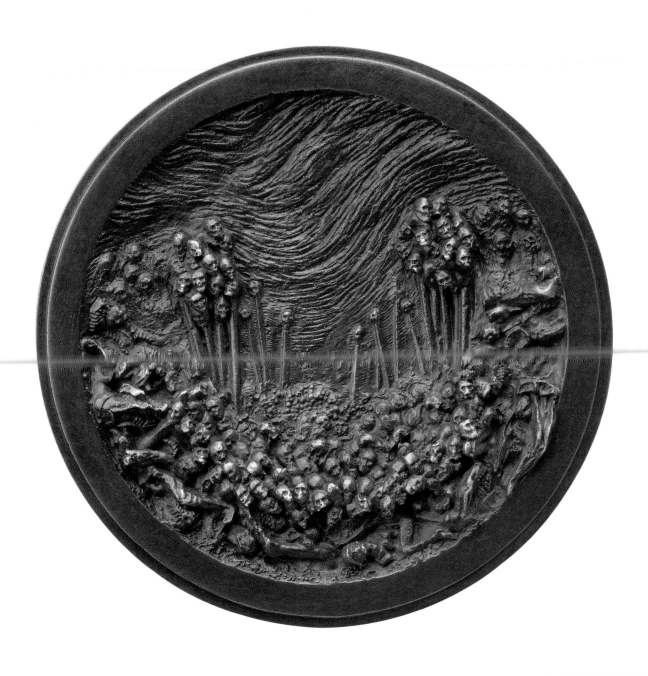

25

MEDDLING WITH DISHONOUR, 2008

Jake and Dinos Chapman (b. 1966 and 1962)

Cast bronze, 155 mm

Cast by AB Fine Art Foundry Ltd, London

Edition: 5 (plus 6 artists' proofs)

2009,4066.6

Presented by the British Art Medal Trust

Although relatively small in size, this medal presents a vision of carnage that has an intensity comparable to Goya's etching series *The Disasters of War* (1810) and such earlier works as Pieter Bruegel the Elder's *The Triumph of Death* of around 1562, in which armies of skeletons swarm over a muddy Flemish landscape, terrorizing, torturing and imprisoning the civilian populace. In Bruegel's painting the scenes of barbarity stretch from one edge of the panel to the other, suggesting a universal apocalypse, a theme taken up by the Chapmans in their sculptural piece *Hell* (2000) which, destroyed by fire in 2004, has since been remade as *Fucking Hell* (overleaf).[76] In this work thousands of individually made and painted figures, many of them skeletal, mutilated, deformed and wearing Nazi insignia, are immersed in an orgy of violence, torture and triumphalism. In the catalogue produced for the new version, Simon Baker refers to 'the complicit relationship between analysis and participation in horror',[77] drawing attention to the deep ambivalence the viewer experiences on encountering this work. This observation can equally well be applied to the present medal, which has grown out of those larger pieces.

The single face of the medal depicts a landscape of skulls, skeletons, dismembered torsos and severed limbs. Crowding the lower half of the medal and piling up at the sides, these human remains appear to press forward, with one leg being forced out of the confining circle to emerge into the viewer's space, while at the same time a deep spatial vortex draws the spectator's gaze inward towards more skulls impaled on spikes, and beyond into what appears to be a limitless distance. A threatening sky swirls above, seeming to bear both down and outwards. The effect on the viewer is of being sucked down a plughole, even as its nightmarish inhabitants are being forced out. The subtle use of pictorial space to suggest great depth in a small area is a feature of many medals (for example, cat. nos 3 and 4). In the Chapmans' medal these devices combine to suggest that this horrific scene is without end, just as the abrupt and seemingly arbitrary truncations created by the vertical glass walls of *Fucking Hell* create the illusion that, despite the vast numbers of tiny figures that people it, the viewer is experiencing just a small section of a much wider scene. The implication is that human barbarity knows no bounds.

The medal's conflation of the grotesque with the carnivalesque is reinforced by the 'smiley face' that is formed by the areas of high relief, a further disturbing element that involves a total shift in scale and operates as a sort of hideous picture puzzle. The established order is inverted here, as it is in the First World War German medallists' sardonic portrayal of skeletal figures engaged in human pursuits (cat. no. 16). This medal is not specific to a location or a place. These killing fields are mass graves that might be drawn from any number of conflicts at different times and places. The Chapmans conjure up a spectacle of inhumanity with grim humour.

Overleaf: Jake and Dinos Chapman: Detail from *Fucking Hell*, 2008, glass fibre, plastic and mixed media, 9 parts (8 parts 2150 x 1287 x 2498 mm; 1 part 2154 x 1280 x 1280 mm).

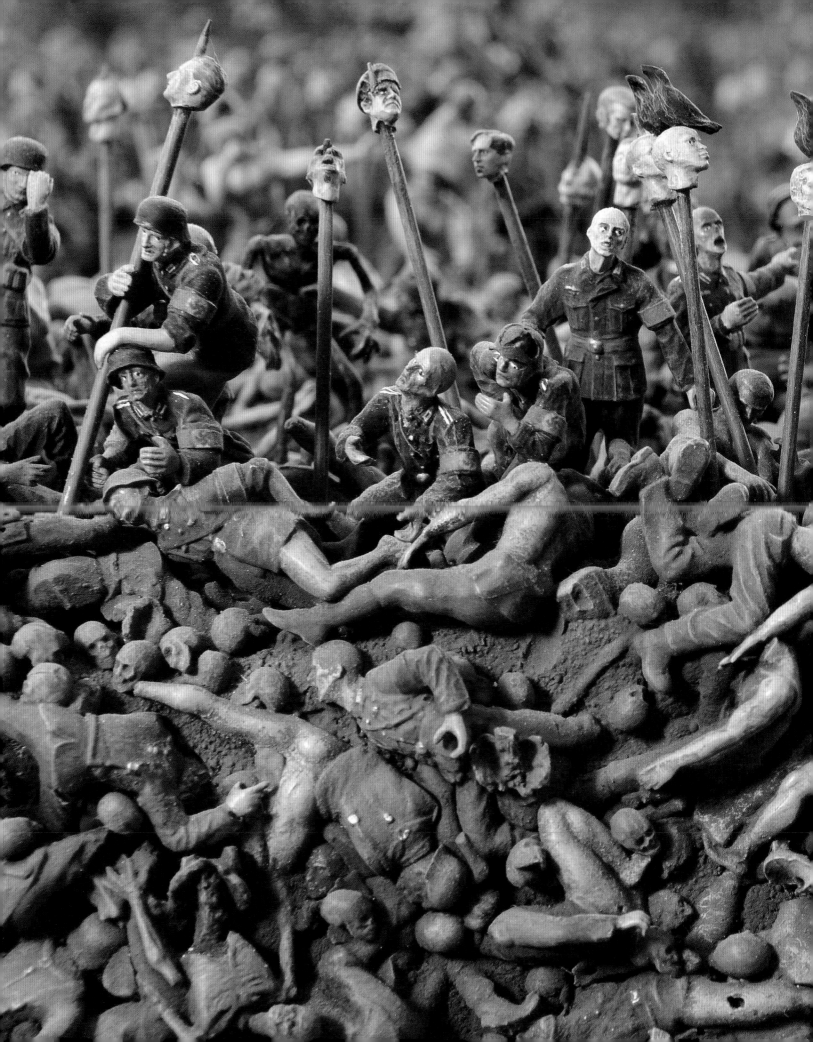

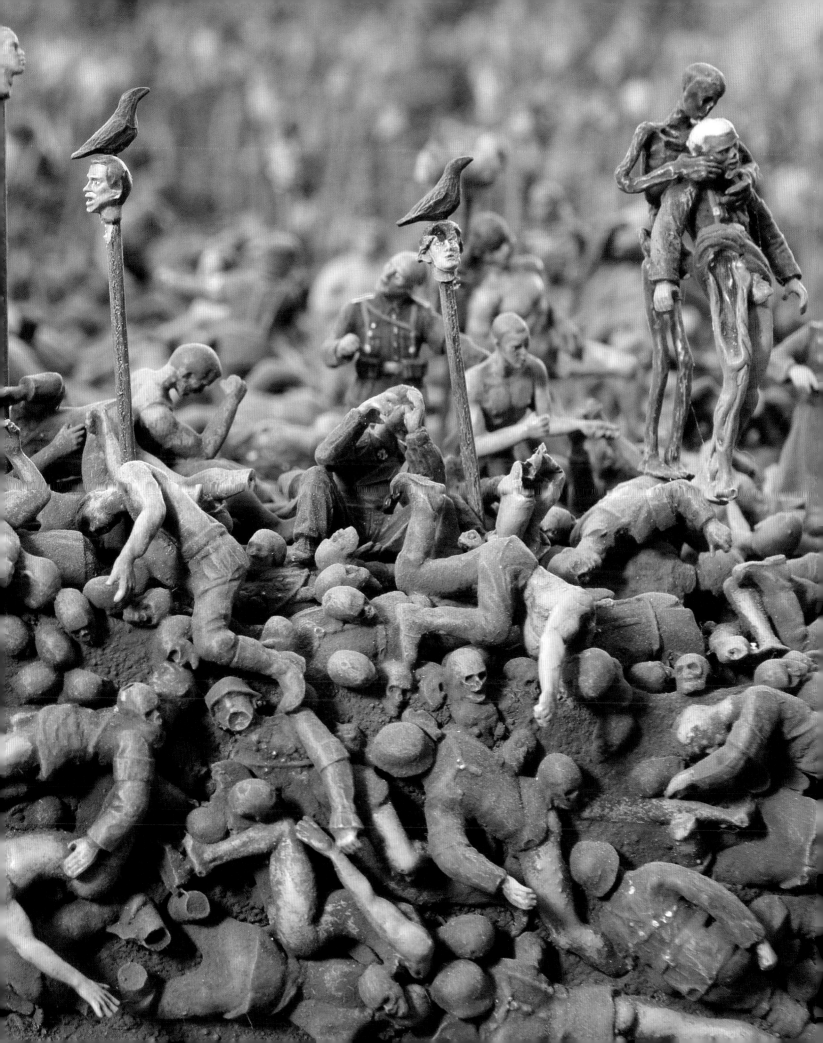

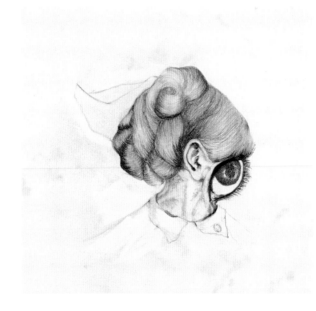

Ellen Gallagher: Design for *An Experiment of Unusual Opportunity*, 2008, graphite, 258 x 357 mm.

Ellen Gallagher: Designs for *An Experiment of Unusual Opportunity*, 2008, cut paper, 256 x 358 mm, 233 x 310 mm.

26

AN EXPERIMENT OF
UNUSUAL OPPORTUNITY, 2008

Ellen Gallagher (b. 1965)

Struck silver and cast and silvered gilding metal, 57 mm

Struck by Bigbury Mint, Ermington

Edition: 13

2009,4066.3

Presented by the British Art Medal Trust

OBVERSE:

NURSIE SIE XUS 1 2 Bni uonsp AN nt of UNUSUAL OPPORTUNITY.

REVERSE:

BC. PRACTICAL NURSE 1932 OO HUMANIA Bunions LES SUFFERERS
NEW g A.D.J.U.S.T.S SIX g e SEShU 1 GLOO.

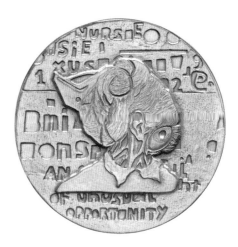

The protagonist on the obverse of Gallagher's medal is a nurse,
her profession indicated by the cap that is placed on her carefully
brushed and neatly arranged hair. Her facial features, however,
have been subsumed into a single giant eye that obliterates any
trace of identity and transforms her into a kind of watchful monster,
grotesque and yet pathetic, while the flayed form of the neck is in
shocking contrast to the primness of her collar.

The figure of the nurse recurs in various guises in Gallagher's
work, with one enormous eye as here or with the eyes blanked out
as in prints in the *DeLuxe* installation (2004–5).[78] She is derived in
part from the black nurse, Eunice Rivers, who for forty years played
a key role in the United States Public Health Service's Tuskegee
Experiment, under which 399 black men from Alabama – mostly
poor and illiterate farm workers – were denied treatment for
syphilis and instead enrolled as the subjects of an observational
project researching the effects of the disease on untreated sufferers.
The study began in 1932, continued after the discovery of penicillin
as a cure for the disease, and ended only in 1972 after newspaper
reports led to a public outcry. The role of the black woman shocked
many, and the degree of her culpability has been much debated.
In the medal the background to the nurse's head is made up of
partially erased text, which can be read more fully in a drawing the
artist made for the medal, where the word NURSIE, the date 1932,
and the phrase AN EXPERIMENT OF UNUSUAL OPPORTUNITY
are visible clearly (opposite). In 1936 a report had stated that infect-
ed black men 'seemed to offer an unusual opportunity to study …
the disease to the death of the infected person', a chilling phrase
that also appears in Gallagher's drawing *Magnificent* (p. 94).[79]

The words on the other side of the medal are taken from
advertisements in American magazines targeting a specifically Afro-
American readership, which offer quick home cures for such minor
ailments as bunions. These words are linked by lines (or stitches) to

a large pill bearing the letters BC, suggestive of the phrase Black
Consciousness, which might be considered the sole effective
remedy for the concerns expressed in the medal although, as
Meghan Dailey writes, 'In Gallagher's art, race, like language, is
presented as a construction; it always has more than one face and,
in its subjectivity, remains unresolved and variable'.[80] The pill and
similarly arranged text appear on Gallagher's larger work, *Esirn
Coaler* (2007), now in the Tate collection (p. 95). The double O
recalls the disembodied eyes of the traditional black-faced minstrel
mask that occur in other pieces, such as her *Oh! Susanna* of 1993.[81]

Gallagher works in many media. To make the medal, she used
a technique of layering and shallow carving into thick watercolour
paper to create the two elements of the obverse (opposite) and the
reverse. A pencil drawing of the nurse's head also served to clarify
details (opposite). In a complex process, casts were then taken
directly from the paper and reduced to form the dies, from which
the medal was struck in silver. The pill on the reverse was cast
separately, partly silvered, and inserted into the body of the medal.

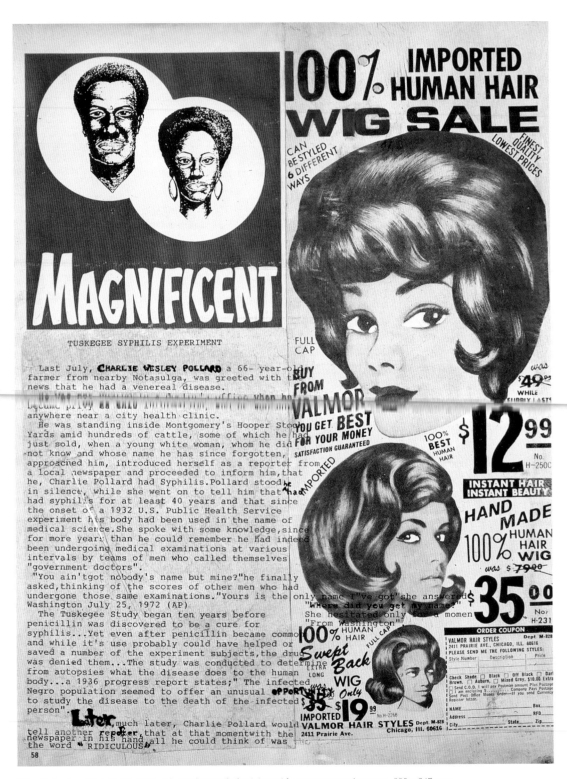

Ellen Gallagher: *Magnificent*, 2001, oil, graphite and plasticine with text on magazine page, 335 x 247 mm.

Ellen Gallagher: *Esirn Coaler*, 2007, plasticine and aluminium, 894 x 552 mm, Tate.

Richard Hamilton: *Shock and Awe*, 2007–8, inkjet print on Hewlett-Packard Premium canvas, 2000 x 1000 mm.

27

THE HUTTON AWARD, 2008

Richard Hamilton (b. 1922)

Cast silver, 72 mm

Milled by the University of the West of England, Bristol; cast by BAC Castings Ltd, London; finished by Irene Gunston, London

Edition: 8

2009,4066.1

Presented by the British Art Medal Trust

OBVERSE:
CONFIDIMVS DEO DE ABSOLVTIONE: MMIV
(We trust in God for absolution, 2004).

REVERSE:
DEALBATI (Whitewashed). HUTTON AWARD.

This medal relates to the Hutton Inquiry, set up by the British government to investigate the circumstances surrounding the death of the government scientist David Kelly in July 2003. Just eight days before he died, Kelly had been publicly named as the source for claims broadcast by the BBC that in the run-up to the invasion of Iraq earlier that year the government of prime minister Tony Blair had 'sexed up' a report on Iraq's military capability. In his report, published in January 2004, Lord Hutton strongly criticized the BBC, leading to the resignation of its chairman and director-general, but his exoneration of the government resulted in several newspapers describing the report as a 'whitewash'.

Richard Hamilton's art has long had a political and satirical dimension. His *Portrait of Hugh Gaitskell as a Famous Monster of Filmland* of 1964 (fig. 24, p. 35) was produced in answer to the self-imposed question, 'What angers you most now?' The artist found the answer in Gaitskell, the leader of Britain's Labour Party, whom he saw as 'the main obstacle to adoption by the Labour Party of a reasonable nuclear policy' at a time when much of the Labour movement was against 'our continuing nuclear attachment'.[82] A more recent example is *Shock and Awe* (2007–8), a portrait in which former prime minister Blair is cast as a gun-slinger (left). *Shock and Awe* is a direct response to the British participation in the war in Iraq, in which, it has been said, 'Hamilton captures precisely the lethal absurdity of his [Blair's] misidentification as Texas ranger.'[83]

Hamilton has described how a print *Kent State* (1970), which took as its subject the shooting of American student protestors by National Guardsmen, 'could help to keep the shame in our minds.'[84] Like prints, medals are multiples; made of metal, they are also enduring. Hamilton has made here what he calls a 'two-faced medal', referring to the human face that appears on each side but also punning on what he sees as the duplicity of the individuals depicted. Whereas the two heads on Cornelia Parker's medal (cat. no. 34) are reduced almost to anonymity, here they are presented openly, their expressions suggesting that they are extremely pleased with their actions: Blair grins on the obverse, whilst the reverse shows a smiling Alastair Campbell, the government press secretary who, it was claimed, had been instrumental in making changes to the Iraq report. The satirical potential of recontextualizing a pair of familiar faces recalls a seventeenth-century medal showing Oliver Cromwell and Thomas Fairfax as a devil and a fool (cat. no. 2). Hamilton's mock-religious legends are in Latin, a standard language for medals over the centuries.

Hamilton has always worked at the cutting-edge of technology. Here he converted colour photographs into black-and-white tones representing the depth of relief. He then transposed the tones on his computer using standard Photoshop tools, so that the white produced the highest relief – the tip of the nose – and black the background; bump map simulations of the three-dimensional object were rendered in Lightwave to check progress. A three-dimensional printing process under development at the University of the West of England produced regular wax relief trials. Finally, a master was milled to cast the edition. Hamilton's medal is in silver, a material that over time will tarnish – just as, he believes, will the images of Blair and Campbell.

Above
Mona Hatoum: *Nature morte aux grenades*, 2006–7, crystal, mild steel and rubber, 950 x 2080 x 700 mm.

Left
Detail from Mona Hatoum: *Nature morte aux grenades*, 2006–7.

28

MEDAL OF DISHONOUR, 2008

Mona Hatoum (b. 1952)

Cast bronze, 65 mm

Fabricated by MDM Props Ltd, London; cast by AB Fine Art Foundry Ltd, London

Edition: 12

2009,4066.7

Presented by the British Art Medal Trust

Salwa Mikdadi, 'The states of being in Mona Hatoum's artwork', in *Mona Hatoum*, exh. cat. (Amman: Darat Al Funun – The Khalid Shoman Foundation, 2008), pp. 59–73, at p. 71

OBVERSE:

صنعت في الولايات المتحدة
(Made in the United States).

REVERSE:

MH (Mona Hatoum) 2008 1/12.

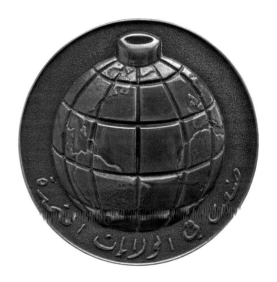

The obverse of this uniface medal is dominated by the image of a hand grenade, on which the outlines of continents are lightly indicated and the weapon's deeply incised grip-marks double as lines of longitude and latitude. Placed centrally on the circular medal, the grenade, which is of an older spherical design rather than the more usual contemporary lozenge shape, has a small detonator cap at its top and beneath it an inscription in Arabic. Apart from the artist's initials and the year and edition number, the reverse is blank, its polished surface allowing a warm but indistinct reflection to appear in the bronze. The artist's proposal for the medal and various models are reproduced here (overleaf).

The image of an exploding world has a medallic precedent in a Dutch work of 1689, in which a terror weapon favoured by the French is shown blowing itself apart in order to suggest that France is engaged in a process of self-annihilation (cat. no. 6). Hatoum, who was born in Beirut of Palestinian parents, used grenade imagery in her sculptural piece *Nature morte aux grenades* (opposite),[85] in which grenades made in multicoloured crystal were arranged on a steel table: displayed as desirable objects, they appeared festive and decorative in stark contrast to their deadly associations as weapons. The globe has been another theme of her work, as in the glowing neon sculpture *Hot Spot* (2006),[86] which is also concerned with conflict, while Arabic text was a key element of her video piece *Measures of Distance* (1988), where it was overlaid onto images of the artist's mother – and misinterpreted by some as barbed wire.[87]

As with all medals containing both image and written text, the present medal's inscription has both a formal and a critical function, but in this case the latter is available only to those viewers who read and understand Arabic. For much of their history Latin was the preferred language for medals, as this ensured that their messages would be understood by educated people across multilingual Europe. Here language is employed as a barrier between the work and much of its audience. The deliberate avoidance of English on a modern medal commissioned and produced in Britain will undoubtedly cause some unease among those excluded by the use of a script and language they do not understand; unless provided with a translation, the inscription represents a mysterious presence for which the primary associations for many westerners – particularly when seen next to the image of a hand-grenade – will be with little-understood cultures viewed mainly through news stories involving violence and death. A further surprise is that the inscription comprises no grand statement in the traditional medallic manner, but a commonplace piece of incidental information of the sort carried on millions of diverse manufactured items. Translated into English, it reads, 'Made in the United States'. However, although the image's reference to violence is clear, the relationships between the different elements of the medal remain ambiguous, and the piece, like all Hatoum's works, defies any single reading.

Mona Hatoum's *Medal of Dishonour* in production, 2007.

MONA HATOUM
PROPOSAL FOR MEDAL
TO BE CAST IN BRONZE
ABOUT 6CM DIAM.

GRENADE - LIKE GROOVES
CORRESPONDING TO 12 MERIDIANS
AND 5 PARALLEL LINES

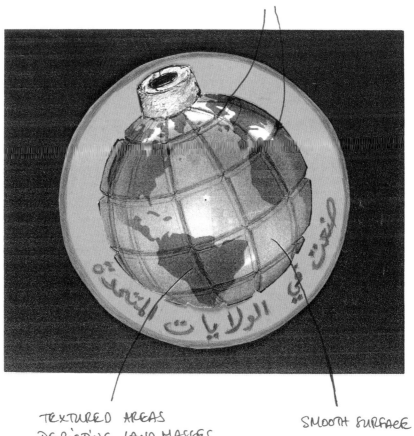

TEXTURED AREAS
DEPICTING LAND MASSES

SMOOTH SURFACE

Mona Hatoum: Proposal for *Medal of Dishonour*, 2007, graphite and ink on photocopied paper, 297 x 210 mm.

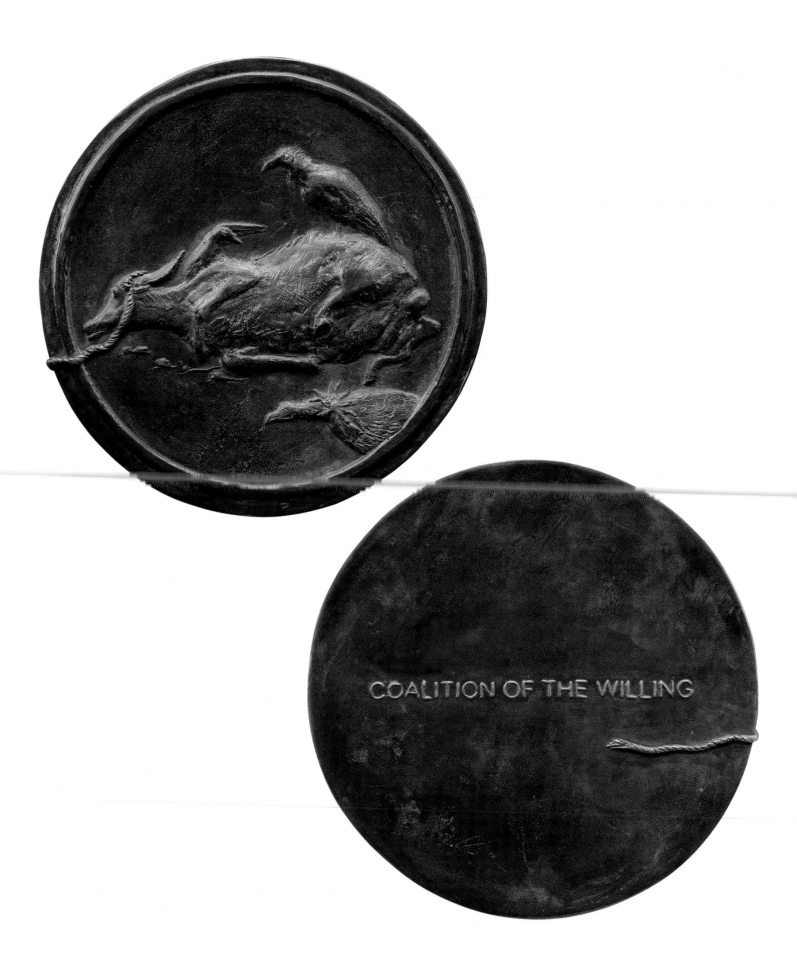

29

COALITION OF THE WILLING, 2008

Yun-Fei Ji (b. 1963)

Cast bronze, 121 mm

Modelled by Felicity Powell, London; cast by Niagara Falls Castings (UK) Ltd, Warwick.

Edition: 10

2009,4066.8

Presented by the British Art Medal Trust

REVERSE:
COALITION OF THE WILLING.

Yun-Fei Ji was born in Beijing and now lives in Brooklyn, New York. His subject matter touches on politically sensitive issues, which are expressed in code and phrased obliquely through the use of metaphor and allusion. Many of his past works have commented on recent changes in his home country, but this medal (like cat. nos 24, 27 and 34) refers specifically to the 2003 invasion of Iraq by the United States and its allies. The medal's title is a phrase that first entered public consciousness in late 2002, when it was used by US president George W. Bush to indicate mutual support and purpose among the allied nations. It has since been used with deeply ironic tones by political commentators,[88] and it is this ironic sense that underlies Ji's adoption of the phrase for his medal of a dead goat about to be attacked by vultures. The motives underlying the coalition's action are paralleled with those of scavenging birds surrounding an animal already reduced to a corpse; nor can the goat in any sense be said to be willing. This imagery brings to mind the reverse of a laudatory medal of Alfonso V, king of Aragon, by Pisanello, the fifteenth-century creator of the earliest medals, in which an eagle, vultures and other birds of prey surround the prostrate body of a dead deer;[89] the implications, though, form a marked contrast, for in this medal of 1449 the eagle is sharing its prey with the other birds and the whole is an allegory of liberality.

Jeremy Lewison has written of the present artist's graphic work: 'Ji draws from a satirical and grotesque streak that has roots deep in folklore, taking its inspiration from masters like Bosch and Bruegel, as well as from the biting humour of the great American comic strip artist Robert Crumb.'[90] Ji's drawing for the medal consists of fluid, rapid marks that are used to build the forms, convey the various textures of the surfaces made from hair and feathers, and cast light (above, right). There is a complex and shifting interaction between form, outline and illusionistic space. The technical considerations that inform the drawing are carried through into the cast medal, in which the image is rendered in shallow relief, thereby retaining the suggestion of traditional

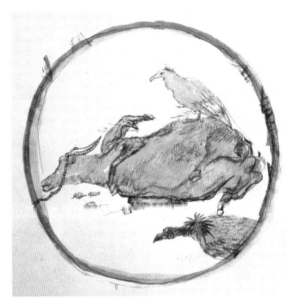

Yun-Fei Ji: *Coalition of the Willing*, 2007, graphite, ink and wash.

Chinese draughtsmanship (which constitutes another important basis of Ji's practice).[91]

On the obverse of the medal the swollen carcass of the goat and the surrounding vultures are contained within a raised circular border, with the plane of the ground indicated only by four small stones. The halter running from the goat's horn falls on to the stony ground, trails across the containing border and, with its detailed twists echoing the action of turning required to see the other side of the medal, navigates the edge in order to continue onto the reverse. Here, raised in relief, the text stands out starkly on a dark, empty ground, and the underlining of the word WILLING by the frayed rope adds a final note of irony. The two sides thus combine with the edge of the medal to lure the viewer into a state of complicity with the image: the text to which he or she has been led by the rope locates the viewer within the medal's subject and brings home its full caustic impact.

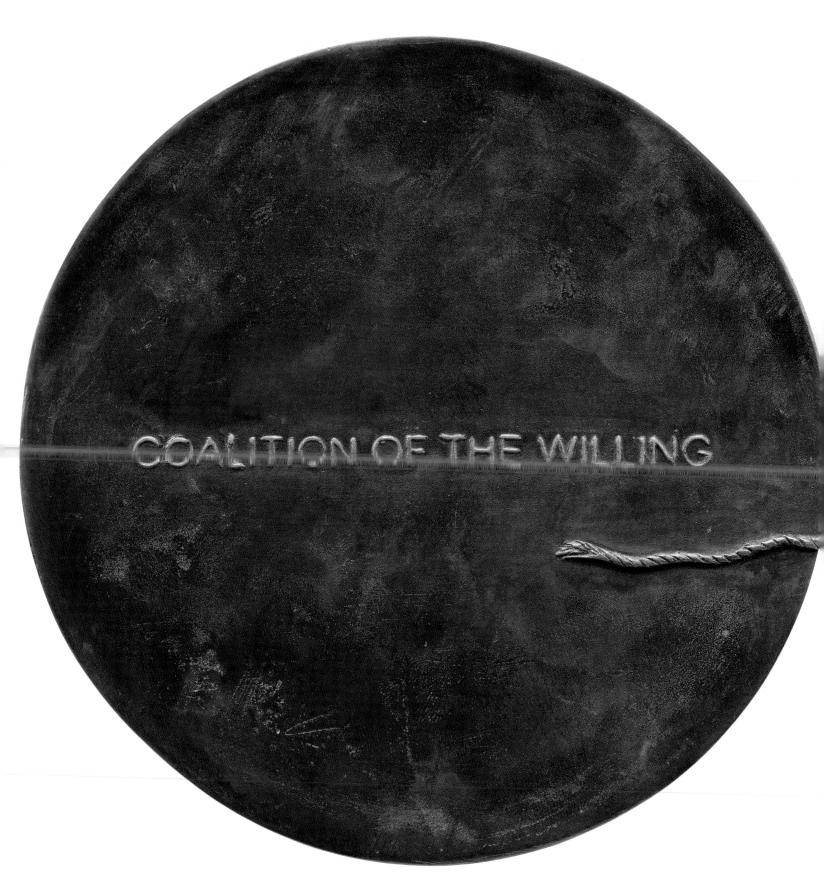

Yun-Fei Ji: *Coalition of the Willing*, enlarged.

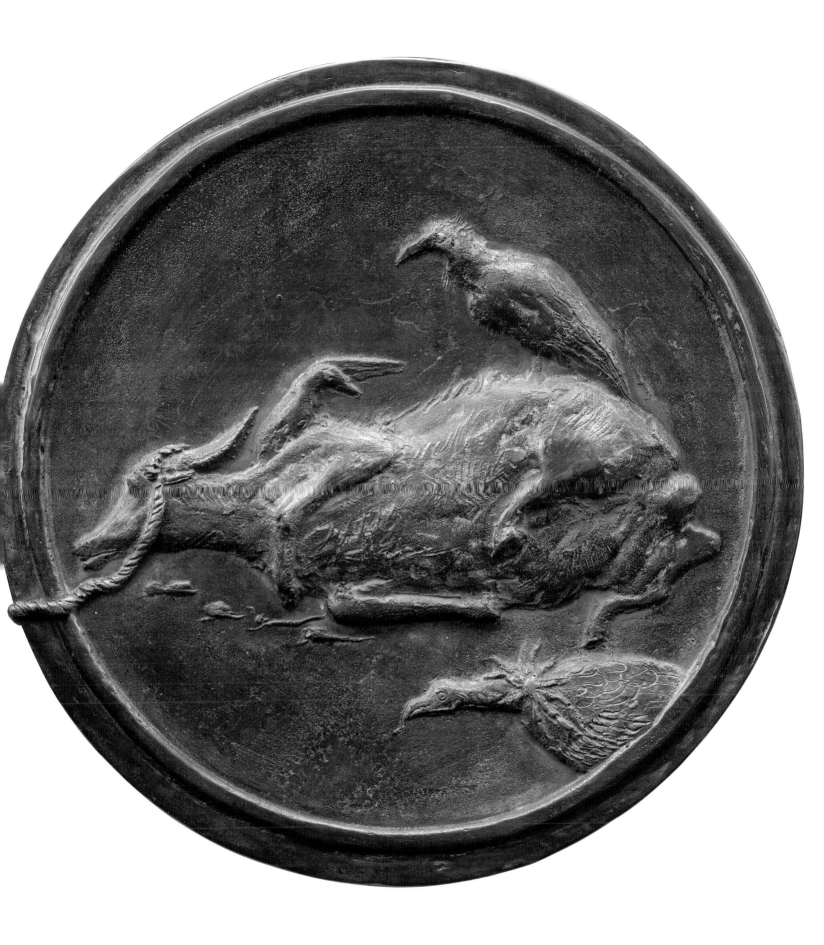

Медаль Позора" (Лондон, Британский музей, 2007)
THE MEDAL OF DISHONOUR (London, The British museum, 2007).

отверстия в медали
holes in the medal

6,5cm

back side (reverse. flat, smooth. without relief)
Обратная сторона (плоская, без рельефа)

"The bottom" (lower area of the medal)
"ДНО" (нижняя площадка МЕДАЛИ)

очень мелкие зубцы
very fine cogs.

relief of the wings
Рельеф крылышек

relief of the back
Рельеф спинки

relief of the abdominal part
Рельеф брюшка

relief Рельеф

"ДНО" медали "The bottom" of the medal

thin furrows тонкие

front side of the medal
ЛИЦЕВАЯ СТОРОНА МЕДАЛИ

ДИАМЕТР МЕДАЛИ = 6,5 см
ТОЛЩИНА = 5 мм
МАТЕРИАЛ: ТЕМНО-КОРИЧНЕВАЯ БРОНЗА

DIAMETER of the medal= 6,5cm
THICKness: = 5mm
material: - dark-brown bronze

Ilya and Emilia Kabakov: Design for *Medal of Dishonour*, 2007, ink and graphite, 296 x 421 mm.

30

MEDAL OF DISHONOUR, 2007

Ilya and Emilia Kabakov (b. 1933 and 1945)

Cast and engraved bronze, 66 mm

Modelled by Felicity Powell, London; cast by BAC Castings Ltd, London; engraved by George Lukes, London

Edition: 5 silver, 3 bronze

2009,4066.9

Presented by the British Art Medal Trust

EDGE:
MEDAL OF DISHONOUR I & E KABAKOV BAMT 2007 3/3

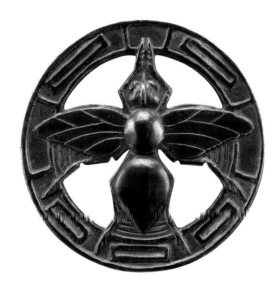

Flies are a recurring motif in the Kabakovs' work, appearing as a physical presence, an abstraction and an elaborate metaphor in works as diverse as the enamel on plywood *Queen Fly* (1965) and the installation *Life of Flies* (1992, fig. 00, p. 00).[91] In the present medal the fly is depicted as a single form in low relief, with wings and legs delicately outstretched to fix it to the encircling band that defines the area of the medal. The spaces between the hind and middle legs and between the wings and forelegs are cut away, while other spaces have striations laid in curves suggesting vibration. Bronze examples (the medal has also been cast in silver) have a rich dark brown patina, with the insect's body and wings burnished almost to iridescence. The reverse of the medal is flat, with the outlines created by the pierced areas forming a ghostly counterpart to the three-dimensional obverse. The engraved inscription is confined to the rim and gives the medal's title, the artists' names, the commissioning body (the British Art Medal Trust), the year the medal was conceived, and the edition number.

A rare historical precedent for the appearance of an insect as the central motif of a medal is the Bonapartist cockchafer in a work by an unknown French artist, in which the crude vitality of the image bordering on vulgarity is suggestive of the artist's opinion of his subject (cat. no. 15). The fly in the present medal, with its blend of rounded and angular forms and polished and matt surfaces, is an altogether more ambivalent presence. Despised for the dirt and disease they carry and generally perceived as the antithesis of all sorts of benevolent flying creatures from bees to angels, flies are generally non-aggressive; they also predate the evolution of human beings, their multi-facetted eyes the witnesses of passing civilizations.

The Kabakovs' schematic drawing for the medal is annotated with precise instructions in Russian and English as to how the finished work should appear (opposite). It relates closely to drawings of 1992 for *Life of Flies*,[93] but also recalls aspects of Ilya Kabakov's work as a children's book illustrator in the Soviet Union between 1959 and 1987, a time when his art was subject to rigorous scrutiny and control by the Soviet authorities and had to fit within prescribed doctrines concerning illustrative methods. The artist's response was to adopt another persona: 'it wasn't "I" but "he (the social character)" who illustrated all the books, although "he" drew using my hand.'[94] This theme of the multiple personae of the artist has been taken up in the Kabakovs' work since leaving Russia, notably in *An alternative history of art: Rosenthal Kabakov Spivak*, in which all three protagonists, including Kabakov himself, are imaginative constructs.[95]

The medal belongs very much within this schema, proposing several versions of itself, each plausible but equally fictitious. Recalling perhaps the imagery of Soviet military badges, with their crossed weapons and hand-tools, their wings and warplanes, could this medal be the insignia of an army of flies, with the swarming and destruction that that implies? Its formal beauty and sense of symbolic purposefulness give it the authority of an historical artefact produced within the context of a society in the process of decay.

31

GREED ENVY RAGE, 2008

William Kentridge (b. 1955)

Cast bronze, 110 mm

Cast by Bronze Age Art Foundry, Simon's Town, South Africa

Edition: 8

2009,4066.10

Presented by the British Art Medal Trust

REVERSE:

GREED ENVY RAGE. WJK (William Joseph Kentridge) 2008.

The art of William Kentridge is steeped in the political and historical contingencies of apartheid and post-apartheid South Africa, but in its broad themes and attachment to sympathetic narratives it is universal. In his drawings for the present medal Kentridge rehearses many of the iconic images that populate his artistic world: the megaphone, here fused with a horse's body; the gas mask that resembles an elephant's head; the globe set on slender mechanical legs resembling inverted electricity pylons; and, in the sketch closest to the final design, the megaphone striding through a landscape (overleaf).

Works by Kentridge in which the motif of the walking megaphone has appeared include bronze figures of various sizes, films such as *Felix in Exile* (1994), one of a series of animations set in South Africa (see fig. 25, p. 36), and the sculpture *Phenakistoscope* (2000), which incorporates two vinyl records and lithographs.[96] Along with the gas mask, it has featured more recently in a series of prints entitled *L'Inesorabile Avanzata* (*The Inexorable Advance*) (2007) and an anamorphic film *What Will Come (Has Already Come)* (2007), a work that centres on the Italian invasion of Ethiopia of 1935 and includes as part of its soundtrack a popular Italian song of the time, 'Facetta nera' (Little black face), as well as the sound of exploding bombs.[97] Just as the viewer's understanding of the anamorphic film is enabled by the use of a central polished chrome cylinder to amend the distortions of the drawings, so the weight and protruding points of the medal are devices that opens up its meaning. The sharp elements emerging from the megaphone have the appearance of both multiple tongues emanating from a gaping mouth and drills;

created from screws inserted into the artist's original model, they add to the image's mechanical and malevolent aspects and increase the viewer's disconcertion by rendering the medal problematic as a tactile experience.

The legs of the monstrous creature depicted here resemble calipers, giving the suggestion of stiff-jointed movement, something between a waddle and a goose-step. The dry scrub-land through which it moves and the low flat horizon are reminiscent of the veldt around Kentridge's native Johannesburg. The megaphone seems not simply to amplify sound but to create it, even though it is detached from any discerning brain. Of the three words on the medal's reverse, GREED and RAGE are shown in relief, whereas ENVY, perhaps because it is a more insidious emotion, is incised and has been given the added flourish of a seriffed font. These words refer to three of the seven cardinal sins, but the use of 'rage' in place of the more commonly used 'anger' or 'wrath' adds an imperative quality, shifting the words from a descriptive into an active mode: the implication is that these are commands issued by the megaphone. The medal is animated by Kentridge's vigorous handling, redolent of the expressionist style of some of the First World War German medallists, with Ludwig Gies' beast of 1917 (cat. no. 18) offering a grim precedent for this unatural being. It is, however, typical of Kentridge's nuanced approach to all his work that this sinister megaphone construction also has a pitiful aspect: the curve of its 'back' and upturned 'head' suggest something human, as though, isolated and bellowing as it is, it is raging against its own condition and is itself trapped within the tyranny it enforces.

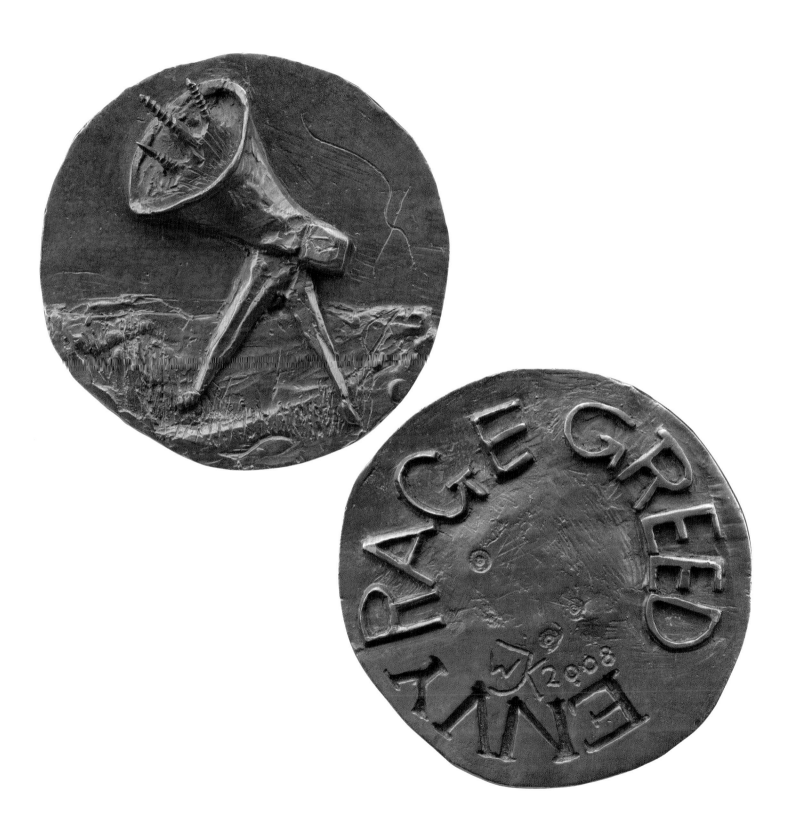

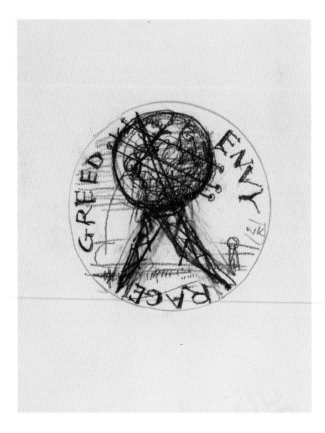

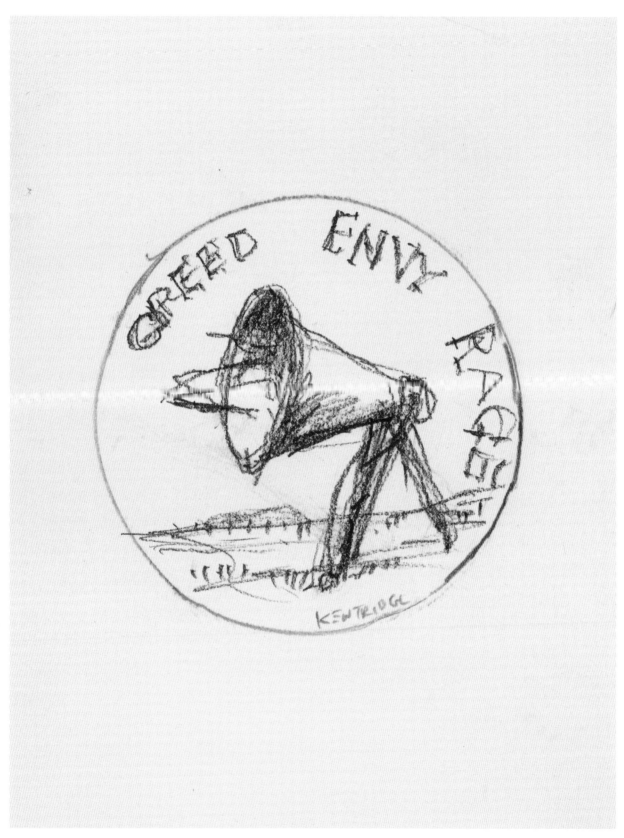

William Kentridge: Five drawings for *Greed Envy Rage*, 2008, black and red chalk, all 115 mm diameter.

Presented to

DEAN ROWBOTHAM

for breaking his **ASBO**

on more than 20 occasions

WHAT HE DID:

Issued threats of violence

Was verbally abusive

Harassed residents of Hartlepool

Caused a nuisance while under the

influence of alcohol in public

Damaged property

Threw missiles

32

ASBO MEDAL, 2008

Michael Landy (b. 1963)

Photo-etched brass, 89 mm

Photo-etched by Mercury Engraving Ltd, London

Edition: 3

2009,4066.11

Presented by the British Art Medal Trust

REVERSE:
Presented to DEAN ROWBOTHAM for breaking his ASBO on more than 20 occasions WHAT HE DID: Issued threats of violence Was verbally abusive Harassed residents of Hartlepool Caused a nuisance while under the influence of alcohol in public Damaged property Threw missiles.

Michael Landy is ill be best known in many for *Break Down* (2001), in which he catalogued and then destroyed each of his 7,227 possessions. His next major work was *Nourishment* (2002), a series of etchings depicting the flowers that grow unnoticed in the cracks in urban pavements. More recently he has turned to portraiture.[98] In their different ways these works reveal a central theme in Landy's work, leading us into an examination of the familiar and the overlooked. The present medal continues this exploration.

The ASBO (Anti-Social Behaviour Order) was introduced in Britain in 1998 as a non-custodial punishment for an individual considered to be acting 'in an anti-social manner, that is to say, in a manner that caused or was likely to cause harassment, alarm or distress to one or more persons not of the same household as himself'.[99] Newspapers soon began to report that it was regarded by some young people as a 'badge of honour'. The obverse of Landy's medal carries a photo-etched facing portrait of Dean Martin Rowbotham, who in December 2006, at the age of seventeen, received an ASBO, and who subsequently agreed to be the subject of this medal. The photograph, taken by Landy, is similar to the one used on the leaflet distributed locally to notify the public of Rowbotham's misdemeanours and punishment, whilst the reverse of the medal has text taken directly from the leaflet (overleaf). An historical example of this sort of division between obverse and reverse is provided by a sixteenth-century Italian medal bearing on one side a portrait of an Italian clergyman Gabriele Fiamma and on the other a 25-line inscription listing his achievements; such statements as 'Even as a boy he produced works of highly accomplished

learning' and 'Rivalling the divine eloquence of our ancient forefathers, he gained not a little glory' may appear unattractively pompous and self-aggrandizing to a modern audience.[100] Landy has taken this format but up-ended the life story, replacing exemplary qualities with anti-social behaviour. Yet even here there may be an element of boastfulness on the part of the medal's subject, as Hartlepool police have records of seven ASBO breaches by Rowbotham rather than the 'more than 20' claimed on the medal.

The medal is made of brass, an alloy of copper and zinc, which is lighter and more yellow than bronze, the more usual medallic metal. It is also cheaper, and is well-known as a signifier of low status – a connotation exploited in James Sayers' medallic etching of 1783, *A Coalition Medal Struck in Brass* (fig. 10, p. 21). When polished, the metal is highly reflective and, if the present medal is looked at directly, the viewer's reflection appears underneath the etched image, seemingly contained within the medal rather than superimposed upon it. In taking up the medal, we unavoidably hold up a mirror to ourselves.[101] Landy's medal courts controversy. The combination of portrait image and formal inscription places it within the tradition of the medal as a designator of status. Are we meant, therefore, to see the medal as an award for bad behaviour? Certainly, it inverts the norm whereby medals commemorate what is honourable and replaces it with a celebration of selfishness and destructiveness. Is Landy lampooning a perceived ineffectiveness in the official response to such behaviour? Is Rowbotham the target of his satire? Or is his intention more subtle: to make visible the contradictions and multivalence of all our everyday lives?

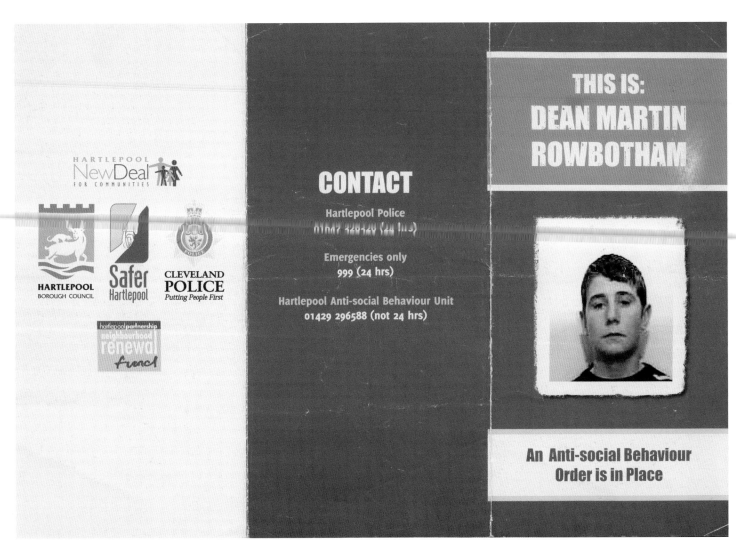

**THIS IS:
DEAN MARTIN
ROWBOTHAM**

CONTACT

Hartlepool Police
01642 328120 (24 hrs)

Emergencies only
999 (24 hrs)

Hartlepool Anti-social Behaviour Unit
01429 296588 (not 24 hrs)

**An Anti-social Behaviour
Order is in Place**

HARTLEPOOL
NewDeal
FOR COMMUNITIES

HARTLEPOOL
BOROUGH COUNCIL

Safer
Hartlepool

CLEVELAND
POLICE
Putting People First

hartlepool partnership
neighbourhood
renewal
fund

Printed leaflet, 2006, 211 x 297 mm.

NAME:

DEAN MARTIN ROWBOTHAM

WHAT HE DID:

- Issued threats of violence

- Was verbally abusive

- Harassed residents of Hartlepool

- Caused a nuisance while under the influence of alcohol in public

- Damaged property

- Threw missiles

The Courts have issued an Anti-social Behaviour Order for the duration of three years against **DEAN MARTIN ROWBOTHAM** which states that he must not:

- Act in a manner that causes or is likely to cause harassment, alarm or distress to one or more persons not of the same household as himself within England and Wales.

- Encourage or incite others to intimidate or seek to intimidate any person within England and Wales.

- Consume alcohol in an unlicensed public place.

- Associate with Dean Paul Stallard and/ or Liam Gascoigne in a public place.

- Congregate in a group of three or more people (including the defendant) where the behaviour of the group as a whole causes or is likely to cause harassment, alarm or distress.

If at any time, **DEAN MARTIN ROWBOTHAM** breaks the terms and prohibitions of his ASBO, he will be arrested and is liable on conviction to receive a custodial sentence.

WHAT YOU CAN DO

If you see **DEAN MARTIN ROWBOTHAM** breaking the terms and prohibitions of his ASBO, please contact Hartlepool Police or Hartlepool's Anti-social Behaviour Unit. You can be safe in the knowledge that we will protect your privacy and that you are helping to make your area safer.

LET'S WORK TOGETHER

DEAN MARTIN ROWBOTHAM is now experiencing the consequences of his own anti-social behaviour. If others are behaving in the same way, let us work together to stop them. This ASBO is proof that residents are successfully stopping unacceptable behaviour by working with the Council and the Police. By getting involved, you will be helping to make life safer for your family as well as improving your community – take back the control.

The recovery has started – with more help from you we can work together to tackle Anti-social Behaviour.

YOUR SAFETY COMES FIRST

When you call us on the numbers listed on the back of this leaflet, we promise to act quickly on the information you provide about **DEAN MARTIN ROWBOTHAM** or others behaving anti-socially.

33

VIRTUAL WORLD, 2008

Langlands and Bell (b. 1955 and 1959)

Struck and enamelled silver, 75 mm

Struck and enamelled by Thomas Fattorini Ltd, Birmingham

Edition: 25

2009,4066.4

Presented by the British Art Medal Trust

OBVERSE: CIA UDA ALF GIA IRA AIM DIE ETA SAS LRA ALA WHO HRW PHO IRC MSF CIC JEN AMI IMC NCA PWJ MDM WIN GMS DDG CRF HHI COW UNO DAM MAD HAM LHR SIN MEX BOM LAX SYD RIO HKG BIO ROM WAR TYO AMS BUD HEL WAS DUB PEN BOG MRS HAV TIP IST BSR DKR ATH CAS.

REVERSE: .es .va .za .ie .ye .ro .qa .vn .fr .tw .kw .uz .zw .ru .om .rw .ar ᴵᵁᴬ ᴵᵁᴵ ᴵᴵᴵ ᴵᴵᴵ ᴵᴵᴵ ᵁᴵ ᴵᵁ ᴵᴵ ᵁᴵ ᴵᴵ ᴵᴵ ᴵ ᴵ ᴵ ᴵ ᴵ ᴵᴵ ᴵᴵ ᴵᴵ ᴵᴵ ᴵᴵ .sa .nl .it .se .ch .nz .pk .cn .ma .bg .iq .hk .no .be .lb .dk .bd .cg .de .ad .kz .ae

EDGE: VIRTUAL WORLD LANGLANDS & BELL 2008 1:25.

The obverse of this medal is enamelled in coloured rings of black, blue and red, with a central white spot and lettering in silver: the outer ring bears the codes of various international airports; the middle ring has the acronyms of some of the non-governmental organizations (NGOs) working in Kabul in 2002; and the inner ring mixes the acronyms of state-sponsored bodies and proscribed groups from around the world with other three-letter words that make clear the violent aspect of this particular assemblage. The reverse, of unadorned silver, has raised letters giving the internet domain codes of sixty countries in the familiar format of lower-case letters preceded by a dot. The artists' names, the medal's title, the year and edition number are engraved on the rim.

Langlands and Bell have described their work as an exploration of 'systems of international communication and exchange – linked at times to issues of geo-strategic confrontation', a statement taken up by Angela Weight with reference to the artists' commission from London's Imperial War Museum to research the aftermath of the September 11th attacks and the war in Afghanistan;[102] it may also be applied to the medal. Within the body of work that resulted from the artists' stay in Afghanistan in 2002 were computer animations, prints and flag designs that incorporated similar combinations of acronyms and abbreviations (overleaf),[103] elements that have been further developed in other more recent works. The circular arrangement of airport codes in the medal's outer ring recalls the various versions of the artists' *Frozen Sky* (1999),[104] as well as the huge neon and glass *Moving World (Night and Day)* (2008), commissioned by the airport company BAA for London Heathrow's new fifth terminal. In all these works the texts appear as concrete poems. In the case of the medal the form they take is that of a target.

Historically, medals have often used coded language to convey their message and Langlands and Bell have brought this conceit right up to date. The text can be read both within and across the rings and, with no hierarchy imposed on its arrangement, the viewer, turning the medal in the hand, can begin and end anywhere. Familiar codes and acronyms leap out instantly, while unfamiliar ones are all the more disquieting for being intimately connected with those that are recognizable; licit and illicit organizations become interchangeable, indistinguishable from each other in a dizzying whirl. In an attempt to decipher the medal, the viewer becomes caught up in a game that is puzzling and sometimes bleakly humorous. For the English speaker, the airports include the innocuous MRS (for Marseilles) but also the more ominous MAD, SIN and WAR (Madrid, Singapore and Waris in Indonesia), and it is tempting to question whether DIE and AIM might be actual terrorist or anti-terrorist organizations rather than indications of the purpose and methods of all bodies that employ violence to achieve their ends. Turning the medal over, one moves from the physical to the virtual world, where the cyberspace locations are suggestive of the global strategies now open to such organizations. A similar duality is evident in the form of the medal, its polished surfaces and machined edges lending it the appearance of a scientific instrument, a reading that is soon subverted by the incongruous textual juxtapositions that reject classification. The medal is a global compass that points us everywhere at once.

Langlands and Bell: *Ruined Palace*, from the folio 'world wide web.af', 2004, Piezo pigment ink jet print on Hahnemuhle photo rag paper, 660 x 850 mm.

Cornelia Parker: *Chomskian Abstract*, 2007, stills from a video.

34

WE KNOW WHO YOU ARE. WE KNOW WHAT YOU HAVE DONE, 2008

Cornelia Parker (b. 1956)

Struck silver, 38 mm

Modelled by Danuta Solowiej, London; struck by Tower Mint Ltd, London

Edition: 13

2009,4066.2

Presented by the British Art Medal Trust

OBVERSE:
WE KNOW WHO YOU ARE.

REVERSE:
WE KNOW WHAT YOU HAVE DONE.

On each side of this work a man turns his face against the outside world and looks into the heart of the medal – and into the eyes of the other. Although the two heads are intended to represent any number of powerful men around the world, they are modelled on those of former US president George W. Bush and former British prime minister Tony Blair. Unlike Richard Hamilton's medal of Blair and Alastair Campbell, in which the expressions of the two men imply undisguised self-satisfaction (cat. no. 27), Parker's turning of the heads away from the gaze of the viewer suggests a more general anonymity. The impossibility of our seeing their faces also brings with it a suspicion of untrustworthiness, much in the manner of Christian Wermuth's medal of the back of the financier who disappears when it suits him (fig. 8, p. 20). The view of the two heads on the present medal turns a close relationship into a secret conspiracy.

Although the text is divided between the two sides of the medal, it is clearly intended to refer in its entirety to each man. The phrase was used against Bush in 2001, in a speech given by Vietnam veteran Ed Reiman protesting against Bush's narrow victory in the previous year's presidential election: 'And I am here to tell Dick Cheney, Don Rumsfeld, Henry Kissinger, George Shultz, James Baker and the rest of the Committee running this country – and the corporations that own them (like Boeing, Lockheed Martin, TRW, and others) – We know who you are, we know what you've done and how you did it, and – if we have our way – this is your last hurrah!'[105] The medal's extension of the application of the phrase to Blair makes an implicit reference to the 2003 US-led invasion of Iraq, of which the British prime minister was a key supporter. The absence of immediately recognizable faces extends it even further to all powerful, and sometimes publicly little-known, groups of men who exercise political and economic influence. The allusion is to all that is faceless (the anonymous bureaucrat), secretive and covert (as, for example, recent cases of extraordinary rendition).

Coins and medals have in the past formed a starting point for several of the artist's works, as in the flattened coin sculpture *Matter & What It Means* (1989), *Embryo Money* (1996), *Stretched Medal* (1992), in which a medal that had been passed through heavy rollers was suspended by wire, and *The Measure of a Man* (2004), wire drawn out from a silver war medal.[106] Sadie Plant has described such works as 'an endorsement of the importance of material culture as a kind of foundation, a cultural unconscious, the matters underlying our aesthetics and ideas'.[107] Plant also noted that the artist's focus shifted in a recent work, *Chomskian Abstract* (2007), a video of an interview with the American philosopher Noam Chomsky centring on 'ecological catastrophe and military might' (opposite). Parker had written to Chomsky requesting an interview on 'the unfolding environmental disaster now threatening our world',[108] but the final work covered a broad range of interrelated political and economic subjects that included big business, consumerism and the Iraq invasion, extending to the harm done to the country's archaeological sites. In its small size and low relief the present medal mirrors and subverts the traditional official medal presented as an award of honour, and brings together Parker's concerns for materiality and world affairs.

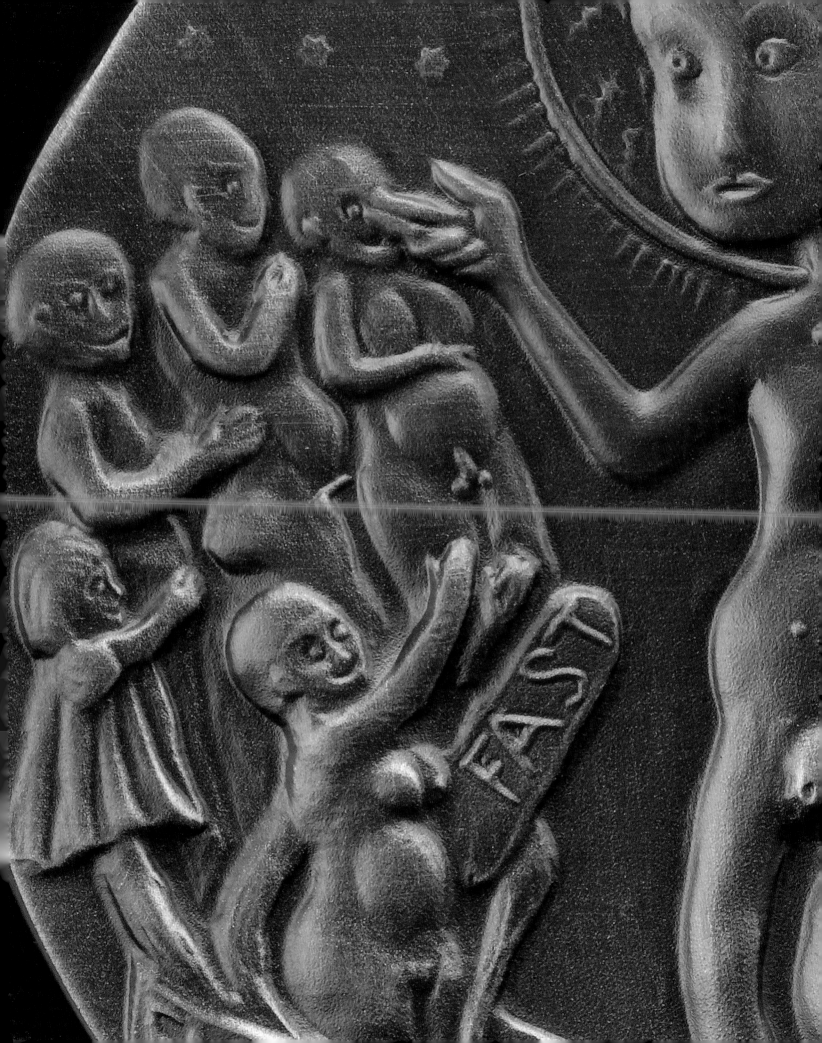

35

FOR FAITH IN SHOPPING, 2008

Grayson Perry (b. 1960)

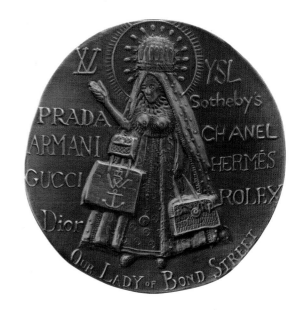

Struck copper, 70 mm

Struck by Toye, Kenning & Spencer Ltd, Birmingham

Edition: 53

2009,4066.12

Presented by the British Art Medal Trust

OBVERSE: LV YSL Sotheby's PRADA CHANEL ARMANI HERMÈS GUCCI ROLEX Dior OUR LADY OF BOND STREET.

REVERSE: FAST EASY SIMPLE SLOW HARD COMPLEX BORN TO SHOP.

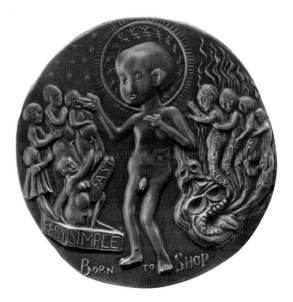

This medal is dedicated to the contemporary western culture of consumerism. Making playful use of historic prototypes, it borrows much of its imagery from the medieval works of art that the artist saw during a tour of continental Europe taken in 2007 when he was beginning to think about the medal and during which he visited many cathedrals. The appearance of a fine art auctioneer among the names indicates that the critique extends to the art world, and Perry acknowledges that he himself is not excluded from its focus.

The obverse shows a haloed figure wearing a star-spangled cloak and richly decorated crown. At first glance she resembles historical representations of the Virgin as the Queen of Heaven, but a closer examination very soon reveals major differences between this gaunt creature and her Christian prototype: the expression is not one of serenity but of avarice; beauty and modesty are replaced by hollow eyes and exposed breasts; a pound sign dangles at the end of her rosary; and instead of the traditional attributes of orb or sceptre she carries a mobile phone and a variety of shopping bags. The dollar signs and logos of expensive cars and fashion houses that adorn her robe and (along with Perry's own mark) the largest of her bags are depicted in obsessive detail, but under all her finery she appears as though in a trance, trapped by the array of luxury brands that surround her. The inscription below identifies her as the patroness of one of London's most exclusive shopping streets.

The reverse shows a similar metamorphosis, with Christian imagery appropriated to the god of commercialism. The Christ child is transmuted into a grotesque infant, not born to save the world, as the Christian message has it, but, as the legend says, BORN TO SHOP; pound signs decorate his halo. The imagery around him derives from medieval judgement day scenes, in which the ultimate fates of the righteous and the sinful are contrasted. On the left, smiling figures receive the blessing of the child under a starry heaven. Some appear to be in a state of sexual arousal and one is perhaps Perry himself dressed as his transvestite alter ego, Claire. The words surrounding this group are those of the ubiquitous catch-phrases of advertising. By way of contrast the figures to the right of the child are being consumed by flames issuing from the mouths of monstrous skulls. The words are the exact opposites of those on the left and show that these people are suffering because of the very different choices they have made. In this deeply ironic medal the activity of shopping has been elevated above any more complex and hard-won understanding of the world and the shopper is eternally rewarded.

Perry is best known as a potter,[109] in whose work the making process is a vital element. For the present medal he modelled two large terracotta roundels (overleaf), which were scaled down mechanically to produce dies from which the medals were struck. This reducing process intensifies the detail that covers the surfaces and produces a decorative richness that is also found in the artist's ceramics: 'I find it difficult to leave empty space, my instinct is to cover up emptiness and always elaborate It's part of my psychological make-up that I'm a detail freak.'[110] Some of Perry's pots are deliberately stained so as to look old;[111] the choice of metal and finish gives the medal an antique look that will increase with time.

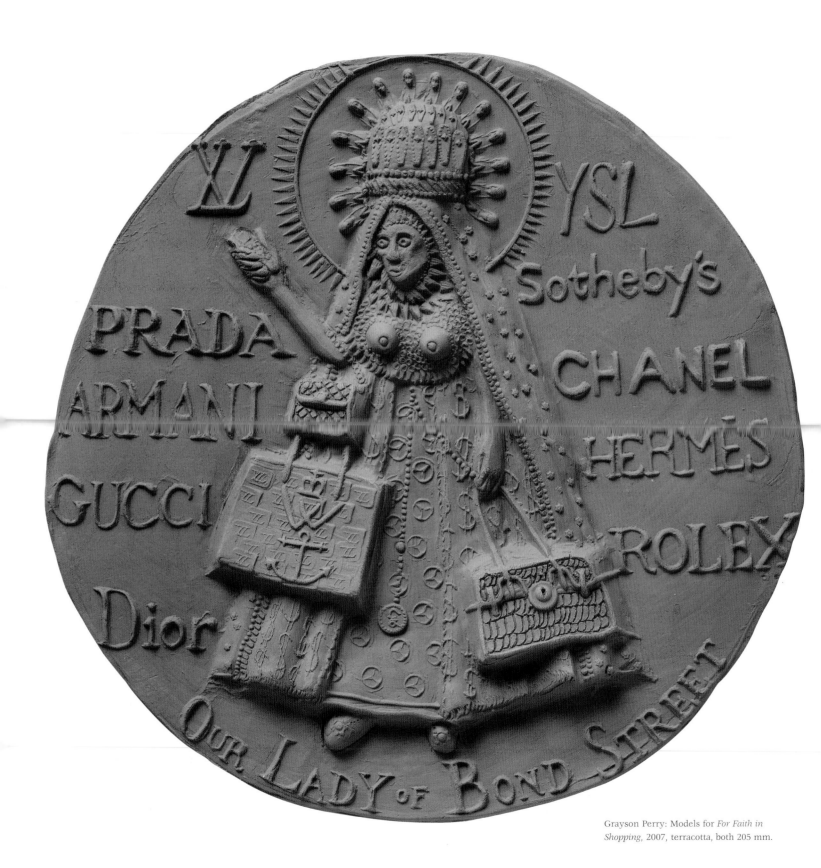

Grayson Perry: Models for *For Faith in Shopping*, 2007, terracotta, both 205 mm.

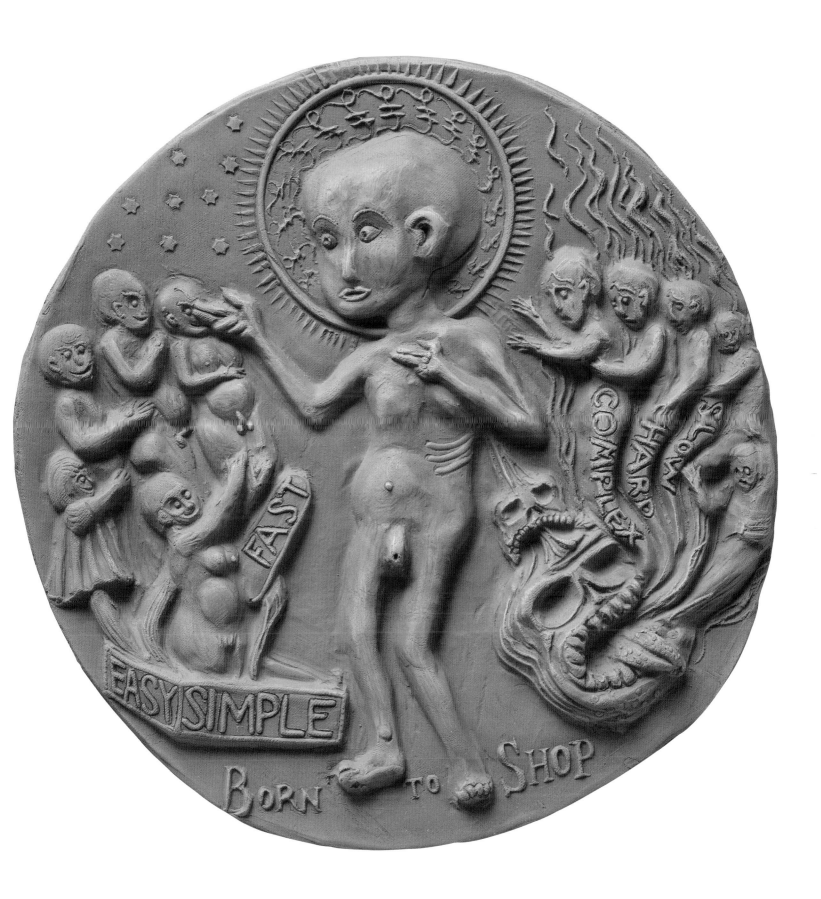

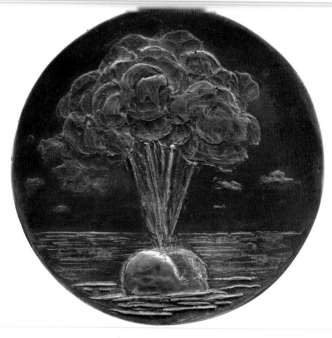

36

HOT AIR, 2009

Felicity Powell (b. 1961)

Cast and assembled bronze and printed fabric tape, 85 mm

Cast by Niagara Falls Castings (UK) Ltd, Warwick

Edition: 10

2009,4066.13

Presented by the British Art Medal Trust

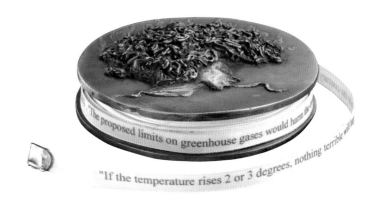

This medal takes the form of a retractable tape measure, on which
numbers have been replaced with words that act as an unravelling
edge inscription in a stream of retractable quotes. The head on the
obverse undermines the traditional medallic notion of the profile
as the noblest aspect of the head. Shown gently steaming, it has a
protruding whiplash tongue that echoes the action of the tape and,
like it, suggests the idea of verbal retraction. The buttocks breaking
wind on the reverse indicate that there is hot air at this end too.
The meaning of the words on the tape is barely discernible, over-
whelmed as it is by the dissonance of yet more words and phrases.

Neither the head nor the words belong to any particular indi-
vidual. Instead the reference is to a type – the metaphorical 'big
wig' or universal glib-tongued politician – with the snake-like tongue
and hot air intended to suggest political posturing on the subject of
carbon emissions and climate change. The snake, a traditional sym-
bol of evil, also brings with it an allusion to the fraudulent remedies
for illness known as snake oil. In this work Powell makes full use of
the powerful resonance of historical medals: the reverse conflates
the exploding world and undignified scatology that make up the
two sides of a Dutch medal of 1689 intended to humiliate Louis XIV
of France (cat. no. 6), while the wind imagery evokes medals of
around 1720 condemning unrestrained and irresponsible financial
speculation and greed (cat. no. 8).

Powell's preparatory sketches for the medal were worked up
in white wax on a dark ground, the wax appearing both bony and
fleshy, dense and translucent (overleaf). This process, which
reverses the usual drawing practice of placing dark upon light, has
long been the traditional way of making models for medals. It is
exemplified by a collection of 124 wax models on slate made by the
Hamerani family in Rome between the seventeenth and nineteenth

centuries, which was acquired by the British Museum in 1998.[112]
These have been much admired by Powell, who has produced
finished works in this way as well as a related animation *Anima*
(2005).[113] Most of the Hamerani waxes were for struck medals, and
their principal function was to show the patron the design and to
serve as a pattern for the die-engraver, but similar models are also
used as part of the making process for cast medals. It was in this
way that Powell's reliefs for the present medal were used, moulds
being taken from which the obverse and reverse of the medals were
cast in bronze.

Fragile life forms have been a theme running through Powell's
artistic practice, as in drawings such as *Fallen Fruit* (2001; British
Museum), medals such as the *Millennium Medal* (1999)[114] and
Delesseria (2006; British Museum), and larger works including her
installation *Drawn from the Well* (2002) in the Victoria and Albert
Museum's European sculpture galleries, in which etched mirrors
inserted into Renaissance well-heads responded to the theme of
water.[115] The present medal develops the previously unspoken
political implications of such works.

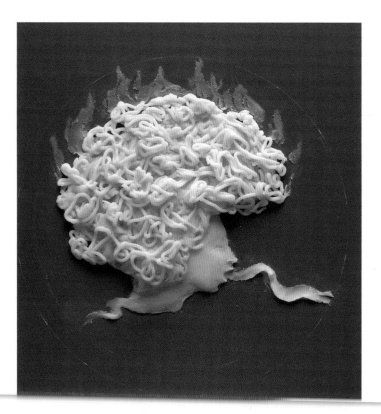
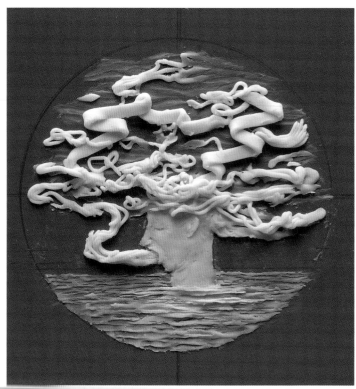
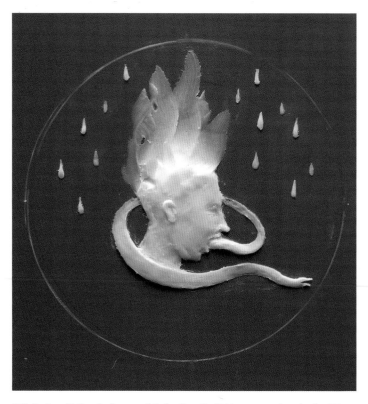
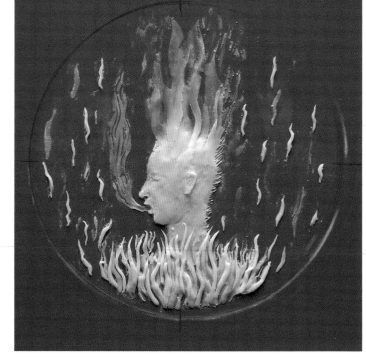

Felicity Powell: Details from models for *Hot Air*, 2008, wax on mirror backs, 200 mm.

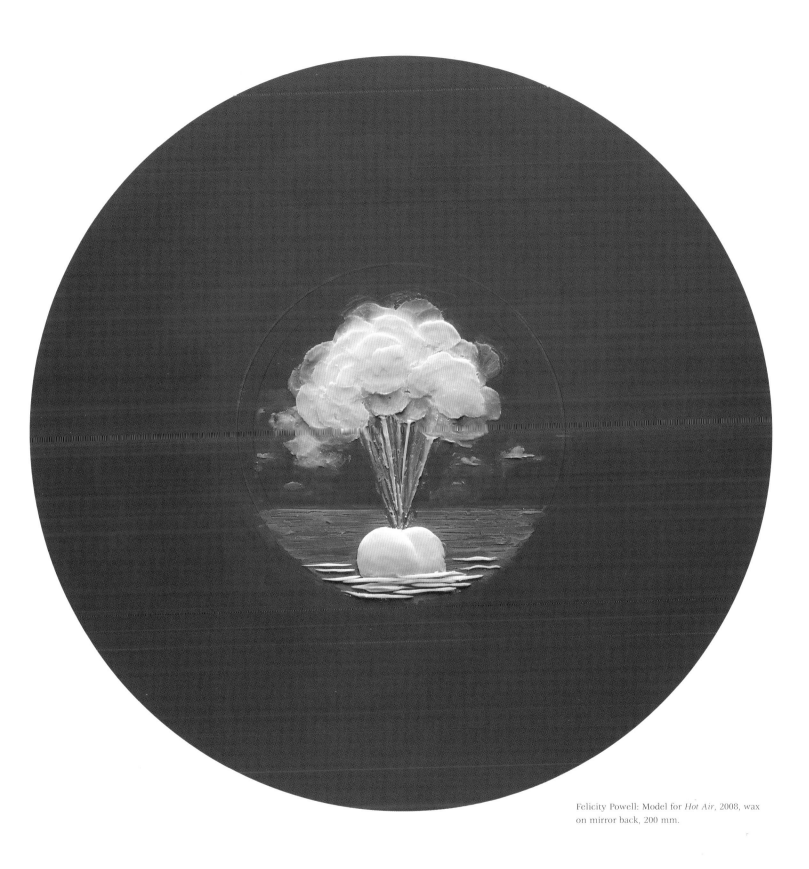

Felicity Powell: Model for *Hot Air*, 2008, wax on mirror back, 200 mm.

NOTES ON MEDALS

1 Roovers 1953.

2 G.P. Sanders, 'The Awards of the United Provinces', *The Medal*, no. 44 (2004), pp. 5–12, at p. 9.

3 Habich 1929–35, vol. i, part 1, p. 100, 701–4; vol. ii, part 1, p. 286, cat. 1979–80; Barnard 1927; George 1959–60, vol. i, p. 6, pl. 2; Margildis Schlüter, *Münzen und Medaillen zur Reformation 16. bis 20. Jahrhundert* (Hanover: Kestner-Museum, 1983), pp. 20–21.

4 Quoted in Barnard 1927, p. 45.

5 Cromwell's religious non-conformism led to his continuing association with the devil and Antichrist into the 18th century, as in George Bickham the Elder's *A genealogy of Anti-Christ. Oliver Cromwell triumphant, as head of yᵉ fanaticks and their vices, supported by devils*; Stephens and George 1870–1954, vol. i, cat. 820. With the establishment of the Protectorate in 1653, a parliamentary supporter might also see him as the Antichrist; Christopher Hill, *Antichrist in seventeenth-century England*, revised ed. (London and New York: Verso 1990) pp. 121–2.

6 Hawkins 1885, vol. i, p. 578, no. 250.

7 Manning, *The emblem*, pp. 318–19, for Rex Whistler's Shell advertisement of 1932 juxtaposing a mayor and mayoress.

8 Woolf 1988, p. 20.

9 Evelyn 1697, pp. 149, 151; Van Loon 1732–7, vol. iii, pp. 306–7; Hawkins 1885, vol. i, p. 613, cat. 23; p. 615, cat. 27.

10 Hawkins 1885, vol. i, p. 698, cat. 100.

11 Van Loon 1732–7, vol. iii, p. 437; vol. iv, p. 138; Hawkins 1885, vol. i, pp. 701–2, cats 105–6; vol. ii, p. 88, cat. 307.

12 Claude Menestrier, *Histoire du roy Louis le Grand* (Amsterdam, 1691), p. 38.

13 Hawkins 1885, vol. ii, p. 392, cat. 247.

14 Hawkins 1885, vol. ii, pp. 393–7, cats 248–53; Wohlfahrt 1992, p. 313, cats 12 007–8; p. 315, cats 12 012–14.

15 Hawkins 1885, vol. ii, pp. 399–407, cat. 256–70.

16 Hawkins 1885, vol. ii, p. 407, cat. 271; Wohlfahrt 1992, p. 323, cat. 13 028.

17 Wohlfahrt 1992, p. 329, cat. 14 016.

18 For 'windnegotie' (windy speculation) in the Dutch satirical publication of 1720, *Het groote tafereel der dwaasheid* (The great mirror of folly), see Stephens and George 1870–1954, ii, cats 1623, 1624, 1630, 1654, 1661, 1676, 1683 (financiers use bellows in cats 1654 and 1676); Cole 1949, pp. 5, 7, 20, 23, 26–8, 30, 32.

19 Aesop, *The complete fables*, trans. Olivia and Robert Temple (London: Penguin, 1998), p. 137, no. 185.

20 Hawkins 1885, vol. ii, p. 450, cat. 57; 1979, pl. CXLIV, cats 2–3; Wohlfahrt 1992, p. 371, cats 20 011; Adams 2005, pp. 38–39, cats 14–15.

21 Hawkins 1979, pl. CXLIV, cats 4, 5; Wohlfahrt 1992, pp. 371–2, cats 20 012–13; Adams 2005, pp. 40–41, cats 16–18.

22 Hawkins 1979, pl. CXLIV, cat. 8; Wohlfahrt 1992, p. 371, cat. 20 010; Adams 2005, p. 45, cat. 23.

23 Hawkins 1979, pl. CXLIV, cat. 13; Wohlfahrt 1992, p. 374, cat. 21 006; Adams 2005, p. 49, cat. 30.

24 Hawkins 1885, vol. ii, p. 450, cat. 56; Wohlfahrt 1992, p. 371, cat. 20 007; Adams 2005, p. 44, cat. 22.

25 Adams 2005, p. 42, cat. 19.

26 Bindman 1989, pp. 21, 110; cat. 55.

27 Dalton and Hamer 1910–17, ii, p. 201, cat. 1105–11; Bell 1987, p. 264; Bindman 1989, p. 110, cat. 54a.

28 Stephens and George 1870–1954, vol. vii, cat. 8294A.

29 For Spence's issues, including those cited below, see Dalton and Hamer 1910–17, vol. ii, pp. 165–79, cats 676–901; Bell 1987, pp. 209–53; Bindman 1989, p. 198, cats 205–6.

30 Stephens and George 1870–1954, vol. vii, cat. 8710; Bindman 1989, p. 194, cat. 197.

31 Stephens and George 1870–1954, vol. ix, cat. 13287; George 1959–60, vol. ii, p. 184; pl. 73; O'Connell 1999, p. 148; Gatrell 2006, p. 493, fig. 242.

32 As, for example, the corn-factor Rusby in London in July 1800, satirized in Isaac Cruikshank's print of August 1800, *A Legal Method of Thrashing Out Grain or Forestallers & Regraters Reaping the Fruits of their Harvest*; Stephens and George 1870–1954, vol. vii, cat. 9545.

33 Illustrated in Dykes 2005, p. 310.

34 Hawkins 1885, p. 444, cat. 160; Jones 1979ᵇ, p. 20, fig. 16.

35 For twentieth-century cartoons of the enemy consuming the globe, see Keen 1986, pp. 48–50.

36 Marc Baer, *Theatre and Disorder in Late Georgian London* (Oxford: Clarendon Press, 1992), pp. 71–2.

37 Davis and Waters 1922, p. 16, cat. 183; Friedenberg 1970, pp. 22–5; Brown 1980, p. 166, cat. 676. Brown 1995, p. 262, illustrates an original accompanying label for this medal, where the abbreviations are explained.

38 Stephens and George 1870–1954, vol. viii, cat. 11419.

39 Quoted in Davis and Waters 1922, p. 17.

40 Donald 1996, pp. 184–98: 'Peterloo, and the end of the Georgian tradition in satire'; O'Connell 1999, p. 147.

41 Stephens and George 1870–1954, vol. ix, cats 13258, 13260; Donald 1996, p. 190, figs 197, 198.

42 Stephens and George 1870–1954, vol. x, cat. 14210.

43 Brown 1980, p. 64, cat. 269.

44 Stephens and George 1870–1954, vol. vii, cats 9043, 9391.

45 Brown 1987, p. 19, cat. 1824.

46 Gay van der Meer, 'The beggars' medals worn by the rebellious Dutch nobles in 1566', *The Medal*, no. 33 (1998), pp. 14–22.

47 Brown 1987, p. 72, cat. 2060.

48 Example in British Museum (P&D 1998,1004.10).

49 Nicole Villa, Denise Dommel and Jacques Thirion, *Collection De Vinck. Inventaire analytique*, vii, *La révolution de 1848 et la Deuxième République* (Paris: Bibliothèque Nationale, 1955), p. 542, cat. 15189.

50 See Collignon 1984; also fig. 15, p. 25 above for a medal of 1858.

51 Jones 1979ᵇ, p. 21, fig. 32; Fearon 2009.

52 Frankenhuis 1919, p. 157, cat. 1319; Jones 1979ᵇ, p. 3; Ernsting 1995, p. 221, cat. 164; Steguweit 2000, p. 35, cat. 76.

53 Antony Griffiths, 'The design and production of Napoleon's *Histoire Métallique*', *The Medal*, no. 16 (1990), pp. 16–30, at p. 26; Antony Griffiths, 'The origins of Napoleon's *Histoire Métallique*', *The Medal*, no. 17 (1990), pp. 28–38, at p. 37, fig. 19.

54 Frankenhuis 1919, p. 183, cat. 1495.

55 Brown 1995, p. 148, cat. 4269; p. 180, cat. 4409.

56 Typewritten report, 2 November 1918, 'Reports 1917–18', British Museum, Dept of Coins and Medals, p. 90.

57 Griffiths, Wilson-Bareau and Willet 1998, p. 15.

58 Frankenhuis 1919, p. 189, cat. 1537; Jones 1979[a], p. 150, fig. 408; Jones 1979[b], p. 25, fig. 43.

59 Viktória L. Kovásznai, *Modern Magyar éremm vészet I. Modern Hungarian medals I. 1896–1975* (Budapest: Magyar Nemzeti Galéria, 1993), p. 76; Steguweit 2000, p. 330.

60 Henry T. Allen, *The Rhineland occupation* (Indianapolis: Bobbs-Merrill Company, 1927), pp. 319–24, appendix 4: 'Black troops'.

61 Kienast 1967, p. 79, cat. 264.

62 Kienast 1967, p. 79, cat. 263.

63 Smith to William Blake, 16 August 1940; Wisotzki 1988, p. 151.

64 Smith to Cameron Booth, 28 July 1940; Wisotzki 1988, p. 147.

65 Smith describes the language as 'coffee pot Greek', that is, colloquial; Wisotzki 1988, p. 101.

66 David Margolick, *Strange fruit: Billie Holiday, café society, and an early cry for civil rights* (Philadelphia and London: Running Press, 2000).

67 Gray 1968, p. 30; Krauss 1977, p. 15, cat. 95; Wisotzki 1988, pp. 108–13; Lewison 1991, p. 26, cat. 1; Marks and Stevens 1996, p. 49, cat. 1; Giménez 2006, p. 347, cat. 116.

68 Smith quoted in Gray 1968, p. 24; Wisotzki 1988, p. 17.

69 Gray 1968, p. 29; see also Wisotzki 1988, pp. 90–92.

70 Burrows and M. Brown respectively, quoted in Giménez 2006, p. 340. Published comments on the medals ranging from 1940 to 1996 are reprinted on pp. 339–44. The critical reception of the medals in 1940 is the subject of Wisotzki 1988, ch. 6.

71 Richard Hamilton interviewed by Louisa Buck, *The Art Newspaper*, no. 132 (January 2003), p. 27.

72 Schwarz 1997, vol. ii, p. 843, cat. 608; Mundy 2008, p. 213, fig. 269.

73 Bell has, however, used the medallic format in graphic form, as in a design for a French euro coin sh ... g Madame dryguillp Alalll ,lllllll' (published in the *Guardian*, 5 December 1995; original drawing in the British Museum) and another design for a euro in which Margaret Thatcher as Britannia cuddles a bull representing Europe, used for the cover of *Eurobollocks! Britain's relationship with 'Europe' 1957–2007*, exh. cat. (London: Cartoon Museum, 2007).

74 Collateral damage is defined as 'unintentional civilian damage or damage to civilian property caused by military action', *Collins essential English dictionary*, 2nd ed. (London: HarperCollins, 2006). The US Department of Defense, *Joint targeting* (Joint Publication 3-60, 13 April 2007), Glossary, Part II, Terms and Definitions, has: 'Collateral damage. Unintentional or incidental injury or damage to persons or objects that would not be lawful military targets in the circumstances ruling at the time. Such damage is not unlawful so long as it is not excessive in light of the overall military advantage anticipated from the attack.'

75 Steve Bell, *Apes of wrath* (London: Methuen, 2004), p. 96. The book is Bell's satirical account of recent US policy on the Middle East.

76 Norman Rosenthal *et al.*, *Apocalypse. Beauty and horror in contemporary art* (London: Royal Academy, 2000), pp. 214–15, 218–25; Christoph Grunenberg, *Jake and Dinos Chapman. Bad art for bad people*, exh. cat. (Liverpool: Tate Liverpool 2006), pp. 22–3, 26–7; *Fucking Hell. Jake & Dinos Chapman* (London: White Cube, 2008), with text by Simon Baker, Robin Mackay and Rod Mengham. Bruegel's painting (Museo del Prado, Madrid) is reproduced in Rosenthal 2000, pp. 20–21.

77 *Fucking Hell* 2008, p. 15.

78 For example, *Negro a Day*; Burton 2005, p. 112.

79 For this drawing, see *Ellen Gallagher. Preserve*, exh. cat. (Des Moines: Des Moines Art Center, 2001), p. 51. The quotation is from R.A. Vonderlehr, T. Clark, O.C. Wegner *et al.*, 'Untreated syphilis in the male negro', *Venereal Disease Information*, vol. xvii (1936), pp. 260–65.

80 Burton 2005, p. 112.

81 Roxana Marcoci, *Comic abstraction. Image-breaking, image-making*, exh. cat. (New York: Museum of Modern Art, 2007), p. 58, pl. 13.

82 Richard Hamilton, *Collected words 1953–1982* (London: Thames and Hudson, 1982), p. 56. Hamilton claims this as his first satirical picture. See also *Richard Hamilton*, exh. cat. (London: Tate Gallery, 1992), p. 156, cat. 26;

Richard Hamilton. Protest pictures, exh. cat. (Edinburgh: Royal Botanic Garden, 2008), pp. 16–17.

83 Hal Foster in *Richard Hamilton* 2008, p. 9. *Shock and Awe* is reproduced on p. 44.

84 Hamilton 1982, p. 94. The work's continuing relevance is discussed in Ken Neil, 'Double trauma: mute art of terror', in Graham Coulter-Smith and Maurice Owen, eds, *Art in the age of terrorism* (London: Paul Holberton, 2005), pp. 131–43.

85 Mikdadi 2008, pp. 60–2.

86 *Mona Hatoum*, exh. cat. (London: Jay Jopling/White Cube, 2006), pp. 52–5.

87 Mona Hatoum interviewed by Janine Antoni in *Bomb* (New York), vol. 63 (Spring 1998) pp. 54–61 (www.bombsite.com/issues/63/articles/2130). Guy Brett describes the text as 'rather like a cage of wire or a veil', in Michael Archer, Guy Brett and Catherine de Zegher, *Mona Hatoum* (London and New York: Phaidon, 1997), p. 53.

88 As in the opening sentence of Michael Moore's anti-Bush polemic, *Dude, where's my country?* (London: Allen Lane, 2003), p. ix: 'Greetings, fellow members of the Coalition of the Willing!' Moore later rebrands it as a 'Coalition of the Coerced, Bribed and Intimidated'; p. 73.

89 Hill 1930, p. 12, cat. 41; Luke Syson and Dillian Gordon, *Pisanello: painter to the Renaissance court* (London: National Gallery, 2001), pp. 125–6, fig. 3.44.

90 Lewison 2006, p. 120.

91 Burton 2005, pp. 152–3.

92 Boris Groys, David A. Ross and Iwona Blazwick, *Ilya Kabakov* (London: Phaidon 1998), pp. 37, 112–19; also p. 39, n. 74 above.

93 See fig. 26, p. 37 and Groys *et al.* (1998), p. 112.

94 Ilya and Emilia Kabakov, *Ilya Kabakov Orbis Pictus. Children's book illustrator as a social character* (Tokyo: Tokyo Shimbun, 2007), p. 9.

95 Ilya and Emilia Kabakov, *An alternative history of art: Rosenthal Kabakov Spivak*, exh. cat. (Cleveland OH: Museum of Contemporary Art and Bielefeld: Kerber, 2005). See also Boris Groys in Groys *et al.* (1998), p. 35.

96 For *Felix in Exile*, see Dan Cameron, Carolyn Christov Bakargiev and ... Coetzee, *William Kentridge* (London and New York: Phaidon, 1999), pp. 122–7; *William Kentridge*, exh. cat. (Milan: Skira Editore, 2003), pp. 94–104. For *Phenakistoscope, William Kentridge* (2003), p. 184.

97 The film was exhibited at the Städel Museum, Frankfurt, and Kunsthalle, Bremen, in June-September 2007. Both film and prints were shown in *Fragile Identities*, an exhibition presented by the University of Brighton in November–December 2007. The prints reached a particularly wide audience, being published at full-page size on separate days in March–April 2007 in the Italian national business daily newspaper, *Il Sole 24 Ore*.

98 For all these works, see *Michael Landy. Everything must go!* (London: Ridinghouse, 2008); for *Nourishment*, also Lewison 2006, pp. 144–9. Seven years after *Break Down*, the artist commented, 'Apart from this studio, I still don't have that many possessions'; interview with Helen Sumpter, *Time Out London*, no. 1991 (16–22 October 2008), p. 55.

99 Crime and Disorder Act 1998 (c. 37), part 1, ch. 1, 1:1a.

100 Philip Attwood, *Italian medals, c. 1530–1600, in British public collections* (London: British Museum, 2003), p. 293, cat. 684.

101 An historical precedent for the medal as mirror is an Italian medal of the 1470s signed Lysippus, showing a young man, perhaps a self-portrait, with an inscription that probably translates as 'See on the other side your beautiful face and here your servant' – clearly, the reverse was intended to be polished; Hill 1930, p. 206, cat. 796; Markus Wesche, 'Lysippus unveiled: a Renaissance medallist in Rome and his humanist friends', *The Medal*, no. 52 (2008), pp. 4–13. For Man Ray and Marcel Duchamp's use of mirrors as portraits in 1944 and 1964 respectively, see Mundy 2008, pp. 71, 74, 213; for Duchamp, also Schwarz 1997, vol. ii, p. 841, cat. 607.

102 *The House of Osama Bin Laden. Langlands & Bell* (London: Thames & Hudson, 2004), p. 285. The book documents the artists' journey through Afghanistan. The artists' nomination for the 2004 Turner Prize resulted from these works, praised for their 'intelligent, but ultimately impartial, style that allows viewers the space to contemplate the themes explored, rather than being overwhelmed by an emotive response'; Katharine Stout in *Turner Prize 2004* (London: Tate, 2004), n.p.

103 *The House of Osama Bin Laden. Langlands & Bell* (London: Thames & Hudson, 2004), pp. 144–85. The NGOs based in Kabul when Langlands and Bell visited

are listed on pp. 107, 121–2, 132, 142. Both those and a list of banned organizations, liberation armies and security agencies appear in *Langlands and Bell Domain*, exh. cat. (Milton Keynes: Milton Keynes Gallery, 2005), pp. 28–31.

104 *Langlands & Bell. Language of places*, exh. cat. (London: Alan Cristea Gallery, 2002), pp. 9, 13, 20–21.

105 Speech given in San Francisco on 19 May 2001; published on the website of the anti-Bush organization Citizens for Legitimate Government (www.legitgov.org/library).

106 For the coin pieces, see *Cornelia Parker*, exh. cat. (London: Serpentine Gallery, 1989), n.p.; *Cornelia Parker. Avoided object*, exh. cat. (Cardiff: Chapter, 1996), pp. 7, 8; *Cornelia Parker*, exh. cat. (Boston: Institute of Contemporary Art, 2000), pp. 14, 23. For the medal pieces, see *The Medal*, no. 23 (1993), p. 109; *Cornelia Parker. Never endings*, exh. cat. (Birmingham: Ikon, 2007), pp. 24–5.

107 *Cornelia Parker* 2007, p. 15.

108 Quoted by Parker from her initial letter to Chomsky; *Guardian*, 12 February 2008. The interview, which took place on 9 March 2007, is transcribed in *Cornelia Parker* 2007, pp. 46–57.

109 However, Perry's enjoyment of bronze sculpture is expressed in the pieces in *Unpopular culture. Grayson Perry selects from the Arts Council collection*, exh. cat. (London: Hayward Publishing, 2008). Included in the exhibition, which tours Britain until January 2010, is Perry's *Head of a Fallen Giant* (2007–8), a large bronze skull memorializing a lost Britain (p. 85, cat. 51).

110 Wendy Jones, *Grayson Perry. Portrait of the artist as a young girl* (London: Vintage, 2007), p. 183. In her discussion of the artist's work, Lisa Jardine writes that, 'Perry rewards [viewers] with a breathtakingly rich level of detail which, in his words, "never lets them down"'; Lisa Jardine, *Grayson Perry*, exh. cat. (London: Victoria Miro Gallery, 2004), n.p.

111 Javier Pes, 'Costume drama', *Museum Practice* (Autumn 2006), pp. 32–5, at p. 34.

112 Jack Hinton, 'Forming designs, shaping medals: a collection of wax models by the Hamerani', *The Medal*, no. 41 (2002), pp. 3–57.

113 *The Medal*, no. 48 (2006), pp. 90–91; Leah Oldman in *Los Angeles Times*, 18 January 2008.

114 Marcy Leavitt Bourne, 'Being an account of the Royal Mint-BAMS millennium medal competition and of its winner Felicity Powell, *The Medal*, no. 35 (1999), pp. 87–94.

115 Nancy Roth, '"Now is the time": Felicity Powell's tribute to John Charles Robinson', *The Medal*, no. 42 (2003), pp. 75–82; Felicity Powell, '*Drawn from the Well*: photographing sculpture, a sculptural practice', *Sculpture Journal*, vol. xv (2006), no. 2, pp. 278–81.

BIBLIOGRAPHY

John W. Adams, *The medals concerning John Law and the Mississippi system, Numismatic notes and monographs*, no. 167 (New York: American Numismatic Society, 2005)

Philip Attwood, *British art medals 1982–2002* (London: British Art Medal Trust, 2002).

Philip Attwood, '"Hony soit qui bon y pense": medals as vehicles of antipathy', *The Medal*, no. 54 (2009).

Francis Pierrepont Barnard, *Satirical and controversial medals of the Reformation* (Oxford: Clarendon Press, 1927).

R.C. Bell, *Political and commemorative pieces simulating tradesmen's tokens* (Felixstowe: Schwer, 1987).

David Bindman, *The shadow of the guillotine. Britain and the French Revolution*, exh. cat. (London: British Museum, 1989).

Laurence Brown, *British historical medals 1760–1960*, 3 vols (London: Seaby, 1980; Seaby, 1987; Spink, 1995).

Jean-Pierre Collignon, *Médailles politiques et satiriques, decorations et insignes de la 2° république française 1848–1852* (Charleville-Mézières: Jean-Pierre Collignon, 1984).

R. Dalton and S.H. Hamer, *The provincial token-coinage of the 18th century illustrated*, 6 vols (n.l., 1910–17).

W.J. Davis and A.W. Waters, *Tickets and passes of Great Britain and Ireland* (Leamington Spa: Courier Press, 1922).

Bernd Ernsting, *Ludwig Gies: Meister des Kleinreliefs* (Cologne: Letter Stiftung, 1995).

John Evelyn, *Numismata. A discourse of medals, antient and modern* (London: Benjamin Tooke, 1697).

L. Forrer, *Biographical dictionary of medallists*, 8 vols (London: Spink & Son, 1904–30).

M. Frankenhuis, *Catalogue of medals, medalets and plaques relative to the World War 1914–1919* (Enschede: M. Frankenhuis, n.d.[1919]).

Daniel M. Friedenberg, *Jewish medals from the Renaissance to the fall of Napoleon 1503–1815* (New York: Clarkson N. Potter for the Jewish Museum, 1970).

Carmen Giménez, *David Smith. A centennial*, exh. cat. (New York: Guggenheim Museum, 2006).

Cleve Gray, ed., *David Smith by David Smith* (New York, Chicago and San Francisco: Holt, Rinehart and Winston, 1968).

Georg Habich, *Die deutschen Schaumünzen des XVI. Jahrhunderts*, 5 vols (Munich: F. Bruckmann AG, 1929–35).

Edward Hawkins, *Medallic illustrations of the history of Great Britain and Ireland to the death of George II*, eds Augustus W. Franks and Herbert A. Grueber, 2 vols (London: British Museum, 1885); reissued with plates and appendix, 19 parts (London: British Museum, 1904–11); reissue reprinted as one volume (Lawrence, Mass.: Quarterman Publications, 1979).

George F. Hill, *A corpus of Italian medals of the Renaissance before Cellini* (London, 1930; reprinted with addenda, Florence: Studio per Edizioni Scelte, 1984).

George F. Hill and G.C. Brooke, *A guide to the exhibition of historical medals in the British Museum* (London: British Museum, 1924).

Mark Jones, *The art of the medal* (London: British Museum, 1979[a]).

Mark Jones, *The dance of death. Medallic art of the First World War* (London: British Museum, 1979[b]).

Mark Jones, 'The medal as an instrument of propaganda in late seventeenth- and early eighteenth-century Europe', *Numismatic Chronicle*, vol. cxlii (1982), pp. 117–26; vol. cxliii (1983), pp. 202–13.

Katalog satyrischer Medaillen und Münzen. Collection Fieweger (Berlin, 1885; reprinted Freiburg: Kricheldorf-Verlag, 1976).

Gunter W. Kienast, *The medals of Karl Goetz* (Cleveland, Ohio: Artus Company, 1967); supplement (Lincoln, Nebraska: Artus Company, 1986).

Bruno Kirschner, *Deutsche Spottmedaillen auf Juden* (Munich: Ernst Battenberg, 1968).

Rosalind E. Krauss, *The sculpture of David Smith. A catalogue raisonné* (New York and London: Garland Publishing, 1977).

Jeremy Lewison, *David Smith. Medals for Dishonor 1937–1940*, exh. cat. (Leeds: The Henry Moore Centre for the Study of Sculpture and Leeds City Art Galleries, 1991).

Matthew Marks and Peter Stevens, *David Smith. Medals for Dishonor*, exh. cat. (New York: Independent Curators Incorporated, 1996).

Jennifer Mundy, ed., *Duchamp Man Ray Picabia*, exh. cat. (London: Tate, 2008).

Olga N. Roovers, 'De Noord-Nederlandse triumfpenningen', *Jaarboek van het Koninklijk Nederlandsch Genootschap voor Munt- en Penningkunde*, vol. xl (1953), pp. 1–48.

Stephen K. Scher, ed., *The currency of fame. Portrait medals of the Renaissance*, exh. cat. (New York: Harry N. Abrams and the Frick Collection, 1994).

Arturo Schwarz, *The complete works of Marcel Duchamp*, 2 vols (London: Thames and Hudson, 1997).

Wolfgang Steguweit *et al.*, *Die Medaille und Gedenkmünze des 20. Jahrhunderts in Deutschland* (Berlin: Münzkabinett, Staatliche Museen, 2000).

Edmund B. Sullivan, *American political badges and medalets 1789-1892* (Lawrence, Mass.: Quarterman Publications, 1981).

Luke Syson, *size immaterial: hand-held sculpture of the 1990s. an exhibition at the british museum* (London: British Art Medal Society, 1999), reprinted from *The Medal*, no. 35 (1999), pp. 3–32.

Gerard Van Loon, *Histoire métallique des XVII provinces des Pays-Bas*, 5 vols (The Hague: P. Gosse, J. Neaulme and P. de Hondt, 1732-7).

Paula Wisotzki, 'David Smith's *Medals for Dishonor*', PhD dissertation, Northwestern University, Illinois, 1988.

Cordula Wohlfahrt, *Christian Wermuth: ein deutscher Medailleur der Barockzeit* (London: British Art Medal Society, 1992).

Noel Woolf, *The medallic record of the Jacobite movement* (London: Spink, 1988).

General bibliography

Johanna Burton *et al.*, *Vitamin D. New perspectives in drawing* (London and New York: Phaidon 2005).

Arthur H. Cole, *Het groote tafereel der dwaasheid ('The great mirror of folly). An economic-bibliographical study* (Boston, Mass.: Harvard Graduate school of Business Administration, 1949).

Diana Donald, *The age of caricature: satirical prints in the reign of George III* (New Haven and London: Yale University Press, 1996).

Vic Gatrell, *City of laughter: sex and satire in eighteenth-century London* (London: Atlantic, 2006).

Mary Dorothy George, *English political caricature*, 2 vols (Oxford: Oxford University Press, 1959–60).

E.H. Gombrich, *Meditations on a hobby horse* (London: Phaidon, 1963), pp. 127–42: 'The cartoonist's armoury'.

Antony Griffiths, Juliet Wilson-Bareau and John Willett, *Disasters of war: Callot Goya Dix*, exh. cat. (London: National Touring Exhibitions, 1998).

Matthew Hodgart, *Satire* (London: Weidenfeld and Nicholson, 1969).

Sam Keen, *Faces of the enemy: reflections of the hostile imagination* (San Francisco: HarperCollins, 1986).

F.D. Klingender, *Hogarth and English caricature* (London and New York: Transatlantic Arts, 1944).

Jeremy Lewison, *Arte nell'età dell'ansia / Art in the age of anxiety*, exh. cat. (Biella: Assoc. Premio Internazionale Biella per l'Incisione, 2006).

John Manning, *The emblem* (London: Reaktion Books, 2002).

Sheila O'Connell, *The popular print in England* (London: British Museum, 1999).

Frederic George Stephens and Mary Dorothy George, *Catalogue of political and personal satires in the British Museum*, 11 vols (London: British Museum 1870–1954).

INDEX

PICTURE ACKNOWLEDGEMENTS

All images are © The Trustees of the British Museum unless otherwise stated. The British Museum wishes to thank the following individuals and organizations for providing the following illustrations:

p. 6 © Felicity Powell; p. 34 (fig. 23) © Cornelia Parker; p. 35 (fig. 24) © Richard Hamilton, Arts Council collection, London; p. 36 (fig. 25) © William Kentridge, courtesy William Kentridge Studio; p. 37 (fig. 26) © Ilya and Emilia Kabakov; pp. 80, 81 (cat. no. 21), 82, 83 (cat. no. 22) the Estate of David Smith, photo: D. James Dee, courtesy Gagosian Gallery; pp. 84–5 (cat. no. 23) © Succession Marcel Duchamp/ADAGP, Paris and DACS, London 2009, p. 85 (bottom) International Collectors Society, New York; courtesy Richard Hamilton; pp. 86 (cat. no. 24), 87 © Steve Bell; p. 88 (cat. no. 25) © Jake and Dinos Chapman; p. 90 © Jake and Dinos Chapman, photo: Todd-White Art Photography, courtesy Jay Jopling, White Cube, London; pp. 92, 93 (cat. no. 26) 94 © Ellen Gallagher; p. 95 © Ellen Gallagher, courtesy Gagosian Gallery; pp. 96, 97 (cat. no. 27) © Richard Hamilton (represented by DACS, Design and Artists Copyright Society); p. 98 (top and bottom) © Mona Hatoum, photo: Marc Domage, courtesy Galerie Chantal Crousel, Paris; p. 99 (cat. no. 28), Mona Hatoum, p. 100 © Mona Hatoum, courtesy Nigel Schofield, p. 101 © Mona Hatoum; pp. 102 (cat. no. 29), 103–5 © Yun-Fei Ji; pp. 106, 107 (cat. no. 30) © Ilya and Emilia Kabakov; pp. 109 (cat. no. 31), 110–11 © William Kentridge; p. 112 (cat. no. 32) © Michael Landy (represented by DACS,); pp. 114–15 Hartlepool police; p. 116 (cat. no. 33) © Langlands and Bell, pp. 118–19 © Langlands and Bell, courtesy Alan Cristea Gallery, London; pp. 120, 121 (cat. no. 34) © Cornelia Parker; pp. 122–5 (cat. no. 35) © Grayson Perry; pp. 126–9 (cat. no. 36) © Felicity Powell.

Front cover (top to bottom, left to right):
Top row: *Meddling with Dishonour*, Jake and Dinos Chapman (cat. no. 25); *An Experiment of Unusual Opportunity*, Ellen Gallagher (cat. no. 26); *Waterloo Medal*, Félicien Rops (fig. 15); second row: *The Revival of Income Tax*, Thomas Halliday (cat. no. 14); *The Hungarian Soviet Republic*, Erzsébet Esseő (cat. no. 19); *Hot Air*, Felicity Powell (cat. no. 36); *The Uncharitable Monopolizer*, John Gregory Hancock (cat. no. 11); third row: *Medal of Dishonour*, Ilya and Emilia Kabakov (cat. no. 30); *Medal of Dishonour*, Mona Hatoum (cat. no. 28); fourth row: *Financial Speculation*, unidentified German artist (cat. no. 8); *For Faith in Shopping*, Grayson Perry (cat. no. 35); *America in the War*, Ludwig Gies (cat. no. 18); *Bonapartism as a Cockchafer*, unidentified French artist (cat. no. 15); fifth row: *The Humiliation of Louis XIV*, unidentified Dutch artist (cat. no. 6); *The Good Fortune of William III* (reverse), Jan Smeltzing (cat. no. 5); *The Covent Garden Theatre Old Price Riots*, unidentified British artist (cat. no. 12); *Greed Envy Rage*, William Kentridge (cat. no. 31).

Back cover (top to bottom, left to right):
Top row: *We Know Who You Are. We Know What You Have Done*, Cornelia Parker (cat. no. 34); second row: *Coalition of the Willing*, Yun-Fei Ji (cat. no. 29); third row: *The Hutton Award*, Richard Hamilton (cat. no. 27); *The Good Fortune of William III*, Jan Smeltzing (cat. no. 5); *The Hungarian Soviet Republic* (reverse), Erzsébet Esseő (cat. no.19); fourth row: *Financial Speculation* (reverse), unidentified German artist (cat. no. 8).

Back flap:
Virtual World, Langlands and Bell (cat. no. 33).